Preparing
Teachers of Art

Edited by Michael Day
Brigham Young University

NATIONAL ART EDUCATION ASSOCIATION
RESTON, VIRGINIA
1997

Library of Congress Cataloging-in-Publication Data is available upon request.

ISBN 1-890160-01-6

PRINTED IN THE UNITED STATES OF AMERICA.

First Printing, June 1997

Contents

Preface

Michael Day

ONE might posit that, of all the many aspects related to the field of art education, none is more important than the preparation of teachers of art. Prospective art teachers, newly graduated from college teacher preparation programs, are the future of the field and will, it is assumed, serve for many years. New teachers entering classrooms and other venues for art education are expected to carry with them the current knowledge and best practices of the field. It is typically assumed that this knowledge and these skills result from participation in and graduation from quality art teacher preparation programs. The assumptions associated with this scenario, and their relative validity, have recently become topics for analysis and discussion on a broad scale (National Commission on Teaching and America's Future 1996).

Education is a dynamic field of professional inquiry and practice that regularly experiences significant trends, changing issues, and new perspectives. The field of art education, as an example, has experienced major changes in approaches to curriculum and instruction during the past twenty years. If art teacher education programs are to prepare knowledgeable and competent practitioners and participants in the educational issues of the day, these programs must also be dynamic and current. Simply stated, art teacher preparation programs must change and improve in ways parallel to the changing issues and expectations of art education. The field of art education, in turn, participates within the larger and broader concerns and practices of general education.

One of the most ubiquitous of current discussions in general education is focused upon professional development for teachers in service within an institutional setting, typically a school district. The need for practicing teachers to learn new approaches and to participate in forming the educational environment is becoming increasingly apparent.

Entire catalogues listing audio, visual, print, and digital professional materials are devoted to the ongoing education of teachers in service. The field of art education, like the many other fields within general education, has placed considerable emphasis on programs of in-service professional development (NAEA 1996, Getty Center for Education in the Arts 1996). However, even the best quality in-service efforts cannot compensate for inadequate preparation of new art teachers. *In-service professional development in art education should not be a remedial activity.*

Many colleges and universities in North America continuously improve and update their art teacher preparation programs. College students who intend to teach art are provided with strong backgrounds of study in visual arts disciplines, the content of their future instruction. They spend appropriate time learning in foundation areas, including educational philosophy, history, and psychology. Quality preparation programs for teachers of art provide students with knowledge, skills, and experiences in methods for curriculum, instruction, and assessment. All of these topics and many other theoretical and practical issues are studied within the contexts of goals and objectives of art education. College professors who direct quality programs typically maintain professional currency and educate their students in light of recent events such as the National Visual Arts Standards, the work of the National Board for Professional Teaching Standards, and recommendations of the National Art Education Association. Such programs consistently provide public and private schools with a corps of excellent new art educators.

For various reasons, however, too many programs graduate students without strong professional preparation. Students in weak programs might not have access to a comprehensive curriculum in the visual arts; they might be weak in foundational studies in education; they might not have access to current literature or knowledge of professional organizations in art education; their student teaching experiences might be supervised by a professor with no expertise in art education; or they might experience any number of similar deficiencies in their preparation to teach art.

Even the best in-service programs for employed art teachers cannot keep pace with any appreciable flow of poorly prepared new graduates leaving colleges and universities each year. With the realization that this problem exists, a number of questions arise: Why are poorly prepared teachers hired? Why are some art teacher preparation programs deficient? How can art teacher preparation programs be improved?

Consideration of these and related questions leads to analysis of the complex system of education in the United States and Canada, where a

number of influential forces combine to thwart easy answers. When the preparation of art teachers is considered, one must address issues such as the values society holds for art in the school curriculum, the status of professors of education on university campuses, requirements of teacher accreditation associations, relationships of art education faculties with colleagues in colleges of education, state requirements for certification and licensure, culture of the schools, and recommendations of professional organizations, to name a few.

While any one of these topics might be addressed and discussed independently, when the focus is upon improving art teacher preparation, all issues must be considered interdependently. This dialogue seems to be of interest to many factions in the field of art education: students who attend colleges and universities; practicing art teachers in the schools; school administrators who hire new teachers; art professionals who are concerned with the integrity of art content; and parents and community members who have various reasons for supporting art instruction in the schools.

This book is an attempt to contribute to the dialogue about the preparation of art teachers. Each author has addressed one of the essential issues from a position of knowledge and experience. The initial essay by Michael Day places preservice art education in the larger context of the field of art education. He discusses some of the major changes and issues that shape art education today and describes recent events that promise to influence the future of the field.

Enid Zimmerman investigates the demographics of art teacher preparation programs: Where are they? What are they like in terms of curriculum, supervised teaching, and so on? Who teaches within them, and what are these teachers' professional backgrounds and affiliations? How many teachers of art do they graduate on an annual basis? Although the task of identifying where prospective art teachers are prepared might seem simple, the very condition that brings some programs under question also keeps them from being identified and located—that is, they are not connected to the professional field. For example, the professors who direct such programs might not be members of the Higher Education Division of the NAEA, or they might associate with disciplines other than art education, such as studio art or general education.

Yet students are graduated from such "unconnected" programs and enter the field as teachers of art, not having the benefits of knowing their professional foundations, the literature of their chosen field, or the major contributors to art education, past and present. Zimmerman reports her research on these and other questions and, after sharing details

of a fascinating quest for information, concludes that much remains to be learned about "Whence Come We? What Are We? Whither Go We?"

Lynn Galbraith investigates the content of curricula experienced by undergraduate students preparing to teach art. Her task is to conduct research about what prospective art teachers are being taught in the colleges and universities they attend, and to discuss implications of her findings for professors of art education and for the field. Of particular interest in Galbraith's research is her use of electronic means to gather information about art teacher preparation programs and the courses they offer. Galbraith's research addresses the type of changes in curriculum content that might be expected to take place with comprehensive contemporary approaches to art education. She explores topics such as number of full-time or part-time art education faculty; coursework in art history, aesthetics, and art criticism; attention to multicultural issues and exceptional learners; and the philosophical emphasis of the program in terms of child-centeredness, studio-centeredness, discipline-based instruction, and so forth.

With a number of case studies of particular colleges and universities, Galbraith reports her findings gathered not only from written materials, such as catalogue descriptions, but also from communications with faculty members who responded to her E-mail inquiries. Her findings and discussion pose significant problems for the field of art education as it aspires to improve in the realm of art teacher preparation. Galbraith provides suggestions for uses of electronic media to strengthen some of the particularly weak areas of typical art education curricula in higher education.

Regardless of what art education students—prospective art teachers—are taught during their undergraduate years, they eventually leave the college or university and receive certification to teach in some state or province. Margaret DiBlasio investigates relationships between certification or licensure requirements among the various states and college programs and discusses implications for art teacher preparation.

DiBlasio researched requirements of state departments of education and reports her findings in charts that explicate the various art-related requirements, professional education requirements, and entry tests for certification. As with each of the studies conducted for this book, two major findings are salient: first, there is tremendous diversity among states, colleges and universities, and school districts on virtually any of the issues investigated; and second, there is a paucity of useful, current, and reliable research.

In her discussion of the research findings, DiBlasio raises telling issues regarding the blurring of distinctions between certification (of program completion) by colleges and universities and the licensure to practice issued by states. She discusses questions of quality control for art teachers entering the schools, the locus of political power to shape teacher preparation programs, and effects of licensure requirements on the rigor of course content and curriculum in art teacher preparation programs.

One of the most interesting and positive events in recent years with respect to art teacher practice is the development of national standards for certification by the National Board for Professional Teaching Standards (NBPTS 1994). As of this writing, the first group of art teachers has completed the year-long evaluation. Forty-seven highly accomplished and experienced teachers have passed the stringent and comprehensive board evaluation process and are now recognized with NBPTS licensure in art.

Mac Arthur Goodwin was a member of the advisory committee that worked for a period of years on development of the standards and assessment procedures. Although the NBPTS licensure is voluntary, it is a means that has not existed before by which art teachers might demonstrate the professional strengths they have developed with experience, advanced study, and thoughtful practice. This nationally recognized licensure is one of the few avenues available for excellent art teachers to gain recognition for their abilities and achieve a position of advanced status within their profession.

Goodwin traces the origins of the movement to develop teaching standards, beginning with the 1983 publication of *A Nation at Risk* by the National Commission on Excellence in Education. The standards attempt nothing less than to describe, within appropriate categories, the types of behaviors that characterize highly accomplished teachers of art. He reports that the standards are based on five broad propositions about teaching:

1. Teachers are committed to students and their learning.
2. Teachers know the subjects they teach and how to teach those subjects.
3. Teachers are responsible for managing and monitoring student learning.
4. Teachers think systematically about their practice and learn from experiences.
5. Teachers are members of learning communities (NBPTS 1994, 1–3).

Throughout his article, Goodwin discusses and analyzes how each of these propositions contributed to the development of the NBPTS standards for art teachers and suggests ways that these same assumptions might guide the preparation of prospective art teachers as they study at the undergraduate level.

Regardless of the nature, quality, and philosophical direction of college programs for prospective art teachers, graduates must face and survive within the culture and value system of the school districts in which they are employed. Facing their students in the classroom, their colleagues, administrators, and their students' parents becomes the primary concern for most new teachers. This school culture is very powerful and can virtually nullify values or practices new teachers received in their college art education programs, if they conflict. More influential in many new teachers' thoughts than "how I was trained to teach art at the university" is the standard of "how art is taught in my new school job."

Kellene Champlin shares her experiences and views on the school culture that new teachers face and explains how she guides new teachers within a successful art education program in a major metropolitan school district. In her discussion of a wide range of practical problems, issues, and situations faced by most art teachers, Champlin provides university professors with much to consider as they prepare their students for the real world of schools.

An important implication of Champlin's report has to do with the relationship between college art education programs and the school settings for student teaching experiences. Champlin emphasizes the benefits of close collaborative efforts and cooperation between schools and universities for the benefit of both public school students and college students who intend to teach. The type of reality check provided by Champlin from her school setting is essential for any college or university program.

The final essay in this series deals with the problem of effecting change in the university setting. When art educators determine that changes are needed to strengthen art teacher preparation programs, they face the typical resistance of the academic bureaucracy. It is one thing to recognize a need to change and to identify needed program improvements; it is another to actually implement meaningful, positive change. James Hutchens addresses this very large and complex issue and provides useful strategies for achieving successful change.

Hutchens recognizes that "the culture of the university and departments in which art teachers are educated has embedded within it

customs and traditions that will be very difficult to change." Nevertheless, Hutchens encourages readers to consider major change as well as modest "correctives." He addresses issues in higher education such as university responsibility for teacher education, confluence of research and teaching, and the need for art disciplinarians to abandon their trenches and work more collaboratively.

One of Hutchens's suggestions for reform in art teacher education relates very positively to Lynn Galbraith's recommendations for uses of electronic media. He suggests a national consortium of discipline-based programs, possibly utilizing the World Wide Web for communications. His recommendations also include the suggestion that those art teacher preparation programs that are unwilling or unable to provide this type of current comprehensive curriculum and teaching experience for their students should consider withdrawing.

Finally, on a macro level, Hutchens discusses possibilities for "building a national corporate and government constituency for art teacher education reform efforts." Within this scenario he refers, possibly, to the type of effort seen in the advertising supplement to the magazine *Business Week* (October 1996), advocating the arts as an essential component in education. Art education is described in this twenty-page piece as contributing to the type of education valued by business interests.

These seven essays, all dealing with some aspect of art teacher preparation, are presented to stimulate discussion, suggest needed research, and provide a focus for issues that remain with the field and for the field of art education to address. The issues are many and complex, and the problems are difficult and persistent. The beginning of improvement, however, comes with their identification and recognition of their impact, leading to proposals that strive to improve upon the status quo.

It is a certainty that preparation of the multitude of new teachers of art who are needed in schools, museums, and communities is a very worthwhile endeavor. It is an endeavor worthy of the best efforts for improvement that the corps of professional art educators can bring to bear, with the assurance that these efforts will pay dividends in the lives of many for years to come.

REFERENCES

Association for Supervision and Curriculum Development. 1996. *Educational Leadership* 54 (4). [See this issue and regular ASCD brochures advertising professional development materials and events.]

Educating for the workplace through the arts. 1996. *Business Week,* October 28. [Special advertising section.]

Getty Center for Education in the Arts. 1996. *Have an eye-opening experience.* [Brochure advertising nine professional development summer programs for art educators.]

National Art Education Association. 1996. *NAEA News.* April. [See listing of sixteen NAEA-cosponsored summer academies for art educators.]

National Board for Professional Teaching Standards. 1994. *Early adolescence through young adulthood/art: Standards for National Board certification.* Washington, D.C.: National Board for Professional Teaching Standards.

National Commission on Educational Excellence. 1983. *A nation at risk: The imperative of education reform.* Washington, D.C.: United States Department of Education.

National Commission on Teaching and America's Future. 1996. *What matters most: Teaching for America's future.* New York: Teachers College, Columbia University.

Acknowledgments

In October 1995, a symposium on the topic of art teacher preparation was held at the Sundance Resort near Provo, Utah, through the generous support of the Getty Education Institute for the Arts (formerly known as the Getty Center for Education in the Arts). The Sundance Symposium brought together a small group of art educators from across the country to discuss the challenge of improving art teacher preparation programs. Invited papers were presented by the authors featured in this book and were discussed by symposium participants. The essays reflect authors' responses to the symposium discussion.

I wish to acknowledge the contributions and express appreciation to the participants in the Sundance Symposium, in addition to the authors. They are listed according to their professional positions in October 1995.

- Karen Carroll, Maryland Institute, College of Art
- Bruce Christensen, dean, College of Fine Arts and Communications, Brigham Young University
- D. Jack Davis, University of North Texas
- Barbara Ann Francis, California State University–Long Beach
- Karen Hamblen, Louisiana State University
- Bennett Lentczner, New World School of the Arts
- David Pankratz, Getty Program Officer
- Robert Patterson, dean, College of Education, Brigham Young University
- Sarah Tambucci, National Art Education Association, president, Pittsburgh, Pennsylvania

Because of the centrality of the topic to the field of art education, the National Art Education Association chose to publish *Preparing Teachers of Art* in collaboration with the Getty Education Institute. The preparation of this book required sustained efforts by a number of persons in various professional roles, including the following fine professionals:

- David Hawkinson, photographer
- Wayne Kimball, artist, cover lithograph
- Bruce Patrick, art director
- Jonathan Saltzman, book designer
- Barbara Wilkinson, proofreader

As managing editor, Elizabeth Watkins brought her extensive professional experience and high standards to the publication. She communicated extensively with all authors and members of the publication team and kept the complex process moving. Virgie Day provided critical expertise and emotional support from inception to completion of this project.

Special thanks to NAEA Presidents Mark Hansen and Sarah Tambucci for their encouragement and support, and many thanks to NAEA Executive Director Thomas Hatfield for his support and the expertise he brought to make the publication possible.

Without the generous support of Leilani Lattin Duke, director of the Getty Education Institute, neither the Sundance Symposium nor *Preparing Teachers of Art* would have been possible. Thank you so much, Lani.

—*M.D.D.*

Preparing Teachers of Art

Preparing Teachers of Art for 2000 and Beyond

Michael Day
Brigham Young University

*We are not likely to have good schools without
a continuing supply of excellent teachers.*
—JOHN GOODLAD

THE nation needs caring, competent, talented, and dedicated art teachers for the year 2000 and beyond, and preparation to meet this need must begin now. The idea of preparing art teachers for the future assumes that the demands of schools in the next millennium are known; otherwise, how would one know how to meet those demands? Although no one knows the future, current trends, practices, and events suggest to experienced professionals some of the challenges that teachers are likely to face in schools at the beginning of the third millennium.

How can art educators strengthen teacher preparation programs and provide the nation with teachers who can meet the needs of students and the demands of schools? This question assumes that programs to prepare art teachers need to be improved. Art education programs in some colleges and universities are already very strong and promise to remain so, although they will need to change over time in order to accommodate developments within a dynamic professional field.

Many other programs, however, do not provide sound preparation for college students who wish to teach art. These programs will need to improve significantly if they are to meet the requirements for education

3

in the next millennium. Institutions of higher education that are unwilling or unable to provide high-quality programs should seriously consider retiring from the job of art teacher preparation. Prospective art teachers will have difficult challenges to face on the job; it is unfair to send them out from the college or university unprepared to meet those challenges. The field of art education carries the knowledge needed to help improve teacher preparation programs. There is a fund of theory, foundational principles, and criteria that might be applied in order to foster reform. Given the availability of such knowledge, how can this reform be accomplished, and by what means might reformers measure their accomplishments?

This essay suggests a process by which improvement in art teacher preparation programs might be addressed. It asserts the importance of teachers within the general education enterprise—including the field of art education—and addresses the continuing need to prepare excellent teachers. It acknowledges problems in teacher preparation and suggests the need to recruit, prepare, and retain excellent teachers. The primary topic of preparation is discussed in light of the paradigm shift toward a content-centered approach in the field of art education. Recent relevant reports and events are discussed as resources for program improvement. Finally, this essay proposes a system for the analysis of art teacher preparation through the construction of program profiles and the development of action plans.

..

Teaching is the most important element for successful learning.
—NATIONAL COMMISSION ON
TEACHING AND AMERICA'S FUTURE

..

TEACHERS: THE KEY TO SUCCESS IN EDUCATION

American education has experienced a prolonged period of reform stimulated by events such as the publication of *A Nation at Risk: The Imperative of Educational Reform* (National Commission on Excellence in Education 1983), *Beyond Creating: The Place for Art in America's Schools* (J. Paul Getty Trust 1985), *Tomorrow's Teachers* (Holmes Group 1986), *Toward Civilization: A Report on Arts Education* (National Endowment for the Arts 1988), and *National Standards for Arts Education: What Every Young American Should Know and Be Able to Do in the Arts* (MENC 1994).

Much attention has been given to a wide range of topics associated with the entire educational enterprise: school organization, educational implications of cognitive psychology, multicultural curriculum, technology in education, and standards for student learning. A casual observation of current books on education reveals titles that reflect the diversity of educational reform: *Restructuring Schools for Linguistic Diversity; Teaching with Technology; Special Education, and Reform; Authentic Assessment in Action; Funding for Justice; Restructuring Urban Schools;* and *Negotiating the Maze of School Reform.* Although each of these topics and many others might be worthwhile targets for improvement in education, they all beg the question: Who will carry out this reform?

Recently, educators have recognized that classroom teachers are key individuals for all reform efforts and have acknowledged the necessity of placing them at the center of educational reform (Petrie 1990, 14). Shulman comments:

> The teacher must remain the key. . . . Debates over educational policy are moot, if the primary agents of instruction are incapable of performing their function well. No microcomputer will replace them, no television system will clone and distribute them, no scripted lessons will direct and control them, no voucher system will bypass them (National Commission on Teaching and America's Future 1996, 5).

This recognition of the essential role of teachers for the purposes of educational reform has not come simply because teachers have the power to thwart reform initiatives. Teachers increasingly are viewed not as educational technicians, but as professionals integral to the educational enterprise in all its complexity. However, this perhaps belated recognition of the role of teachers might be in some part due to "the unwillingness of the teacher, once the classroom door is closed, to do what curriculum developers and policy makers say ought to be done" (Petrie 1990, 14). It is clear that major improvements in education cannot be accomplished without the intelligent cooperation of teachers.

THE NEED FOR EXCELLENT TEACHERS

Considering that, during the next ten years, we will recruit and hire more than two million teachers for America's schools, the responsibility to prepare competent, knowledgeable, and caring teachers becomes paramount. Perhaps with this responsibility in mind, in his State of the

Union Address on February 4, 1997, President Clinton issued the *President's Call to Action for American Education in the Twenty-First Century*, which includes a provision to "make sure there is a talented and dedicated teacher in every classroom."

This call to action applies as well to the nation's art classrooms. The nation needs well-prepared art teachers right now and will need many more excellent, talented, and dedicated art teachers in the decades to come. If this assertion was in doubt in the past, its verity was reinforced in 1994 when the United States Congress passed the *Goals 2000: Educate America Act*, which acknowledges that "the arts are a core subject, as important to education as English, mathematics, history, civics and government, geography, science, and foreign language" (MENC 1994).

An important distinction of the president's challenge is to provide "talented and dedicated" teachers for the nation's schools. Already, too many ill-prepared teachers are teaching subjects for which they are neither competent nor credentialed. As one former student comments, "Just being a caring person does not mean one is a good teacher" (National Commission on Teaching and America's Future 1996, 6). Nor does a thorough knowledge of discipline content automatically qualify a person as a good teacher—an observation that many college students will support.

In their contemporary role, teachers are much more than educational technicians implementing what others decide is worth teaching. Increasingly, the teacher is an "instructional leader who orchestrates learning experiences in response to curriculum goals and student needs and who coaches students to high levels of independent performance" (National Commission on Teaching and America's Future 1996, 68). Good teachers are driven in their daily work by " a desire to teach satisfyingly, to have all their students excited about learning, to have their daily work square with their conception of what this work should be and do" (Goodlad 1994, 203).

Teaching is a profession with rigorous standards that requires intensive study; development of a broad range of skills; and extensive understanding of learners, learning environments, instructional strategies, community social issues, curriculum development, and evaluation. To teach well is a difficult and demanding activity. As the primary source for qualified teachers, college and university teacher education programs have a strong responsibility and a major challenge. The 47 million school children in the nation's 108,000 schools have a right to be taught well by well-prepared teachers.

RECRUIT, PREPARE, AND RETAIN EXCELLENT TEACHERS

In his book *Teachers for Our Nation's Schools* (1990), Goodlad decries the current state of the educational profession, likening it to the status of the medical profession before Abraham Flexner's landmark study of medical education and medical schools (1910). Goodlad points out "clear parallels between medical education in 1910 and teacher education eighty years later" (33), especially noting the lack of collaboration between medical schools and practitioners.

Major problems exist because of a lack of clear standards for admission to the teaching profession. "Clearly, the gates to teaching are unlatched, this one requiring less of a push than that. . . . The state is culpable, but there seem always to be institutions of higher education ready to provide what is minimally required" (Goodlad 1994, 158). Most states do not require schools of education to be accredited, and only about 500 of the nation's 1,200 education schools have met common professional standards. State departments or offices of education often routinely approve teacher education programs, including those that lack qualified faculty and are out of touch with new knowledge about teaching (National Commission on Teaching and America's Future 1996).

Clearly, problems exist in the procedures by which individuals are educated to become teachers and by which they receive approbation of the state to enter the nation's schools in one of the most responsible positions imaginable. Teachers are given access to and responsibility for our most valuable and precious resource, yet many teachers do not receive the preparation they need, and few standards are in force that distinguish those who are able to teach successfully from those who are not.

The problem of improving teaching—both in-service and pre-service—is a very large, systemic one that defies simple solutions. The factors that influence the quality of teaching in the schools are many and varied, and some are very large in their own right. In addition to the pervasive and persistent economic issues in education, a plethora of problems interface with the need to recruit and prepare a corps of excellent teachers for America's schools. Questions abound regarding topics such as curriculum content and organization, evaluation and assessment, diversity in student populations (including the range of first languages spoken by students), school organization, local control, discipline and security in schools, status of teachers in society, gender and the teaching profession, minorities in education, and many others.

Accomplishing positive change in education is difficult, in part, because many of these factors interact, forcing reformers to deal with a

group of issues simultaneously instead of only one or two at a time. In the case of teacher education, strong academic preparation will not serve a prospective teacher well if that teacher is unable to work effectively with a range of learners. Ability to develop a rich, comprehensive curriculum might be largely wasted if the teacher has not developed a correspondingly comprehensive repertoire of teaching methods. Even well-prepared teachers find it difficult to perform at the highest level in class if they have to take a second job to survive financially.

The National Commission on Teaching and America's Future outlined a three-point strategy for improving schools. This plan focuses on teachers: *"Recruiting, preparing,* and *retaining* good teachers is the central strategy for improving our schools"* (6; emphasis added). In the following sections, each of these activities is discussed in turn.

..

*[Prospective teachers] see working with young students
as a way to contribute to the development of a
positive future for society and the individuals they teach.*
—SUZANNE STIEGELBAUER

..

RECRUIT ART TEACHERS OF PROMISE

Many higher-education programs for teacher preparation are not active in recruiting the best and the brightest for careers in teaching, and major obstacles impede the efforts of those who do try to recruit. For one, the education field suffers from several image problems, both imagined and real, which undoubtedly thwart these efforts. Also, very small percentages of minority students enter teaching, resulting in a lack of diversity within the profession. Finally, teaching in most states is a low-wage occupation.

The issue of image is a serious one. Teaching is not even regarded as a profession by many who hold simplistic views of what teaching requires and what excellence in teaching entails. Goodlad (1990) reminds us that half of new teachers quit before completing five years in the classroom, making the preparation of teachers more expensive in today's society than the preparation of physicians, who average a much longer career of service. He recognizes that the prospect of low pay and slow advancement probably discourages large numbers of top teacher candidates. National data indicate an overall attrition rate of about 75 percent along the pathway from the beginning of undergraduate teacher education through the third year in teaching (National Commission on Teaching

and America's Future 1996, 34). This means that only about 25 percent of students who enter teacher preparation programs in college actually enter a fourth year of service as a professional teacher. This shocking statistic suggests that there is much room for significant improvement at all levels of the teaching profession.

A number of myths are perpetuated by simplistic views of teaching: "Anyone can teach"; "Teacher preparation is not much use"; "Teachers don't work hard enough" (National Commission on Teaching and America's Future 1996, 51). These illustrate perhaps one of the fundamental problems faced by teachers: the wide variance between the lay public and professional educators in their perceptions of teaching. The view of teachers held by disinterested community members (taxpayers) is quite different from the view of teachers held by those who control the gateways into the profession. Both of these views probably vary significantly from the perceptions teachers have of themselves.

For instance, according to conventional wisdom—or unexamined opinion—teaching is not that difficult. Myth asserts that almost anyone could teach if they had a mind to, based on the observation that, after all, most adults have spent years in school classrooms from the time they were small children. If they attended regularly, each person has spent about twelve thousand hours in school classrooms. Certainly, with all this experience, most adults know what goes on in schools. Myth further suggests that those who want to teach do not need education courses, most of which are a waste of time. It seems absurd to require college students to go into public school classrooms to observe. They have already spent twelve thousand hours observing! The education department gives students college credit for observing in the public schools. According to myth, this is a mark of how easy it is to become a teacher.

These myths are simplistic and inaccurate, to say the least. Yet such attitudes can be found all too often among the general public. When teacher preparation and teaching practice are viewed simplistically, lay individuals are encouraged to enter teaching with little regard for the rigors of substantive preparation. Goodlad (1994) describes them as

> the physics professor's wife who graduated cum laude in English before raising a family and now wants to teach; the legislator's niece who does not want to take "those silly education courses"; the retired colonel who taught military logistics in the Marines and now wants to ease the shortage of mathematics teachers (159).

None of these persons, or others like them, would expect to enter engineering, law, or accounting occupations without professional preparation.

In addition to the low status of teaching, the problem of lack of cultural diversity plagues the education profession. One only needs to attend a major education convention to observe how few persons of color are members of the profession—this in spite of the increasing numbers of minority populations in many states and school districts. Why has the teaching profession been so unsuccessful in attracting persons of color? Many reasons, answers, excuses, or discussions in the professional literature address this question, but little progress seems to follow. Sensitivity toward diversity might be easier to achieve than actual diversity in the nation's teaching corps, where nearly 80 percent of teachers are women and an even higher percentage are Caucasian. Certainly, this is a matter for recruiting in a profession that badly needs cultural diversity.

Even more intractable, perhaps, and possibly a contributing factor to the diversity issue, is the reputation teaching has as a low-paying occupation. This reputation is much better deserved in some states than in others. For example, across the nation average teachers' salaries for 1993–94 ranged from $25,153 (Mississippi), $25,259 (South Dakota), and $25,506 (North Dakota) to $45,772 (New York), $47,902 (Alaska), and $50,389 (Connecticut) (National Center for Educational Statistics 1995, 86, table 78). Overall, however, teachers rank lower on the earning scale than those in many other occupations, including social workers, registered nurses, accountants and auditors, and sales representatives. And teachers in the United States rank lower on the salary index than their colleagues in Sweden, Australia, Scotland, Canada, Finland, Denmark, and a host of other countries, including the top-salaried teachers in Switzerland, the Netherlands, and Japan.

Expected level of remuneration is a significant economic factor that relates directly to recruitment of the corps of teachers. Prospective teachers—those who might be recruited into the profession—inquire about salaries as a matter of course. Will a teacher's salary provide the income necessary to support the individual and, perhaps, a family? What the inquiring potential recruit discovers is that pay for teachers is very low in comparison to other professions or occupations for which a college degree is essential preparation. At the same time, there is a movement in teacher preparation programs—and in many locations it is current practice—to require five years of college work in order to enter teaching. However commendable, this five-year requirement results in an even greater disparity between beginning salaries of teachers and those of other college graduates with the same years of preparation.

Given these challenges to the teaching profession in general, how can the field of art education recruit promising teachers for tomorrow's

schools? One straightforward, promising response to this question is to begin recruiting in middle or junior high and high school levels, including students from all groups and segments of their school communities. This approach is exemplified in programs such as the South Carolina Teacher Cadet Program, the Golden Apple Scholars of Illinois, and the National Art Honor Society of the National Art Education Association.

...

Student learning in this country will improve
only when we focus our efforts on improving teaching.
—NATIONAL COMMISSION ON
TEACHING AND AMERICA'S FUTURE

...

PREPARE ART TEACHERS FOR EXCELLENCE

The task of improving art teacher preparation programs in the United States and developing the corps of art teachers is of central importance for the field of art education. Regardless of its difficulty, it is one that can and must be addressed by professional art educators at all levels, especially by those in higher education. The assignment for higher education is to strengthen and improve current art teacher preparation programs, to assure that all programs are at least adequate and preferably better than adequate, and to encourage programs with no intention of meeting high standards to withdraw.

Art education is surely one of the most dynamic fields in education in the sense that so much change has taken place within a relatively brief time period. For many years, art was on the periphery of general education, a "nice" subject that everyone liked but surely not "necessary" within the core of basic subjects (Broudy 1987). Art was a subject that served education at the whim of the local board or superintendent but remained the easy target for budget cuts.

Both the direction of art education and its place in the school have changed significantly in recent years. It is this broad change of approach—or "paradigm shift," as some have claimed—that has major implications for contemporary art education. Changes that can be traced back to the Penn State Seminar of 1965 (Mattil 1966) have drastically altered today's art education expectations and practices, including the conduct of art teacher preparation programs. A major change for university undergraduates, for example, is the expectation that they will study art history, art criticism, and aesthetics as well as becoming proficient in the domain of art production (Clark, Day, and Greer 1987).

As well, they are expected to incorporate concepts from these disciplines within the curriculum they prepare for public school children and young people.

Among many recent events that have had a major impact on art education, three appear to be particularly relevant and influential: publication of the National Visual Arts Standards; national certification in art by the National Board for Professional Teaching Standards (NBPTS); and the anticipated 1998 art assessment by the National Assessment of Educational Progress (NAEP).

Visual Arts Standards

A major event in general education that affected art education as well occurred with the passage by Congress of the *Goals 2000: Educate America Act.* Immediately following adoption of this landmark legislation, the Consortium of National Arts Education Associations, including the National Art Education Association, applied for and received a grant from the U.S. Department of Education, the National Endowment for the Arts, and the National Endowment for the Humanities. This grant provided for development of voluntary National Standards for Arts Education and publication of those standards.

The voluntary standards for dance, music, theatre, and the visual arts were published in the document titled *National Standards for Arts Education: What Every Young American Should Know and Be Able to Do in the Arts* (MENC 1994). Implementation of the standards in all subject areas, including the arts, was funded by the federal government in the amounts of $350 million for fiscal year 1996 and $491 million for fiscal year 1997. Through their professional associations and state arts agencies, art educators have access to these funds for the purpose of implementing the visual arts standards.

The development, publication, endorsement, and adoption of the voluntary National Standards for the Visual Arts has influenced preservice art education as well as school practice. Professors who lead art teacher preparation programs, whether they agree with and support the standards or not, must address them if their students are to become professionally knowledgeable. Those professors who agree with the direction of the standards, which support the paradigm shift toward more knowledge-based art education, will assure that their programs prepare teachers who are able to implement the standards when they graduate and accept teaching jobs.

The Visual Arts Standards emphasize "what every young American should know and be able to do in the visual arts." Young Americans, the

standards proclaim, should be "able to communicate proficiently in the visual arts, develop and present basic analyses of works of visual art, and have informed acquaintance with exemplary works of visual art from a variety of cultures and historical periods" (MENC 1994). These goals and others appear in greater length and detail in the publication. Educators have recognized already that "each of these developments will bear on teacher preparation," and the increased expectations in art for students will require teachers to address new challenges of both content and process (Consortium of National Arts Education Associations 1996). Already a published article by a high school student has turned the tables by stating "What our teachers should know and be able to do: A student's view" (Belton 1996).

National Assessment of Educational Progress in Art

Another major national movement with the potential to influence art teacher preparation programs is the renewed emphasis on assessment of learning. Contemporary art education emphasizes teaching and learning about art from the perspectives of the art disciplines, with balanced attention to assessment of student progress and program effectiveness (Peeno 1996). Interest in assessment as a means of verifying learning and validating programs applies to all subject areas and age levels in general education. Increased interest in alternative methods of assessment (Herman, Aschbacher, and Winters 1992), authentic learning and assessment (Wiggins 1996; Katter and Stewart 1996), use of rubrics for assessment (Goodrich 1996), assessment by exhibition (McDonald et. al. 1993), and portfolio assessment (Beattie 1997) is widespread.

The National Assessment Governing Board recently published the *Arts Education Assessment Framework* (1996), which provides structure for the upcoming National Assessment of Educational Progress in Art, to be conducted on a national level. The NAEP framework provides a rich source of relevant assessment strategies and examples of assessment items for the field of art education. Undergraduate students studying to become art teachers should be introduced to these and other assessment materials in their college and university programs.

National Board for Professional Teaching Standards

During the 1995–96 academic year a number of art teachers from across the country participated in a rigorous assessment as applicants for national board certification. The teachers demonstrated their knowledge and skills through an "extensive year-long series of performance-based assessments, including portfolios of student work, videotapes and

rigorous analyses of their classroom teaching" (National Board for Professional Teaching Standards 1996). Having passed the National Board Standards, forty-four participants (84 percent of them women) became National Board Certified Art Teachers for Early Adolescence through Young Adulthood. This accomplishment is significant, not only in the lives of the forty-four art teachers but for the field of art education as well. The publication *Early Adolescence through Young Adulthood/Art: Standards for National Board Certification* establishes "high standards for what teachers should know and be able to do, to certify teachers who meet those standards, and to improve learning in American schools" (National Board for Professional Teaching Standards 1994, 1).

Although these standards are intended to identify and certify "highly accomplished teachers," the implications for art teacher preparation programs are obvious and numerous. The National Art Education Association distributed complimentary copies of *Early Adolescence through Young Adulthood/Art* to its members, and NAEA plans to publish an updated version of the publication titled *Standards for Art Teacher Preparation Programs* (NAEA 1979) in light of many relevant professional developments, including the NBPTS standards. The National Board Standards should be familiar to all art education program leaders in higher education.

PROFILES FOR ART TEACHER PREPARATION

There is no accepted model for the "best" undergraduate art education program. Virtually every college or university art teacher preparation program differs from others in significant ways. Nevertheless, all programs deal with many of the same factors: admission to the program; curriculum content in art; education and pedagogy coursework; physical and educational resources; uses of technology; field experiences and practice teaching; relationships with public and private schools; assessment and endorsement; and placement, to name a few. Program emphases and curricula vary from school to school, as do requirements for practicum or student teaching experiences. Some programs collaborate closely with school districts, while others do not. Control of program content might reside within the art education program, the art department, or the college of education, or it might be prescribed to some degree by state departments of education through licensure requirements.

A program profile that relates to these common factors can be constructed for each art teacher preparation program. This profile is defined by the unique way in which each common factor is resolved. For example, the proportion of coursework in art versus coursework in education

varies from program to program. The content of study in art, art history, art criticism, and aesthetics varies as well. Like the profile of a person's figure, all the parts are similar to those of other people yet have their own distinguishing characteristics. The various combinations of similar parts result in individual profiles, and these profiles have much in common.

The twelve items listed below appear to be pervasive components among many art education programs. Although they are numbered for convenience, no hierarchy is intended. These and other items of significance might be described and analyzed individually, then combined to form a profile of the particular art education program. This descriptive profile might then serve to illuminate strengths and weakness of the program and suggest targets for improvement. Following insights derived from this process, program leaders could develop a plan of action for improving specific components in their respective programs.

...

Increased expectations for students will require
teachers to address new challenges of both content and process.
—CONSORTIUM OF NATIONAL ARTS
EDUCATION ASSOCIATIONS

...

TWELVE PROGRAM COMPONENTS: DESCRIPTION AND ANALYSIS

1. *Discipline Content: Art Studio/Design, Art Criticism, Aesthetics, Art History*

How many studio art credits are required for the art education program? How much breadth and depth do students achieve with these credits? What level of preparation do art education students receive in the disciplines of art history, aesthetics, and art criticism? In what departments are these courses taught? Do students gain insights regarding the teaching of content from the art disciplines as they attend these courses? Are students prepared sufficiently in the art disciplines to implement the requirements of the National Visual Arts Standards? Are they prepared to meet recommendations implicit within NBPTS?

Suggestion: Prospective art teachers have an intensive course of study in their major. They take courses in the studio areas of drawing, painting, printmaking, ceramics, and sculpture. They study color, composition, and design. They are expected to develop advanced capability in at least one studio or design area. By the time they go out to look for a job, art education majors are expected to have a strong portfolio of studio work.

In order to meet the requirements of the discipline-based approach to art education and to implement the National Standards for the Visual Arts, prospective art teachers need to take coursework in art history, aesthetics, and art criticism. Along with study of the Western traditions of art, they need to learn about the art of other cultures in the world, including Asian, African, and Native American art. It is also important that they gain knowledge about the art of their own time: contemporary art.

The range of study for art education majors includes the applied arts. At least at a basic level, they need to know about and understand the arts of architecture, graphics, illustration, interior design, and industrial design. As teachers they will need to be aware of the roles art plays in society and culture (Chalmers 1996).

2. Education Requirements

What are the relationships between the art education program and the college of education? What is the source for certification requirements? Is the art education program administered within the college of education, the department of art, or some other department? How does location of the program affect its emphasis and character? What are the education requirements for art education programs in professional schools of art and design? What proportion of the art education student's program is dedicated to professional education requirements?

3. Clinical Experiences

At what point in the art education program do clinical experiences begin—classroom visits, visits to other educational institutions, student teaching, internships, and so on? How are visitation sites selected? How are students encouraged to learn from clinical experiences? Do students participate in critiques of videotaped teaching episodes? How are cooperating teachers selected? How are cooperating teachers rewarded for their participation? How are local schools associated with the college or university teacher preparation program? What means are employed for evaluation of student teaching performance and other clinical activities?

Suggestion: Socialization is an essential part of the preservice program at the college or university. Art education students should be engaged in a student chapter of their professional organization and should have opportunities to function as part of a social and professional group.

4. Teaching Methods

How are prospective art teachers introduced to various teaching methods? How is teaching modeled in art education classrooms? Do

students analyze the teaching methods of their university professors? How many specific teaching methods are introduced? How many are practiced? How many are mastered? Are students introduced to the concept of having a repertoire of teaching methods? What teaching methods are unique to teaching the visual arts? Do students observe master teachers applying methods in response to different learning situations?

Suggestion: Art teachers are expected to be able to teach using a repertoire of teaching methods: slide and lecture, demonstration of art techniques, discussions, group study, supervision, interviews, and others. Students should learn about inquiry-based approaches to teaching. They will need to use these methods fluently, responding to the interests of students within the unpredictable and unique environments of each individual art classroom.

5. Technology

In what ways are contemporary computer technologies relevant to art education? Is utilization of computer technology antithetical to traditional art values? Or are computer skills necessary for the development of professional art teachers? If so, what computer skills do prospective art teachers need to gain? How are computers instrumental for creating art? For developing curriculum? For conducting research? For making materials for teaching? What other technologies are applied in art teacher preparation programs?

Suggestion: As college students, prospective teachers are prepared to use computers for their teaching. They learn to use the Internet within the art curriculum, to gain competency with basic computer graphics programs, to use computers for creating curriculum and for developing worksheets and learning aids for students. There is no limit to the level of computer proficiency to which art education students might profitably aspire.

6. Curriculum

What are the different definitions of the term *curriculum* as it is used in education? Which senses of the word carry most meaning for art education? What are the implications for curriculum presented by the Visual Arts Standards and NBPTS? What skills for curriculum development are needed by prospective art teachers? Do students analyze and critique commercially prepared art curricula and teaching materials? Are students prepared to evaluate and select commercial curricula? To adapt commercial curricula to local requirements? To develop art curricula

for local use? Are students prepared to consider integration of the art curriculum with other school subjects?

Suggestion: Art education students are expected to write art curriculum. They need to be able to write comprehensive lessons with all the essential components, including objectives, learning activities, and assessment of student progress. They are expected to write units of instruction with scope, sequence, content, and methods of inquiry derived from the four art disciplines. These units are organized around works of fine and applied art from a range of the world's eras and cultures. Prospective art teachers are prepared to relate, integrate, cooperate, and collaborate across the curriculum. They are taught to work with other teachers to further their school's mission and curriculum.

7. Assessment

How are prospective art teachers prepared to assess student learning and progress? What range of assessment/evaluation methods are emphasized? What do students learn about portfolio assessment, its history in art education, and its contemporary applications? Are students prepared to evaluate their own art programs and their own teaching? How is assessment connected with curriculum and with instruction? What is the role of assessment in relation to other components such as teaching methods, diverse student populations, and discipline knowledge? How much of a teacher's time and effort should be dedicated to assessment/evaluation? How does assessment relate to and interact with grading, reporting progress, and communicating art program goals? How does assessment relate to communication with school officials, parents, and students? What are the implications of the NAEP assessment of art learning?

8. Classroom Management

What skills are required to manage a contemporary art classroom? Do prospective art teachers learn about ordering, storing, distributing, and accounting for materials? About maintaining tools, equipment, and supplies for art production activities? How do prospective art teachers learn about classroom organization, exhibition of student artwork, and classroom environment? How are teaching materials such as art prints, slides, videotapes, CD-ROMs, and books stored, used, and accounted for? How is a discipline-based classroom different from a traditional studio classroom? What skills and strategies for maintaining a positive learning environment are studied and practiced by prospective art

teachers? How are they taught to deal with student behavior problems? What do they learn about the way public and private schools typically deal with behavior problems? What do they learn about school law?

Suggestion: Prospective art teachers must develop skills of classroom management, including management of potentially hazardous tools and materials. Art teachers must know and apply safety cautions and standards. Contemporary art education assumes use of electronic media such as slides, television, videos, CD-ROMs, computers, and the Internet in the classroom.

By the time they enter the art room as teachers, college students need to be able to maintain a positive learning environment for their students. This means that they need to acquire the knowledge and skills necessary to maintain discipline, deal with potential behavior problems, and understand school policies and procedures with respect to student deportment.

9. Diverse Student Populations

Do prospective art teachers have opportunities to work with diverse student populations? What training do they receive to prepare them as teachers of students with various handicaps? Different first languages? Various ability levels? Diverse learning styles? Various ethnic and cultural backgrounds? How do the National Visual Arts Standards and the NBPTS recommendations address diverse student populations? How are prospective art teachers prepared to work with parents, school, and community, as well as with students in their classrooms?

Suggestion: Teachers need to know a great deal about learners; they should study the psychology of children and adolescents. Art teachers need to be very well informed about children's artistic development. Prospective art teachers must be cognizant of different learning styles among their students and be able to adapt instruction to meet the needs of all learners. They should be aware of new information from the field of cognitive psychology, including fundamentals of higher-level thinking and the benefits of a thinking curriculum.

As they enter the mainstreamed classroom, art education students ought to be able to relate positively to children and young people from all cultures and backgrounds, including those who speak English as a second language; to children of nearly all mental and physical capabilities; and to children with a range of disabilities. Art teachers need to be sensitive and responsive to the values of the local communities in which their students reside.

10. Professional Art Education

Are prospective art teachers prepared for the roles they will be expected to perform as professional educators in their schools and communities? Does the art education program sponsor a college student chapter of the NAEA? Do college students receive and read professional publications? Do they participate in local, state, and/or national professional meetings? Are they prepared to promote and advocate the arts and art education as an essential part of general education? Are students familiar with the range of national, state, and local education and art education organizations and their functions? Are prospective art educators prepared to assume the roles of professional leadership?

Suggestion: Prospective art educators need to understand the profession they are entering: how school districts are run; the role of the board of education; the role of parent groups; the role of superintendents; the role of central office staff; and especially the role of the principal, the most influential person in a school building. They need to know basics of school law and their responsibilities and liabilities as teachers.

Art teachers should participate in their professional organizations at the local, state, and national levels; subscribe to professional journals; stay abreast of developments in the field; and become leaders in their communities. Very likely they will need to become effective advocates for the arts in education.

11. Certification/Licensure

What certification or licensure system applies to graduates of this art education program? How is the program directed or influenced by certification requirements? Is certification reciprocal with other states? How do certification/licensure requirements or lack of requirements affect the content of this art education program?

12. Museum/Community Resources

How are students prepared to integrate art museum resources, art galleries, public art, community artists, art critics, and other art professionals for the purposes of art education? Have the benefits of viewing original artwork, as compared with art reproductions, been emphasized? Do students have experiences with the local community as a resource for art education? Are students aware of art teaching resources available from many museums? Do they know how to access and use such materials?

Are they cognizant of ways teachers prepare their students for visits to museums, galleries, and other community resources? Are they able to evaluate such educational experiences?

Suggestion: When they enter the teaching force, new art teachers should be familiar with art museums and galleries and how to utilize the various art resources of the community. They should have extensive experience in viewing, studying, and responding to original art objects and should recognize the potential educational values to be gained by students through their experiences with original art. Prospective art teachers need to understand how the resources of museums can be used for inquiry-based learning, art history, art criticism, and investigations in aesthetics.

These twelve items or components address a few significant questions and issues that pervade the enterprise of art teacher preparation. This list is not exhaustive and could be elaborated extensively; it is intended only as a beginning point for discussion. Although some significant topics are not included on it, this list does suggest the complexity and range of issues, knowledge, and skills that every art teacher education program must address.

..

Teachers are members of learning communities.
—NATIONAL BOARD FOR
PROFESSIONAL TEACHING STANDARDS

..

RETAIN GOOD TEACHERS

If the field of art education is successful in recruiting promising teachers and preparing them for excellence in service, much has been accomplished. There remains, however, the question of how to retain them. Careful preparation and recruitment efforts are wasted when teachers retire prematurely from teaching, perhaps to enter a more lucrative occupation. How can professional art education improve the record for teacher retention?

There are many answers to this question, and only a few are within the aegis of art education. Teachers need to receive more respect from this society for the work they do. Communities need to recognize that teachers work with children and young people, their most precious and valuable resource, and have a profound impact on their students' futures. Communities need to support their school systems financially,

so that the high quality of education consistent with the best recommended practices can be provided for all students. Respect for the work of teachers needs to be reflected in the salaries they receive and in the conditions of their employment.

A great deal of progress is needed to raise the status of educators in general and art educators in particular. Art education programs cannot directly change the financial status or the working conditions of teachers. However, one important step toward retention is taken whenever prospective art teachers enter the profession well prepared for success. Sound art teacher preparation is one answer to any retention problems the field might have. Another significant step is in the direction of providing a more rigorous certification for teachers, offering recognition of excellence, and providing opportunity for advancement as in the National Board certification program offered by NBPTS.

A persistent shortcoming in many school systems has to do with collegiality—the associations teachers have with their colleagues. Many art teachers work alone in their classrooms, especially at the elementary levels, where they might be required to travel between schools. Close professional relationships with other art teachers are limited because of time constraints and teaching assignments. Professional organizations at the local, state, and national levels place art teachers in touch with colleagues. Professional publications deal with issues relevant to their daily work experiences and problems. Membership in professional organizations can provide art educators with at least a modicum of collegiality and, in addition, might assist them to stay abreast of developments in their field of practice.

CONCLUSION

During the millennium of the 2000s, American schools will continue to need well-prepared, well-qualified teachers, including teachers of art. Art education programs in many colleges and universities are currently meeting this demand and will continue to provide competent and caring art teachers for the schools. These sound programs will need to remain active and engaged with the professional field of art education in order to maintain high standards.

Other programs do not meet minimum standards for art teacher preparation. Students are graduated and certified in art education, yet are not well prepared to teach art according to the best recommendations of the professional field. Unless they are willing to make the necessary investments to improve, these inadequate art teacher preparation

programs should stop accepting students, close their operations, and place their resources elsewhere.

The National Standards for the Visual Arts, the National Board for Professional Teaching Standards, the National Assessment of Educational Progress in Art, and numerous other publications, organizations, and resources provide art educators with an abundance of guidance for strengthening art teacher preparation programs. Although each is unique, all art education programs are engaged in similar activities, issues, and practices. Professors of art education can assess and improve their programs through a process of description of various components to create a program profile, followed by analysis of strengths and weaknesses. With the profile in mind, professors can then develop action plans to prioritize and guide the direction and pace of program improvement. This process can be ongoing and responsive to new challenges and demands for art education in the schools.

This discussion has reinforced the well-accepted notion that making positive changes in education is neither simple nor easy. This is an accurate but incomplete observation, because there are also several very positive realities that need no change: well-prepared art teachers who devote decades of their lives to teaching receptive youngsters, enjoying every day of their careers; schools with admirable art programs valued as central within the school curriculum; strong art teacher preparation programs that recruit enthusiastic students, prepare them well, and place them in satisfying positions. These are our models for professional development, and they are worth all our efforts in the pursuit of excellence.

REFERENCES

Beattie, D. K. 1997. *Understanding assessment in art education.* Worcester, Mass.: Davis Publications.

Belton, L. 1996. What our teachers should know and be able to do: A student's view. *Educational Leadership* 53 (September): 66–68.

Broudy, H. 1987. *The role of imagery in learning.* Los Angeles: J. Paul Getty Trust.

Chalmers, F. G. 1996. *Celebrating pluralism: Art, education and cultural diversity.* Los Angeles: J. Paul Getty Trust.

Clark, G., M. Day, and D. Greer. 1987. Discipline-based art education: Becoming students of art. *The Journal of Aesthetic Education* 21 (2): 129–93.

Clinton, W. J. 1997. President's call to action for American education in the twenty-first century. In State of the Union Address, Washington, D.C., February 4.

Consortium of National Arts Education Associations. 1994. *National standards for arts education: What every young American should know and be able to do in the arts.* Reston, Va.: Music Educators National Conference.

Consortium of National Arts Education Associations. 1996. *Teacher education for the arts disciplines: Issues raised by the national standards for arts education.* Reston, Va.: Music Educators National Conference.

Flexner, A. 1910. *Medical education in the United States and Canada.* New York: Carnegie Foundation for the Advancement of Teaching.

Galbraith, L., ed. 1995. *Preservice art education: Issues and practice.* Reston, Va.: National Art Education Association.

Getty Center for Education in the Arts. 1985. *Beyond creating: The place for art in America's schools.* Los Angeles: J. Paul Getty Trust.

Goodlad, J. I. 1990. *Teachers for our nation's schools.* San Francisco: Jossey-Bass.

———. 1994. *Educational renewal: Better teachers, better schools.* San Francisco: Jossey-Bass.

Goodrich, H. 1996. Understanding rubrics. *Educational Leadership* 54 (4): 14–17.

Herman, J., P. Aschbacher, and L. Winters. 1992. *A practical guide to alternative assessment.* Alexandria, Va.: Association for Supervision and Curriculum Development.

Holmes Group. 1986. *Tomorrow's teachers: A report of the Holmes Group.* East Lansing, Mich.: Holmes Group.

Katter, E., and M. Stewart. 1996. Building a foundation for assessment: Eight questions to guide our planning. In *Middle school art: Issues of curriculum and instruction,* ed. Carole Henry. Reston, Va.: National Art Education Association.

Mattil, E. L., ed. 1966. *A seminar in art education for research and curriculum development.* University Park: Pennsylvania State University.

McDonald, J., S. Smith, D. Turner, M. Finney, and E. Barton. 1993. *Graduation by exhibition: Assessing genuine achievement.* Alexandria, Va.: Association for Supervision and Curriculum Development.

National Assessment Governing Board. 1994. *Arts Education Assessment Framework.* Washington, D.C.: National Assessment Governing Board.

National Board for Professional Teaching Standards. 1994. *Early adolescence through young adulthood/art: Standards for national board certification.* Washington, D.C.: National Board for Professional Teaching Standards.

———. 1996. Press release. December 3.

National Center for Educational Statistics. 1995. *Digest of Educational Statistics.* Washington, D.C.: National Center for Educational Statistics.

National Commission on Excellence in Education. 1983. *A nation at risk: The imperative of educational reform.* Washington, D.C.: U.S. Department of Education.

National Commission on Teaching and America's Future. 1996. *What matters most: Teaching for America's future.* New York: National Commission on Teaching and America's Future.

National Endowment for the Arts. 1988. *Toward civilization: A report on arts education.* Washington, D.C.: National Endowment for the Arts.

Peeno, L. 1996. *Status of arts assessment in the states.* Reston, Va.: National Art Education Association.

Petrie, H. G. 1990. Reflections on the second wave of reform: Restructuring the teaching profession. In *Educational leadership in an age of reform,* ed. S. L. Jacobson and J. A. Conway. New York: Longman.

Stiegelbauer, S., and G. Hunt. 1996. Who are the new teachers? In *Teaching teachers,* ed. D. Booth and S. Stiegelbauer. Hamilton, Ontario: Caliburn Enterprises.

Wiggins, G. 1996. Designing authentic assessments. *Educational Leadership* 54 (4): 18–25.

Wygant, F., ed. 1979. *Standards for art teacher preparation programs.* Reston, Va.: National Art Education Association.

Whence Come We? What Are We? Whither Go We? Demographic Analysis of Art Teacher Preparation Programs in the United States

Enid Zimmerman
Indiana University

THE 1990s have witnessed a growing interest locally and nationally in developing a research agenda toward the twenty-first century. This is evidenced by a number of recent publications by the National Endowment for the Arts in Education Program and the U.S. Office of Education (*Arts Education Research Agenda for the Future*, 1994), National Art Education Association (*Art Education: Creating a Visual Arts Research Agenda toward the Twenty-First Century,*[1] 1994; *Blueprint for Implementing a Visual Arts Research Agenda*, 1994; *Briefing Papers: Creating a Visual Arts Research Agenda toward the Twenty-First Century,*[2] Zimmerman, 1996; *Research Methods and Methodologies for Art Education,* La Pierre and Zimmerman, 1997), and the National Art Education Association (NAEA) affiliate, The Seminar for Research in Art Education (*A Survey of Research Interests among Art Educators,* Burton, 1991; *Art Education Historical Methodology: An Insider's Guide to Doing and Using,* Smith, 1995; *New Waves in Art Education Research,* Stokrocki, 1995).

There also have been a number of surveys conducted at local, state, and national levels about teachers, students, programs, and settings that focus on topics related to various aspects of art education, such as the

1. This publication contains eight content areas suggested for an art education research agenda toward the twenty-first century. One of the eight content areas is "Demographics (baseline data about the visual arts teaching force, certification requirements, state and local curricula, resources, facilities, etc.)" (2).

2. One of the eight briefing papers is on demographic research.

status of art education programs in public schools in the United States (Leonard 1991), art teachers' viewpoints on a number of issues (Chapman and Newton 1990), assessment of the arts in Canadian schools (MacGregor, Lemerise, Potts, and Roberts 1993), doctoral research related to American studio education (La Chapelle 1988), interests of art education researchers (Burton 1991), and state visual arts achievement tests (Sabol 1994).

In the past, there was a body of research about general preservice education, but there was a lack of research and practice related to specialist art teacher preparation programs (Galbraith 1990, Zimmerman 1992, 1994a, 1994b). I approached this study with knowledge that there was a paucity of scholarly writing, particularly on demographic research, in this area of the status of preservice programs in art education. A few surveys had been conducted and reported since the 1980s about the content of art teacher preparation programs. In 1984, researchers for the National Association of Schools of Art and Design (NASAD) collected data from ninety-five accredited institutions, including professional art schools and universities, that offered art teacher preparation programs. They concluded that, at that time, most changes in art education programs could be found in the addition of studio and computer graphics requirements and emphasis on discipline-based content in art education methods classes. In 1986, Maitland-Gholson surveyed fourteen undergraduate preservice teacher education programs and found that most courses were in areas of studio and art history, with a growing interest in including courses in art criticism, special populations, and new technologies.

Before any definitive studies about art teacher preparation might be undertaken, it is necessary to establish baseline data about art teacher preparation programs. A first task would be to locate current data and demographic studies in this area. I began my search not knowing the adventure and mystery-solving that lay ahead. After sleuthing through a myriad of dead-ends and contradictory data, I did find a few current surveys in the area of art teacher preparation. Throughout my journey, Paul Gauguin's painting *Whence Come We? What Are We? Whither Go We?* (created in 1897 during his second stay in Tahiti) became the guiding metaphor in my quest for answers about art teacher preparation programs in the United States. About his painting, Gauguin wrote: "The essential part of a work is precisely what is not expressed: it is implicit in the lines, without either colors or words, and has no material being" (Gauguin in Estienne 1953, 96). I decided to look beyond the data I was able to locate from various sources, make interpretations based on what

was implicit in these publicly reported survey results, and suggest new avenues for future inquiry and interpretation.

DEMOGRAPHIC RESEARCH

Demographic research involves identifying characteristics of specific populations according to their size, density, composition, and distribution using geographic, economic, social, educational, and other parameters (Burton 1996). Findings from demographic research can be used to create bases for research in related areas, advocate for present conditions, change educational practice and policy, or demonstrate to funding agencies the importance of conducting research in specific areas. Two methods most commonly used by demographic researchers are conducting surveys and regrouping and analyzing data that have been collected previously and are stored in data banks. In my search for demographic information about art teacher preparation, a number of questions about institutions that prepare preservice art teachers, their faculty, and students enrolled in their programs came to mind:

- Which post-secondary institutions have visual arts teacher preparation programs? Which of these institutions are public? Which are private? Which art education programs are located in schools of fine art? Which are located in schools of education? For each program, is certification offered for undergraduates, graduates, or both? Which institutions offer only fifth-year programs? How many weeks of student teaching are required?
- How many students are enrolled in these post-secondary institutions? How many students are enrolled in visual arts preservice teacher education programs? How many preservice students in these programs were certified to teach in the year of the most recent survey?
- How many faculty teach in each of the preservice programs? What percentage are fine arts faculty? What percentage are art education faculty? What percentage are both? What percentage are tenured? What are their ranks (lecturer, assistant professor, associate professor, full professor)? What is their highest level of education (bachelor's, master's, doctorate)? What percentage have degrees in fine art, art education, or both? What are their salaries at each rank?

Three resources appeared to be likely places to begin my search for information. First were data sets found in the National Data Resource

Center (NDRC) data banks. Second was the ERIC/Art database, to find articles, monographs, or books that might contain pertinent information about the subject at hand. The third group of resources included indexes and guides to American institutions of higher education. The NDRC initially appeared to be the one that would supply the most information; unfortunately, my optimism was unfounded. The NDRC was established by the United States Department of Education's National Center for Education Statistics (NCES) to provide free data analysis on the data sets it maintains. Currently, the NDRC has data for over fifteen studies maintained by NCES, including two databases, the National Survey of Postsecondary Faculty and the Integrated Post-Secondary Education Data System. I thought these should be able to supply information that would be useful. After weeks of waiting for a response and many telephone calls, I was informed that these databases did not contain any of the information I requested, based on questions I sent that were almost identical to those posed in the paragraphs above. A researcher at NCES did offer to send me some information about post-secondary visual arts graduates, but she informed me that data about art education graduates was not available.

The second group of resources from the ERIC database, and my scanning of the major journals in the field of art education, yielded one research study: "The Status of Art Education Programs in Higher Education," conducted by Thompson and Hardiman in 1991. This is the only recent survey, to my knowledge, in which demographic data has been collected about art teacher preparation programs. Three other surveys will be discussed later that focus on instructors of art methods classes for preservice elementary teachers (Jeffers 1993), NAEA curriculum standards in art teacher preparation programs (Rogers 1988, Rogers and Brogdon 1990), and the content of art teacher preparation programs (Zimmerman 1994b).

Thompson and Hardiman Survey

The purpose of Thompson and Hardiman's (1991) survey was to gather baseline data about the status of art education in colleges and universities in the United States. Their survey included three parts. In part one, demographic information about faculty (including gender, rank, salary, institutional affiliation, teaching loads, and criteria for tenure) were presented. Part two consisted of demographic data about student population characteristics, enrollment trends, art education curricular offerings, and proposed program modifications. Opinions and

attitudes held by art education program leaders were the focus of data collected in part three.

The researchers sent questionnaires to 350 institutions listed in the 1990 *American Art Directory* (Adcock 1990) as granting undergraduate and graduate degrees in art education. Of the 350 questionnaires that were sent, 170 were completed (48.6 percent) with 121 from public and 49 from private colleges and universities. Results from part one indicated that 49 percent of the respondents were full professors, 28 percent were associate professors, and 23 percent were assistant professors. Fifty-three percent held doctorates, 50 percent were between 30 and 44 years old, and 28 percent were between 45 and 60 years old; 54 percent were male, and 44 percent were female. There were, however, more females in all ranks except that of full professor; and males' salaries were higher than females' salaries, although the gap appeared to be closing. In respect to race distribution at all faculty ranks, less than 8 percent represented groups other than whites.

Thirty of the institutions surveyed granted doctorates and 140 granted undergraduate and master's degrees in art education. At doctoral institutions, there were on the average 4.1 full-time faculty, while there were only 1.8 full-time faculty at other institutions. Art education faculty at doctoral institutions taught fewer classes than those at other institutions. The average academic year teaching load was five classes at institutions that offered doctoral degrees and seven classes at other institutions. Eighty-five percent of faculty at doctoral institutions and 80 percent at other institutions had been teaching three or more years. Faculty at doctoral institutions reported that publishing in research journals was the most important factor for being tenured, whereas other faculty cited teaching as most important for their becoming tenured. In respect to the academic affiliation of faculty at doctoral institutions, 57 percent were affiliated with schools, departments, and colleges of art; 22 percent were affiliated with schools and colleges of education; and 18 percent were affiliated with both schools of art and education. It was concluded that, in doctoral institutions, a vast majority (75 percent) of art teacher training programs were housed in schools, colleges, and departments of art. Of those art education programs at institutions that did not offer doctoral degrees in art education, 65 percent were affiliated with schools of art, 6 percent with schools of education, and 19 percent with both schools of art and education. It is easy to conclude that these institutions have 84 percent affiliation with schools of art. Thompson and Hardiman predicted that within the five years following their study (which now would be one year beyond their prediction)

projected retirements indicated excellent opportunities for new faculty positions in all art education programs.

Results from part two of the questionnaire indicated that female art education majors outnumbered males by three to one at all degree levels. Only 12 percent of students in all art education degree programs were "minority" students; at doctoral level institutions, 98 percent of the students were white. Courses in art education offered at all institutions included (1) methods of teaching (80 percent); (2) early field experience (50 percent in a separate course, 45 percent within a broader course); (3) curricular theory and planning (27 percent in a separate course, 72 percent within a broader course); (4) history of art education (10 percent in a separate course, 72 percent within a broader course); (5) art development (10 percent in a separate course, 87 percent within a broader course); (6) methods of teaching special populations (18 percent in a separate course, 65 percent within a broader course); (7) methods of teaching art history, art criticism, and aesthetics (12 percent in a separate course, 80 percent within a broader course); and (8) philosophy of art education (10 percent in a separate course, 82 percent within a broader course).

Sixteen weeks of student teaching was the average reported, with an even division between grades K–6 and 7–12. The most common certification, K–12, was offered three times as often as other options, such as K–6 or 7–12. The majority of students completed their degrees in art education in four years (57 percent); only 6 percent took more than five years to complete their degrees. Faculty responding to a question about what areas in their programs they wished to increase indicated, in rank order, an increase in emphasis on art criticism and aesthetics, maintenance of the current level of courses, and a decrease of emphasis on educational studies.

Part three consisted of fifteen directed questions through which a variety of opinions were expressed about professional issues in art education. The researchers concluded that discipline-based art education (DBAE) has made a "favorable impact on art education" (80). They reported that respondents indicated that 73 percent of their students were being educated to teach from a DBAE point of view, using a balanced and integrated use of the disciplines. In fact, 56 percent of the respondents agreed that DBAE was gaining acceptance with art teachers in those parts of the country in which they taught. They overwhelmingly rejected national curriculum guides for secondary schools, standardized tests to assess student art learning, and high-school exiting exams with art-discipline emphases, although these may lead to higher political

status for art education in schools. Competency testing for art teachers before they are certified was viewed much more favorably. More than 75 percent of the respondents believed that faculty in art education should have a minimum of three years' teaching experience at the elementary or secondary level.

Jeffers Survey

In another survey of instructors of art methods classes for preservice elementary teachers, Jeffers (1993) sent questionnaires to forty members of a preservice interest group affiliated with the NAEA and a random, stratified sample of five hundred out of thirteen hundred members of the NAEA Higher Education Division (members who did not appear to be involved in teacher education were eliminated from the mailing). The response rate of 25.4 percent was low. Although the faculty who responded were being surveyed in respect to teaching art methods to elementary education majors, it might be safe to assume that there is some overlap of this survey with the one just discussed. Faculty teaching art methods courses for elementary education majors might in many cases also have been teaching or working in institutions that offered courses for preservice art education majors.

Ninety-four percent of the respondents to Jeffers's study checked the category of art education as best describing their backgrounds. Fewer were full professors (31.2 percent) or associate professors (24.8 percent), and more were assistant professors (33.4 percent) than in the Thompson and Hardiman survey. This may be explained by the fact that in art education departments in larger institutions, junior art education faculty often teach courses for elementary education majors. In the results of this survey, there were more females (54 percent) than males (46 percent) teaching elementary education art methods courses. The percentages of females and males teaching art education majors in the Thompson and Hardiman survey is almost exactly reversed. It should come as no surprise that courses that are considered less prestigious are being taught by a higher percentage of women than men. Jeffers found the same percentage of faculty as members of art departments (75 percent) and departments of education (25 percent) as had Thompson and Hardiman.

Fewer than three-fourths (72.1 percent) of those surveyed reported that their institutions required elementary education majors to take art methods classes. The average number of students in these methods classes was 22.5, and the average number of hours spent in class was 4.6 hours a week. Seventy-five percent of the faculty teaching these classes

required textbooks, with forty-four different textbooks used (thirty were listed by one respondent) and 20.2 percent listing more than one required textbook. Hurwitz and Day's *Children and Their Art* (1991) was listed almost twice as often as the next most frequently required textbook.

Rogers and Rogers and Brodgon Surveys

In 1987, Rogers, as part of his doctoral dissertation research, compared the course requirements in fifteen National Council for Accreditation of Teacher Education (NCATE) art teacher certification undergraduate programs in colleges and universities of Alabama with NAEA (1979) standards for teacher preparation programs. No demographic data were presented in this study. In 1990, he and Brodgon used the same NAEA standards to develop a questionnaire which was sent to higher-education faculty in the United States and Canada. Their purpose was to determine how closely art teacher preparation programs complied with the NAEA standards for art teacher preparation. They surveyed 1,057 NAEA members who were affiliated with the NAEA Higher Education Division and received a 22.5 percent return rate of 225 responses, of which 169 were used in the final study. This is the same group that Jeffers surveyed, and she received the same return rate. Again, no demographic information was offered. They concluded from their survey that 80 percent of respondents indicated that their institutions meet the NAEA standards in studio art foundations, 66 percent indicated they meet art history standards, and 70 percent indicated that the advanced, in-depth work component was met.

Zimmerman Survey

In 1992, I was commissioned to write a paper about research and practice in visual arts specialist teacher education programs in the United States. As part of this paper, I contacted members of the Council for Policy Studies in Art Education, a group with fifty elected members holding leadership positions in art education. My purpose was to gather information about the content of art teacher preparation programs and concerns and issues of importance to faculty who taught in these programs. I did not wish to conduct a definitive survey of art educators or to collect demographic data. I was interested in the responses from those persons who belonged to this group because they represented many outstanding art educators.

I designed and sent an open-ended questionnaire to council members from the United States, and faculty at ten institutions out of the

thirty-one represented responded (there often is more than one faculty member from an institution on this council). Of the ten institutions from which I received responses, eight had doctoral programs in art education and all had high-profile, well-respected art education programs. They therefore were not representative of the majority of art teacher preparation programs in the United States.

I did find that although studio subjects garnered the most attention, all programs included some study of art history, art criticism, and aesthetics. Half the institutions included sociocultural or multicultural emphases in their curricula, and 40 percent cited an emphasis on computer graphics and technology. All institutions included clinical experiences and reported having rigorous teacher education programs that went beyond most standards suggested by NAEA. Seven colleges or universities reported that the average number of credit hours required for certification was 140. The average number of credit hours in art and design courses was 56; in educational theory, methods, and practice teaching 29; and in academic studies 50. Most institutions reported some type of fifth-year teacher preparation program with a trend toward postbaccalaureate certification. I concluded that innovative teacher preparation programs and alternative certification initiatives should be developed and their effectiveness assessed.

REFLECTIONS ABOUT THESE SURVEYS

The Thompson and Hardiman survey is the one source that addressed some of the original questions I posed at the beginning of this inquiry. Nevertheless, I was still left with the big questions: Whence come we? What are we? Where go we? Based as it was on the listings in *The American Art Dictionary* (Adcock 1990), did the Thompson and Hardiman survey data truly represent institutions that have art teacher preparation programs? Although the return rate for their survey was very good, do the 71 percent of public and 29 percent of private institution faculty members that responded represent similar percentages of art teacher preparation programs in public and private contexts across the United States? Are most of these programs (82 percent) housed in institutions that do not grant doctoral degrees? The Jeffers and the Rogers and Brodgon surveys both received low response rates, with about one-fourth of the surveys returned. These two surveys were based on membership of the Higher Education Division of NAEA. They mailed their surveys directly to individual faculty and therefore probably received multiple responses from many institutions, especially those that

grant doctoral-level degrees in art education and have more than one faculty member teaching art education courses. Jeffers acknowledged that doctoral students (associate instructors, teaching assistants, and graduate assistants) often teach art methods to elementary education majors at larger institutions, and they represented fewer than 1 percent of the respondents to her survey. My survey was in no way intended to portray a complete picture of art teacher preparation programs, and the faculty surveyed represent a rarified sample.

To check some of the questions I had about these surveys, I consulted *The American Art Dictionary* (Adcock 1990) used in the Thompson and Hardiman study. I could locate those institutions that offered art education courses but could not find a listing of categories for art education majors. My own art education program at Indiana University was not to be found in the listing, since it is housed in a school of education and not a school of fine arts. Therefore, although the Thomson and Hardiman survey is useful for the purposes of this quest, its limitations in this respect must be acknowledged. *The American Art Directory* (1995) listed 1,585 two- and four-year art schools and art centers in the United States and Puerto Rico. Although art education majors are not listed, 680 institutions were listed as offering art education courses (nine of these separately listed teacher training courses, and one listed art education methods courses).

This initial perusal of *The American Art Dictionary* led me to examine a fourth group of resources, including several registries and directories that contained some pertinent demographic information about art education programs. These resources are good sources for demographic information about institutions, such as their locations and campus settings; addresses and telephone numbers; when they were established; number of scholarships, programs, and courses they offer; total, education, and fine arts enrollments; tuition; and number of full- and part-time faculty and their rankings.

The most recent editions of these directories available in my campus libraries included *Peterson's Register of Higher Education 1995* (1995), which listed nearly 3,700 two- and four-year colleges in the United States; *The College Blue Book* (1989), which listed degrees offered by subject in 2,925 colleges in the United States and its territories and 75 in Canada, including 341 art education degrees offered in the United States; *The College Board Index of Majors* (College Entrance Examination Board 1992), which listed 366 two- and four-year colleges in the United States that offered art education majors (this index included separate listings for branch campuses); the *Guide to American Art Schools* (Wrenko 1987), which listed

384 art schools with selected programs, 210 of which had art education major programs (all offered B.F.A. and M.F.A. degrees and were accredited by NASAD).

It then appeared worthwhile to investigate which art education programs were accredited by two national accreditation organizations previously mentioned, NCATE and NASAD. Membership in both organizations is a voluntary process, and those who are accredited undergo a thorough program of application and approval.

NCATE is authorized by the U.S. Department of Education and the Council on Postsecondary Accreditation to accredit schools, colleges, and departments of education that prepare professional educators to staff school programs for students from preschool to grade twelve (NCATE 1994–95). NCATE evaluates, according to its criteria, an institution's ability to effectively deliver all of the programs it offers. In its annual guide (NCATE 1994–95), accredited schools, departments, and colleges of education are listed by unit accreditation (applicable to an entire education institution) and by program accreditation (applicable to specific programs in professional education institutions). The guide lists all professional education programs that are offered by institutions within areas for which the institution is accredited. It also contains demographic information such as addresses, telephone numbers, affiliations, areas accredited, total enrollments, educational enrollments, basic skills tests required, and programs offered.

NCATE also is authorized to accredit programs in eighteen areas that have met the teacher preparation guidelines of the professional education associations which maintain and monitor national standards of excellence in their academic fields. Institutions in twenty-two states are required to submit their programs for review by appropriate professional associations; many institutions voluntarily seek professional recognition of their programs. The arts, including the visual arts, are not among the eighteen programs reviewed by NCATE through their representative professional associations. Although there are thirteen hundred colleges in the United States that offer programs to prepare teachers and other professional personnel, fewer than half of these institutions are accredited by NCATE. Of these, 221 have accredited programs in art education at K–12 and/or secondary levels.

NASAD's major responsibilities are accreditation of educational programs in the visual arts and design and establishment of curricular standards and guidelines (NASAD 1988). NASAD is the only accrediting agency recognized by the Council on Postsecondary Accreditation and the U.S. Department of Education that covers the entire field of art

and design education. The association publishes an annual directory that is the official accreditation listing for member institutions. NASAD maintains a computer list of all member institutions based on information in the directory. NASAD is also a participating organization in the Higher Education Arts Data Services (HEADS), which produces an annual publication of statistical information, organized by size and type of institution, about art and design programs providing comparative information about enrollment, degrees awarded, admission, graduation, faculty, administration, budgetary matters, credit-hour production, scholarships, faculty teaching loads, and student demographics. According to the 1995 NASAD directory, there are over 182 accredited member institutions, including public and private colleges, universities, and independent art schools, of which 87 (48 percent) offer associate arts, bachelor's, master's, and/or doctoral degrees and/or certification in art education.

Indiana as an Example

There was a difference of 25 art education programs between the 341 programs listed in *The College Blue Book* and the 366 listed in the *The College Board Index of Majors*. The three-year difference in publication of these sources may or may not account for this discrepancy. I soon realized that a true picture of the number of institutions and accompanying demographic data is elusive and depends on definitions of what constitutes art teacher preparation programs and what criteria are used to determine which institutions will be categorized and in what ways. In my professional career, I have been involved in conducting several national surveys and presently am involved in a survey of art teachers who attended a program at Indiana University over the past five years. My major research, however, has involved using case-study methodologies to conduct research about art teachers, students, and programs. It seemed a natural course to decide to use the registries, dictionaries, and guides just mentioned to do a demographic case study of art teacher preparation programs in Indiana, where I teach and live. Indiana's state motto is "The Crossroads of America," and residents often pride themselves on being "typical Americans."

There are, according to *Peterson's Register of Higher Education 1995,* 82 two- and four-year colleges in Indiana and 34 art schools, as listed in *The American Art Dictionary. The College Blue Book* lists 11 institutes of higher education that offer art education degrees in Indiana, and *The College Board Index of Majors* lists 20 institutions (one is listed twice) that have art education major programs. Although *The American Art Directory* does not

list art education majors, it does cite 24 schools in Indiana that offer art education courses. As previously mentioned, Indiana University is not one of the schools listed. The NCATE Guide (1994–95) lists 28 accredited institutions in Indiana, of which 12 have art education programs at K–12 and/or secondary levels. Four institutions in Indiana that have art education programs are accredited by NASAD. The School of Education at Indiana University, in which the art education program is located, has accreditation through NCATE. The art education program also has NASAD accreditation through the School of Fine Arts, even though it does not have an official affiliation with this school.

I also spoke to a career counselor in the School of Education at Indiana University and requested information about accessing Ideanet-Indiana (a database of all public and private schools in Indiana, from elementary through higher education) on my computer so that I could locate institutions of higher education in Indiana that offer art education certification programs. Accessing Ideanet-Indiana produced a list of 26 institutions that offered visual arts education major degrees. Upon further inquiry, I was informed by the counselor that this list consisted of all colleges and universities that had state-level endorsement to offer visual arts major programs, and not necessarily those that currently offer these programs.

After comparing listings in all the resources and making a few telephone calls, I determined, to the best of my ability, that there are eighteen institutions of higher education that currently offer art education major programs in Indiana. Four (22 percent) are located in urban areas (with populations over five hundred thousand), six (33 percent) in suburban areas (with populations of fifty thousand to five hundred thousand), and eight (44 percent) in small towns (with populations of under fifty thousand). There is a close division between eight (44 percent) private, church-supported programs (American Baptist, Church of God, Church of the Brethren, General Baptist, Roman Catholic, United Methodist, and Wesleyan) and ten (56 percent) public, state-supported programs. Two institutions (11 percent) offer bachelor's, master's, and doctorate degrees in art education; one (5.5 percent) offers both a bachelor's and a master's degree in art education; fourteen others (78 percent) offer only bachelor's degrees in art education; one (5.5 percent) offers only an associate arts degree in art education. Two of the eighteen programs (11 percent) are affiliated with schools of education and the other sixteen (89 percent) with schools of fine art; twelve of the eighteen institutions (67 percent) are NCATE-accredited, four (22 percent) are NASAD-accredited, and two (11 percent) are both

NCATE- and NASAD-accredited. The range of enrollment of full- and part-time students in the institutions offering art education major programs varies between 908 and 35,551, with nine (50 percent) having student populations from 900 to 3,000, five (28 percent) with 3,000 to 13,000, and four (22 percent) with 20,000 to 36,000 (all of the latter are public, state-supported schools).

REFLECTIONS ON WHENCE, WHAT, AND WHITHER

What does all of this demographic information tell about whence come we, what are we, and whither go we? A common conclusion to most inquiry in the field of art education is that there is a need for more research in a particular area because few studies exist. This inquiry is no exception. I have suggested that there is a strong possibility that databases used in the surveys cited may not present an altogether accurate picture of the demography associated with art teacher preparation programs in the United States. The profile of art education programs in Indiana is not congruent with the Thompson and Hardiman study because 71 percent of the respondents in their survey were from state-supported institutions and 29 percent from private institutions. In Indiana, 44 percent of institutions are private and church-supported, while 56 percent are public and state-supported. In Indiana, only 11 percent of the eighteen schools that offer art education as a major area of study are in schools of education, whereas about 25 percent are in schools of education in the Thompson and Hardiman and Jeffers studies. The percentage of schools offering doctorates is the same in Indiana as in the Thompson and Hardiman study. Although urban, suburban, and small-town locations are not reported in the other surveys, most art education programs in Indiana are located in small towns with student populations well below three thousand. How typical is this Midwestern crossroads state? There is probably a sizable group of faculty nationally—at small private colleges and, in some cases, state institutions—who are preparing art teachers and yet are not part of the NAEA pipeline at state and/or national levels. They also probably have studio backgrounds and teach art education methods classes as a secondary assignment in a school that has a small number of faculty. These faculty, who are not active in the field of art education, are less likely than are faculty in larger state institutions to fill out surveys when colleagues in art education request them. Of concern is how to bring the latest thinking and resources to those places where art educators may not be aware of current theory and practice and therefore may not be educating preservice art teachers

about themes and issues that should drive contemporary art education programs. These art educators would be prime candidates for workshops, seminars, and projects that focus on discipline-oriented content and other relevant and timely practices in art education.

Given these caveats, a picture does begin to emerge of art educators, and those whom they prepare to teach at all levels, as being almost exclusively white. The students they are teaching also are mostly white (98 percent) and female (66 percent) (Thompson and Hardiman 1992). It appears that there should be a concerted effort to prepare more art educators and to educate more preservice art teachers from diverse backgrounds who will provide role models for students who, in most contexts, are from a variety of racial, ethnic, and cultural backgrounds. There are currently more men at the full-professor level, but there are more women at all other levels; this information, coupled with projections of many retirements within the past five years and in the next few years and of more women faculty being hired, may usher in a new age, with the majority of art educators being women. There should be an awareness that males may need to be recruited to become art teachers if there is to be some sort of gender balance maintained in future years.

If only half of those preparing art teachers held doctorates in 1991, then the currency of their knowledge in contemporary art education theory and practice may be questioned. With 75 percent of those responding to the Thompson and Hardiman survey (and Jeffers's survey) claiming to be affiliated with schools of art at their colleges and universities, it is surprising that, although DBAE is gaining acceptance, as reported by 57 percent of the respondents, only 12 percent of the art education programs have separate courses in art history, art criticism, or aesthetics. Evidence in 1990 that DBAE was not being implemented in depth in about 30 percent of the institutions surveyed can be found in the Rogers and Brodgon survey, in which 80 percent indicated that their institutions met the studio foundations standards, but only 66 percent indicated that they met the art history standards and only 70 percent indicated that the advanced work component was met. Today, the same might be said about implementation of the National Standards for Visual Arts Education if results from a similar survey were reported. Although the majority of art educators preparing teachers are opposed to standardized achievement tests for high school students or development of a national art curriculum, they do support preservice art teachers being required to pass competency exams before being certified and art education faculty being required to have a minimum of three years' K–12 teaching experience. This may indicate, in respect

to art teacher preparation programs, that many art educators are ready to move away from an idiosyncratic model of the teacher-artist in the garret-classroom, instructing his or her students in isolation from the worlds of art and education, toward a more comprehensive program where pedagogy, self-expression, and knowledge about art are all integral parts. It is important, therefore, to uncover, as Gauguin wrote, "what is not expressed," and to bring workshops, programs, and resources about contemporary content and issues in art education not only to those who are enlightened, but also to those who need to be. This may be accomplished at the state level by teaming institutions with established art education programs with institutions that have less of a history and emphasis on contemporary art education practice. These teams might attend workshops focusing on teacher preparation that take place over several days, where sharing of ideas is emphasized, that could benefit faculty members at all institutions that offer programs to certify art teachers. Teams might continue to meet during an academic year, and students in art teacher preparation programs at respective schools could share experiences relative to teaching art to K–12 students from diverse backgrounds in a variety of settings.

New technologies are emerging that can aid in the quest to collect demographic information about art teacher preparation programs. On the Internet, home pages can be accessed that supply information about institutions and their programs in art education. These can serve as databases for collecting demographic data about art teacher preparation programs nationally and internationally. The NAEA, in consortium with a private organization, might establish an electronic database, updated frequently, containing demographic information about art teacher preparation programs. Once accurate information becomes easily accessible, research efforts in art education and practical application can be greatly enhanced. The whences, whats, and whithers of art teacher preparation programs are important questions that need to be addressed. As we approach the twenty-first century, answers to Who are we? Where are we? and Where are we going? become increasingly important if art education is to survive as a viable area of study in a new age of information and communication.

REFERENCES

Adcock, E., ed. 1990. *The American art directory.* New York: Bowker's Database Publishing Group.

———. 1995. *The American art directory.* New York: Bowker's Database Publishing Group.

Burton, D. 1991. *A survey of research interests among art education researchers.* Report distributed to members of the Seminar for Research in Art Education (NAEA affiliate).

———. 1996. Briefing paper on demographic research. In *Briefing papers: Creating a visual arts research agenda toward the twenty-first century,* ed. E. Zimmerman. Reston, Va.: National Art Education Association.

Chapman, L., and C. Newton. 1990. 1990 teacher viewpoint survey: The results and comparisons. *School Arts* 90 (January): 41–45.

College blue book, The. 1989. 22d ed. New York: Macmillan.

College Entrance Examination Board. 1992. *The college board index of majors.* 14th ed. New York: College Entrance Examination Board.

Estienne, C. 1953. *Gauguin.* Translated by James Emmons. Geneva: Editions d'art Albert Skira.

Galbraith, L. 1990. Examining issues from general teacher education: Implications for pre-service art education methods courses. *Visual Arts Research* 16 (2): 51–58.

Hurwitz, A., and M. Day. 1991. *Children and their art.* San Diego: Harcourt Brace Jovanovich.

Jeffers, C. S. 1993. A survey of instructors of art methods classes for pre-service elementary teachers. *Studies in Art Education* 34 (4): 233–43.

LaChapelle, J. R. 1988. A selected survey of doctoral research related to American studio education, 1964–1984. *Studies in Art Education* 29 (2): 72–80.

LaPierre, S., and E. Zimmerman. 1997. *Research methods and methodologies for art education.* Reston, Va.: National Art Education Association.

Leonhard, C. 1991. *The status of arts education in American public schools: Report on a survey conducted by the National Arts Education Research Center at the University of Illinois.* Urbana-Champaign: Council for Research in Music Education, University of Illinois.

MacGregor, R. N., S. Lemerise, M. Potts, and B. Roberts. 1993. *Assessment in the arts: A cross-Canada survey.* Vancouver: The University of British Columbia.

Maitland-Gholson, J. 1986. Theory, practice, teacher preparation, and discipline-based art education. *Visual Arts Research* 12 (2): 26–33.

National Art Education Association. 1979. *Standards for art teacher preparation programs.* Reston, Va.: National Art Education Association.

———. 1994. *Art Education: Creating a visual arts research agenda toward the twenty-first century.* Reston, Va.: National Art Education Association.

———. 1995. *Blueprint for implementing a visual arts education research agenda.* Reston, Va.: National Art Education Association.

National Association of Schools of Art and Design. 1984. *Higher education arts data service report.* Washington, D.C.: National Association of Schools of Art and Design.

———. 1988. *Information: NASAD.* Reston, Va.: National Association of Schools of Art and Design.

———. 1995. *National Association of Schools of Art and Design Directory: Design 95.* Reston, Va.: National Association of Schools of Art and Design.

National Center for Education Statistics. 1993. *One hundred twenty years of American education: A statistical portrait.* Washington: D.C.: U.S. Government Printing Office. (ED.1.1/2: ELF–022.)

National Council for Accreditation of Teacher Education. 1994–95. *Teacher education: A guide to NCATE-accredited colleges and universities.* Washington, D.C.: National Council for Accreditation of Teacher Education.

National Endowment for the Arts in Education Program and the U.S. Department of Education. 1994. *Arts education research agenda for the future.* Washington, D.C.: U.S. Government Printing Office. (Pelvin Associates Inc. Contract No. RR 910990.)

Peterson's register of higher education. 1995. 8th ed. Princeton, N.J.: Peterson's.

Rogers, E. T. 1988. A comparison of the course requirements in art teacher preparation programs in the colleges and universities in Alabama. Ph.D. diss., Auburn University, Auburn, Alabama. (Dissertation Abstracts International, 49, 190A.)

Rogers, E. T., and R. E. Brodgon. 1990. A survey of the NAEA curriculum standards in art education teacher preparation programs. *Studies in Art Education* 31 (3): 168–73.

Sabol, F. R. 1994. A critical examination of visual arts achievement tests from state departments of education in the United States. Ph.D. diss., Indiana University, Bloomington.

Smith, P., ed. 1995. *Art education historical methodology: An insider's guide to doing and using.* Pasadena, Calif.: Seminar for Research in Art Education/Open Door Publishers.

Stokrocki, M., ed. 1995. *New waves of research in art education.* Pasadena, Calif.: Seminar for Research in Art Education/Open Door Publishers.

Thompson, C., and G. Hardiman. 1991. The status of art education programs in higher education. *Visual Arts Research* 17 (2): 72–80.

Wrenko, J. D., ed. 1987. *Guide to American art schools.* Boston: G. K. Hall.

Zimmerman, E. 1992. Visual art specialist teacher education: Research and practice in pre-service education. Paper commissioned by the National Endowment for the Arts and the United States Department of Education for presentation at the Arts in American Schools: Setting a Research Agenda for the 1990s Conference, spring 1992, Annapolis, Maryland.

———. 1994a. Concerns of pre-service art teachers and those who prepare them to teach. *Art Education* 7 (5): 59–67.

———. 1994b. Current research and practice about pre-service visual arts specialist teacher education. *Studies in Art Education* 35 (2): 79–89.

———, ed. 1996. *Briefing papers: Creating a visual arts research agenda toward the twenty-first century.* Reston, Va.: National Art Education Association.

What Are Art Teachers Taught?
An Analysis of Curriculum Components
for Art Teacher Preparation Programs

Lynn Galbraith
University of Arizona

WHAT does the current literature say about the curricular components of art teacher education programs? What are art teachers being taught within teacher education programs today? What are the implications of this research, both for the continuing education of art education faculty and for future curricular research in art education? This essay addresses these three broad questions on the current state of art education. The standard means to collect baseline data for this study would involve traditional surveys using large-scale mailings, interviews, and telephone interviews (see, for example, Eads 1980, Jeffers 1993, Sevigny 1987, Willis-Fisher 1991). However, because the data for this study were collected over the summer months when faculty are traditionally unavailable, I have combined in this paper established ways of gathering data (library and electronic searches) with novel means of data collection involving the Information Superhighway.

The rapidly advancing fields of computer and communications technologies are in the process of revolutionizing all areas of human intellectual endeavor. This essay anticipates and investigates their impact specifically in the area of information about teacher education programs and analysis of their curriculum components. A brief review of *current* literature on the curricular components of art teacher education provides a framework for this study. Research goals are then broadly described, as well as the strategy for data collection and analysis, which centers around a particular form of the Information Superhighway: the

■ *45*

Internet,* and, more specifically, the World Wide Web (WWW). After presentation of selected types of data retrieved via the Internet, it concludes with some recommendations for the continuing education of teacher education faculty and further research in the field.

A FRAMEWORK TO THE STUDY

According to a recent listing from the *Peterson's Education Center* (March 1996), an educational database available on the Internet (http://www.petersons.com), 608 four-year institutions in the United States and Canada offer a variety of art education coursework (for specialists and elementary generalists), degree programs, or certification opportunities, and 152 institutions offer some form of graduate-level art education coursework or programs. These institutions run the gamut from research-oriented universities both large and small, to state-supported and land-grant universities, to professional art schools and private universities, to small liberal-arts colleges funded by the private sector or having religious affiliations. These institutions are located in a variety of settings, ranging from major metropolitan areas to more sparsely populated and rural areas.

Although prospective art teachers usually take coursework in their content area of art education, there is, arguably, not one *single* degree or prescribed set of courses that *all* prospective teachers take in order to teach art. Depending on the individual institution and state, art teachers can become certified through a number of widely differing degree and certification avenues. These avenues range from traditional undergraduate degrees (e.g., B.A. in art education, B.F.A. in art education, B.S. in education, B.S. in art education) to those that involve a five-year program and graduate-level work (e.g., M.A. in education, M.A. in art education, M.A.T. in education), to those that involve some form of postbaccalaureate certification coursework. Some of these programs (and their faculty) are housed within departments of art (or their equivalent), while others are located in colleges, schools, or departments of education (Galbraith 1995). Some states allow art teachers to teach students from kindergarten through twelfth grade, while others make a distinction between an elementary and secondary certification. Thus, what constitutes the most appropriate route for learning to become an art teacher is a matter of discourse within the field; yet little research has been done in this area (Davis 1990). Moreover, this tally of programs and their

*All URL addresses in this chapter were current as of May 1997.

various characteristics points to a multitude of questions and possibilities concerning the curricula employed by these institutions and their faculty members and students.

The curricular issues examined within this paper will address those courses that students take in order to obtain teacher certification (Howey and Zimpher 1989). Sevigny (1987) notes that "teacher education in the visual arts takes on the following forms: the preservice preparation of classroom teachers, the preservice education of art specialists, in-service courses and workshops for the experienced classroom teacher, and advanced graduate education for visual arts teachers" (95). This essay will focus on the preparation of art specialists, although I anticipate that implications from this research may be drawn for other art education coursework.

Sevigny (1987) suggests that the main components of an art teacher education program are academic preparation in visual arts content areas (including studio components, aesthetics, art criticism, and art history), coursework in the theoretical foundations of education (including history and philosophy of art education, curriculum theory, and instructional strategies), and supervised field experiences (student teaching and other internships). However, many prospective teachers also take liberal arts or core general education courses during their first two years of study. My intent is to examine course offerings that stress content in the visual arts, art education, and professional education. However, it is important to keep issues concerning the articulation of coursework within the arts and sciences at the surface of any discussion (Howey and Zimpher 1989). Examining both the articulation of teacher education programs and faculty interactions with colleagues elsewhere on campuses may prove important for strengthening traditional courses and developing new ones, as well as for promoting interdisciplinary collaborations with faculty from disciplines that may serve to enrich teacher education programs (such as the disciplines of philosophy, women's studies, anthropology, art history, and technology). Most art education programs are notably small in faculty numbers and must therefore rely heavily on other campus faculty for the delivery of student coursework.

BEFORE examining current research on what comprises visual arts content and professional education coursework, it is important to acknowledge Schubert's (1986) supposition that the term *curriculum* refers not only to a body of knowledge but to a loosely coupled social organization that assesses what knowledge is worthwhile and undertakes to preserve this knowledge. The design and implementation of an art education

curriculum at a specific institution of higher education is influenced by a variety of factors, including changes in the ways that college-level curricula in general are developed, sequenced, and evaluated; the existence of policies and mandates at both state and local levels; the tradition of past practices; requirements for graduation; faculty expertise and interests; the adequacy of human and economic resources; the availability of curricular materials and textbooks; and the less tangible issues of how the art curriculum is made accessible to students (Eisner 1985) and how it relates to learning theories, to how faculty actually plan and teach lessons, and to what students actually learn (MacDonald 1986). Thus, implicit within the nature of curriculum (design) is the interplay of the intrinsic knowledge and values and beliefs of faculty and prospective teachers about what is important and worthwhile (Galbraith 1995). Art educators at all levels of schooling are accountable for program development and implementation, student learning, and teaching and instructional delivery (Davis 1993). They need to pay special attention to curriculum development and implementation (Day 1996). Furthermore, as Sevigny (1987) rightly points out, they must examine how the visual arts are *actually* taught.

It has been argued that over the years there has been little change in teacher education programs in general, as to either structure or content (Murray 1996). Whether this is also true in programs of art teacher education is unclear, since few descriptive studies exist of the curricula in this area (Davis 1990; Hobbs 1993; Sevigny 1987; Willis-Fisher 1991, 1993; Zimmerman 1994).

Over the past decade, there has been much emphasis on the broadening of curricula in visual arts education to include the disciplines of aesthetics, art history, and art criticism as well as art production (Clark, Day, and Greer 1987). Davis (1990) reports that although there is general agreement that the four disciplines are central to the field of art education, there is disagreement on how much weight should be given to each when trying to balance overall art teacher education programmatic needs. Examination is needed to determine whether art teacher education candidates are required to take coursework in the four disciplines and, if so, what this coursework comprises. For example, do they take courses in each of the disciplines and, if so, how many? Or are these disciplines incorporated into other kinds of courses, such as art education methods courses? Do these courses provide future teachers with a wide breadth of knowledge or in-depth study? As this issue is examined, it is important to keep in mind DiBlasio's (1985) concern that art education reformers do not merely add content to existing courses, but rather

that the courses actually undergo transformation. This latter issue immediately leads to the question of who actually teaches this content, and how. These questions are also relevant to how art teachers are being prepared to teach in today's diverse and changing schools (Day 1993; Guay 1993; Zimmerman 1994).

An examination of the literature found few *recent* studies that examine the visual arts content of art teacher education programs. However, one example is Willis-Fisher's (1991) survey of a representative sample of higher-education institutions that have state-approved art education programs. She examines within these programs the relative proportions of content taken from the four art disciplines: art criticism, art history, aesthetics, and art production. Using data collected from questionnaires, she demonstrates that art production is the most frequent component of visual arts coursework. The predominance of studio art confirms earlier research (Eads 1980; Rogers and Brogdon 1990; Sevigny 1987). Willis-Fisher (1993) notes that future art teachers take an average of 36 semester hours in studio coursework over a total degree program of about 130 semester hours. She found that coursework in art history averaged 9 semester hours, a finding that reflected the study of Sevigny (1987). She concludes that most programs, regardless of size, gave some time to aesthetics and criticism in studio, art history courses, and art education courses.

Murchison's (1989) work compares certain NAEA standards for quality art education with the curricula of twelve visual arts teacher education programs in Louisiana. Through interviews and site visits, she not only points out discrepancies between the NAEA standards and the various program requirements but also demonstrates that there is considerable variation in visual arts curricular content among institutions. Together, these findings indicate that programmatic differences exist at both national and state levels.

Differences may also exist between visual arts and art education courses offered in state and private colleges and universities, and those courses offered by professional art schools. A recent and comprehensive description of an art teacher education curriculum at the Maryland Institute, College of Art, is eloquently presented by Carroll, Sandell, and Jones (1995). They discuss the institute's teacher education curriculum in detail and explain how its program has developed, changed, and grown over the past few years.

Preservice teachers also take a series of professional education courses in the form of art education and general education subject matter, various laboratory experiences, and field experiences (Davis 1990).

At this stage in their programs, preservice art teachers begin to address professional and practical aspects of teaching. Roland (1995) reports on the use of journal writing with preservice art teachers and observes how this type of activity encourages them to reflect upon and examine their own beliefs about art and teaching. Susi (1995) also discusses strategies for promoting reflective decision making within the preservice classroom. These types of studies allow us to understand more fully how curriculum is enacted within preservice classrooms.

One of the most important professional courses is the art education *methods course*, which usually revolves around the teaching of art at the elementary and secondary levels. Unfortunately, little research has been conducted on methods courses for art specialists (Galbraith 1993; Zimmerman 1994), although several descriptive studies examine methods course instruction for elementary classroom teachers (Galbraith 1991; Jeffers 1993; Smith-Shank 1992).

Any study of curriculum must examine the teachers who are involved in putting it in place (May 1989). College-level faculty are powerful figures within art teacher education (Galbraith 1995). It is well known that art education departments or areas are often small and reside, as suggested earlier, in either the visual arts or education college. Does the location of faculty matter, and what are its implications for cross-campus curriculum articulation? Further, it seems important to explore who these faculty are, what they have in mind for their programs, what their qualifications are, and whether they belong to professional art education organizations such as the NAEA. Do smaller (and even perhaps larger) institutions employ art educators at all, or do they employ studio faculty who do "double-duty" as art educators? With the shifts in educational directions in some institutions (particularly those that are supported by state funds), issues related to faculty research and teaching are being closely monitored (Murray 1996).

RESEARCH APPROACH

How does one find out what art teachers are taught in their teacher education programs? Traditionally, the few research studies that have aimed to explore this question have relied on large-scale surveys and questionnaires (Willis-Fisher 1991). However, survey research does have some limitations. For example, Jeffers (1993) believes that her study, centered on instructors who teach college-level methods courses for classroom teachers, was hampered not only by a modest return rate (25.4 percent), but also by the fact that she could not be certain that the

responses came exclusively from the instructors who actually teach these courses. The relatively low return rate (22.5 percent) in Rogers and Brogdon's (1990) survey of art education programs also pinpoints difficulties in collecting data. Thus, I have approached this project in the following three phases.

First came the examination of relevant books and articles in the literature and searches of various electronic and CD-ROM databases such as ERIC, Dissertations Abstract, and Current Contents. Electronic searches of the catalogues of my university library and those of other institutions proved useful, as did perusal of course offerings listed in selected college catalogues on microfiche. Some of the nationally recognized art education programs (e.g., Ball State University, Florida State University, Pennsylvania State University, University of Georgia, and so forth), identified and cited in the Sevigny (1987) study on teacher education, were also examined.

Second was the use of the Internet as a means for data collection. The research potential and data collection possibilities of exploring the World Wide Web (WWW) via the Internet become particularly evident as one *browses HomePage Hypertext documents* using *NetScape 1.1N* (and subsequent versions), a graphical user interface browser, or Lynx, a nongraphical browser, available on both PC Windows and Macintosh platforms. Many institutions have placed home pages on the WWW, and these provide a variety of different types of information, including locations, curricular offerings, and faculty members. Two months of daily explorations proved that many are still under development and are continually being refined and updated. Nonetheless, there was available for analysis a significant amount of information about a cross-section of different institutions. For example, using Netscape, I explored the links to most of the institutions listed on the Internet site *Web U.S. Universities, by State*, developed by the University of Texas at Austin (http://www.utexas.edu/world/univ/state/). The institutions, listed alphabetically by state, represent the diverse nature of American educational institutions and regions—ranging from research-oriented universities to land-grant institutions to small private liberal arts colleges. However, professional institutions that only specialize in teaching visual or fine arts are not listed in this grouping. Any data analyses on professional arts institutions are part of a future research agenda.

Upon entering each institutional home page site, the first task was to search for academic areas, departments or colleges, in order to see whether the institution actually taught art education. If it appeared that it did, any available program philosophies or course descriptions

that applied to this project were printed out or downloaded. Faculty names, biographies, and E-mail addresses were also searched. The *Peterson's Educational Center* site (http://www.petersons.com), which is a graphical Internet version of the Peterson's Guides, Inc. (1995), had, at the time of writing, a total of 608 four-year colleges in the United States and Canada indexed as offering art education programs (http://www.petersons.com/ugrad/select/u40310se.html), as well as 152 graduate programs (http://www.petersons.com). This site was used to substantiate the original searches. Some institutions use on-line E-mail services for catalogue requests and information on admissions procedures; I used some of these.

Third, a cross-section of art educators was surveyed in order to find out what kinds of curricula are in place in their various institutions. The survey data, along with the data collected from the Internet and E-mail correspondence, would allow development of a series of pilot case studies. A small E-mail survey was therefore sent to those faculty tracked down by name through their institutional Internet sites. In addition, Dr. Thomas Hatfield, executive director of the NAEA, kindly provided a listing of Higher Education Division members. Of the over one thousand persons on the list, some recorded addresses at their institutional affiliation; the Internet text-based search engines Gopher and Veronica could then be used to track down their E-mail addresses at their institutions. Many members recorded their home addresses, so it was necessary to try to determine a possible institution with which they might be affiliated. State-specific WWW servers proved useful starting points. Many of the state servers (for example, California, Florida, Georgia, Minnesota, Nebraska, North Dakota, Texas, and Wisconsin) provided "clickable" image-maps that allow the browser to ascertain directly the numbers of different institutions and their locations. Again, these servers were easily found by searching the WWW using the various available "search engines" (InfoSeek, Lycos, WebCrawler). Unfortunately, though perhaps not surprisingly, this part of the project proved that there are a large number of faculty working in art education programs who *are not* members of the NAEA.

THE DATA ACQUIRED

The acquired data is presented in two parts. The first comprises a listing of general information obtained from nineteen institutions (Table 1) and was retrieved exclusively from the various WWW sites. These institutions are tabulated as being *representative* of the many investigated

via the Internet. I examined all of the 608 United States home page sites listed on the *Peterson's* WWW site; and, not surprisingly, some sites were much more developed than others. I have purposely tried to depict the "range" of programs available across the country, rather than deliberately seeking out those programs that have already established reputations. The institutions are listed vertically in the first column of the table. The data fall into five categories—institution, degree and faculty, institutional requirements, art requirements (studio, aesthetics, art history, and art criticism), art education, and professional education. These categories serve as headings placed horizontally across the top of the table.

The second part of the data reporting is taken from fifteen case studies developed on specific institutions. These were self-selected, in the sense that they were the only ones to reply to the E-mail survey and inquiries. A complete listing of these institutions is available at the end of the paper. For these studies, I solicited responses to the following five brief questions via E-mail: (1) Does your institution have a degree in art education? (2) How many full- or part-time art education faculty teach within your program? (3) Are your art education majors responsible for taking coursework in art history, aesthetics or art criticism? If so, how many courses do they take? Also, do majors take coursework in multicultural issues or on art with exceptional children? (4) What art education textbooks do you use in your courses or in your program? (5) How would you define the overriding curricular approach within your art education program: (a) discipline-based, (b) creative self-expression/child-centered, (c) studio-centered, or (d) other?

I present the data under a series of thematic headings. Data received verbatim via E-mail (or letter) are presented in italics and have been taken directly from correspondence. Data from Table 1 are also presented, along with data from some schools that are not listed in Table 1 or in the case studies. I then provide a discussion of the data, its drawbacks, and some implications for designing art teacher education curricula and research.

THE DATA ANALYZED

Given the impressive total number of art education programs in the United States, covering the undergraduate, postbaccalaureate, and graduate levels, the insights provided by this study are somewhat limited in their total coverage. Other potential limitations of the study will be addressed in later sections. Bearing these in mind, I would like to offer the following analysis:

TABLE 1.*

Institution	Degree & Faculty	Requirements	Art Courses	Art Education	Education
Baker University Baldwin City, Kansas http://www.bakeru.edu Private institution, United Methodist	B.A. in Art Education, K–12 certification; (48) art major; 2 full-time art faculty, 1 part-time art faculty housed in art dept.	(42) liberal arts (includes 12 units in aesthetics)	(6) core studio; (18) studio concentration; (3) art history survey; (3) art history elective; (3) art criticism seminar	(15) art education courses (visual language, elementary art, 2-D media, secondary art)	education coursework, art for elementary majors available
Bradley University Peoria, Illinois http://www.bradley.edu Private institution	B.A. or B.S. with major in Studio Art (66) and secondary student teaching; 7 permanent studio art faculty housed in fine arts.	(21) general education	(15) studio core; (18) studio electives; (18) studio concentration; (6) art history core; (9) art history electives	(3) art education methods in College of Education	education coursework
California Lutheran College Thousand Oaks, California http://robles.callutheran.edu Private institution	B.A. with Art Education concentration for single subject, credential, K–12; (42) art major; 3 art dept. faculty	(21) core curriculum concentration	(42) "art" courses as minimum in major (of which (24) must be upper-division); Philosophy of Art offered but not required	arts and crafts for elementary generalists offered in art department	courses for certification after completion of degree; liaison with College of Education
Central Washington University Ellensburg, Washington http://www.cwu.edu State institution	B.A. in Art Education with (45) in major of Art Teaching and (65) in broad area major, K–12; 1 full-time art educator (also teaches art history) housed in art dept.	general education	45 or 65 core courses and electives in studio, with 12 in art history	2 art education courses: elementary methods and secondary methods	education coursework
Cornell College Mount Vernon, Iowa http://www.cornell-iowa.edu Private institution	B.A. in Art with a teaching major in Secondary Art; 4 art dept. faculty	liberal arts emphasis	(27) studio: senior thesis/ exhibit; art history; (3) modernism or feminism	1 general methods course (all teaching subjects)	(9) professional education

Institution	Program	General education	Studio / art history	Art education courses	Education coursework
Florida State University Tallahassee, Florida *http://www.fsu.edu* State institution	B.S., B.A. in Art Education; graduate program available; 6 art educators/faculty; dept. of art education in School of Visual Arts and Dance	(≤9) liberal studies program required of all students	studio core; art history	7 art education courses, including 3 that involve teaching of studio, art history, and aesthetics and criticism; emphasis on computers	education coursework, plus student teaching
Huntingdon College Huntingdon, Indiana *http://www.huntcol.edu* Private institution	B.S. with major in Secondary Art Education; (40) in major; 2 art cept. faculty (1 of which is listed as Art Ed. Ph.D. candidate)	general education	(18) core studio; (6) art history	2 "methods" courses taught in Department of Education	dept. of education courses, plus student teaching
Middle Tennessee State University Murfreesboro, Tennessee *http://www.mtsu.edu* State institution	B.S. in Art Education, K-12; (132) total; 3 art educators housed in art dept. of 15 full-time faculty	specific general studies courses required of all students	minimum of (24) in major	art education coursework includes elementary and secondary modules	minor in secondary education
Minot State University Minot, North Dakota *http:// warp6.cs.misu.nodak.edu* State institution	B.S. in Education with Major in Art, K-12; graduate degrees available; 1 art educator in art dept. of 3 faculty	(41) general education	(31) foundations and studio courses; (3) art history survey; (3) upper-division art history	(2) art methods	(12) core courses, plus (12) student teaching
Northern Illinois University DeKalb, Illinois *http://www.niu.edu* State institution	B.S. in Art Education; graduate degrees available; 6 art education faculty; School of Visual and Performing Arts	general education	(3) aesthetics, criticism; (9) art history survey; (3) upper-division	art education coursework	professional education courses

*Numbers in parentheses reflect credit hours required. URL addresses were current as of May 1997.

TABLE 1 *(continued).**

Institution	Degree & Faculty	Requirements	Art Courses	Art Education	Education
Northwestern University Evanston, Illinois *http://www.acns.nwu.edu* Private institution	B.A. in Art; small department and few majors; use high school art educators for methods instruction and student teaching supervision		studio and art history for art major	1 methods course	professional coursework in education
Ohio State University–Lima Campus *no URL address* State institution within Ohio State University system	Art Education majors transfer to 4-year state institution in Ohio in order to complete art education degrees	general education	studio and art history courses; 1 art criticism course	cover discipline-based issues and multiculturalism	students transfer to another Ohio state institution
Pittsburg State University Pittsburg, Kansas *http://www.pittstate.edu* State institution	B.S. in Education with a major in Art Education, K–12; B.S. in Education (Art Therapy); art faculty housed in art dept.	general education	(28) broad studio; (9) art history	4 courses in art education, including methods	core education courses, plus student teaching
Syracuse University Syracuse, New York *http://www.syr.edu* State institution	B.A. in Art Education; 1 full-time faculty member with joint appointment for art and education	general education	(15) core foundation studio; (36) studio emphases; (9) survey of art history	3 art education courses	(33) in education (includes student teaching)
University of Alabama in Huntsville *http://info.uah.edu* State institution	B.A. in Studio Discipline with Teacher Education, K–12; (51) art; (38) professional education; art in art/art history department and art education in College of Education	general education	(15) lower-division studio; (21) upper-division specialization; (6) survey of art history; (6) upper-division art history (elective)	2 courses: art for elementary teaching and teaching middle and high school—taught in College of Education	(38) professional education (includes (9) student teaching)

	general education		art education	professional education
University of Arizona Tucson, Arizona *http://www.arizona.edu* State institution B.F.A. in Art Education, plus double major in studio art; graduate degrees available; post-bacc. certification; K–12; 3 faculty housed in art department	general education	(60) studio; (6) survey of art history; (9) upper-division art history	7 courses of art education (includes seminars on teaching disciplines of art, cross-cultural influences, and methods)	(14) professional education, plus (12) student teaching
University of Arkansas–Fayetteville *http://www.uark.edu* State institution 5-year program leading to M.A.T., undergraduate certification in pre-education; faculty in art department	general requirements	(39) minimum in art (4 lower-division courses, 3 semesters of emphasis); (6) art history survey; (3) art history elective	3 courses of art education	education core, plus student teaching (Arkansas requires a 5-year teaching program)
University of Idaho Moscow, Idaho *http://www.uidaho.edu* State institution B.S. in Art Education; (128) specializing in studio; 1 art education faculty with joint appointment in art and education	core general education courses required of all students	(40–60) studio courses; (6) art history survey	(3–5) methods courses (elementary and secondary) taught in College of Education	(21) education courses, plus (14) student teaching
Western Michigan University Kalamazoo, Michigan *http://www.wmich.edu* State institution B.A. with teaching major in Art Teaching	general education	(27) studio foundations; (15) art electives; (15) art history (includes studio)	4 art education courses (required)	education courses, plus student teaching

*Numbers in parentheses reflect credit hours required. URL addresses were current as of May 1997.

Degree Programs

The data indicate first that there are a large number of degree programs available to persons wishing to teach art. Art education is taught in a broad cross-section of institutions (see Table 1); most of these offer some form of undergraduate degree:

> We have four undergraduate options: B.A. and B.F.A. in K–12, and B.A. and B.F.A. in 6–12. (Boise State University)

A small minority offer only certification coursework at the master's level (like the University of Arkansas–Fayetteville), or after students have completed a bachelor's degree (as required by states such as California). Most undergraduate degrees require 120 to 130 semester credit hours (although there are a few exceptions) comprising coursework in general education, art, art education, and professional education.

> Students majoring in the B.S. in Art Education (128 credits) are required to take University Core requirements, the Art Core (22 semester hours of drawing, painting, sculpture), art history (6), a studio emphasis (200-level and 300-level courses in one of the following areas: drawing, painting, textile design, sculpture, photography, printmaking, or ceramics), art education methods (3–5 hours in the College of Education), and professional educational coursework (35 hours including 14 for student teaching). (University of Idaho Undergraduate Catalogue)

> Essentially, the art education degree is comprised of courses in liberal studies (general education), professional education coursework, art education courses, art history courses, studio coursework, and a student teaching semester. Overall, the degree program requires approximately 136 semester credits of coursework. (Indiana University of Pennsylvania)

A number of institutions offer art education undergraduate degrees that could be considered "shortened" versions of studio degrees, with art education and professional education coursework added in place of either a studio concentration or upper-division studio and art history courses:

> Students take a Bachelor of Arts with a major in Art Teaching with 60 credit hours in visual arts content. Studio courses include: Foundation Drawing, Foundation Design, Theory of Art, Life Drawing, Ceramics, Sculpture, Painting 1, and Intaglio Relief. The

Art History sequence comprises two survey courses and an elective. Students also take 15 semester hours of art electives. Art Education requirements comprise a sequence of four art education courses: Art Education Workshop, Preparation for Art Teaching (Elementary), Preparation for Art Teaching (Secondary), and Preparation for Art Teaching. Students take 28 semester hours of professional educational coursework, 10 of which is a required secondary student teaching internship. (Western Michigan University)

Visual Arts Content

In all of the institutions surveyed, prospective art education majors take a predominance of studio coursework, although institutions with larger art education programs (e.g., Florida State University, Pennsylvania State University, University of Georgia) have more comprehensive offerings:

> We have 6 full-time, 1 part-time faculty. Students take one course called Aesthetics, Art History and Art Criticism. They take 3 art history survey courses which cover the history of Western art. They take one upper-level art history course. They are also responsible for one non-Western culture course which may be the upper-level art history. They are responsible for taking one course about exceptional children and one general education course or "experience" which deals with multicultural issues. (Northern Illinois University)

From the data, art education majors generally take first a series of core or introductory studio courses (such as at Middle Tennessee State University or Western Washington University). Often referred to as foundations coursework or even as a "freshman block," these courses frequently focus on drawing, painting, and two-dimensional design. Curricula at this lower level typically emphasize *breadth* of subject matter rather than in-depth knowledge. These courses are generally practical in orientation and have very similar catalogue descriptions:

> AS 120: Drawing 1: This course emphasizes development of powers of observation through drawing using a variety of media. (Baker University, Kansas)

> ART 155: Foundations: Introduction to Drawing 1. A study of fundamental pictorial concepts of drawing. Experimentation with various technical means and media directed toward both expressive and descriptive ends. (Grand Valley State University, Michigan)

A complication seems to be that any introductory courses that examine media and processes in the visual arts, or that can be given the designation of art appreciation, tend to be designed for non–art majors undertaking general coursework (as at the University of Arizona, University of Illinois at Urbana-Champaign, or Western Washington University). These courses are often viewed as service courses, rather like art education courses for classroom teachers.

Art education majors are asked to take additional coursework after their foundations blocks. The extent of these courses varies between institutions. For example, some institutions require additional coursework in a breadth of two- and three-dimensional studio art (such as Pittsburg State University in Kansas), while others emphasize selected studio areas (University of Alabama–Huntsville, University of Arkansas–Fayetteville, or University of Florida). A wide range of studio course offerings—painting, jewelry, photography, graphic design, printmaking, lithography, ceramics, illustration—was evident within the various programs surveyed. Some institutions had introduced coursework specifically centered on technology/computers, although few seemed to require art education majors to enroll in these courses as of the time of writing (exceptions include Florida State University and University of Florida). I will revisit this point in my concluding remarks.

Most institutions require majors to take traditional art history survey courses of three to six credit hours as part of their teacher education curricula. These survey courses are usually representative of lower-division courses. A number of programs do require additional art history courses, but in most cases these remain electives. Thus, the choice of art history courses within the program is largely left up to the student. This brings up the issue of the availability of art history offerings. Most institutions offer one or another of the following types of courses: surveys of Western art, eighteenth- and nineteenth-century art, twentieth-century art, American art history, and art since 1945. However, some of the institutions surveyed do offer courses in non-Western art, feminism, and contemporary issues. Substantial course offerings in the discipline of art criticism appear to be missing in many institutions, although some do offer seminars in contemporary art and theoretical issues (like the University of Arizona). Some institutions also offer coursework that includes non-Western issues as part of their arts and sciences or liberal arts requirements (Northern Illinois University, University of Illinois at Urbana-Champaign). Most require some coursework in the arts and humanities (such as Baker University in Kansas) as part of general education requirements.

Art Education Coursework

The amount of required art education coursework varies between institutions. At one extreme (Cornell College in Iowa), art education majors take only a general methods course for the teaching of secondary content areas. Some institutions require coursework only in elementary and secondary methods (Minot State University, Central Washington University). At the other extreme, institutions exist that require over twenty-one credit hours of art education coursework (University of Arizona, Florida State University, and Pennsylvania State University). Other institutions tend to fall somewhere in the middle. It is also evident that, in a majority of cases, aesthetics and art criticism are taught within art education methods courses (examples include Boise State University, Indiana University of Pennsylvania, Minot State University, Syracuse University, University of Nebraska at Omaha, Western Michigan University):

> While aesthetics and criticism courses are not currently required, they are available and encouraged. As well, I incorporate quite a bit about criticism into the basic art ed methods course in conjunction with assessment. (Central Washington University)

> Undergraduates must write in and demonstrate an aesthetic, art history, art criticism/analysis, or multiethnic component in each lesson plan they produce in the courses they take. (Boise State University)

> Aesthetics and art criticism are addressed in the three art education methods courses. Students are schooled in multicultural approaches within the three methods courses. Art education for persons with disabilities is a focal point of this program. (Syracuse University)

> Much of the aesthetics and criticism information is contained within the curriculum of regular studio courses. (Minot State University)

The data also indicate that, in some cases, art education methods courses are taught within departments of education (Bradley University in Illinois, Huntingdon College in Indiana, University of Idaho). In some instances, the "methods courses" are taught by part-time people, especially for the elementary generalist. Also, institutions tend to represent a broad cross-section of philosophical approaches:

> We are primarily an amalgam of approaches: DBAE but child centered at elementary level and a bit more emphasis on studio at the secondary. Moving more to DBAE but are limited because

of focus due to time constraints on class offerings re: aesthetics and criticism. (Middle Tennessee State University)

Our overriding philosophy is a balanced discipline-based approach incorporating collaborative, reflective, and creative methods whenever appropriate. We are beginning to incorporate more off-site experiences and opportunities for authentic assessment as well as art advocacy. (University of Nebraska at Omaha)

The art education program comprises three major emphases: an exploration of media and sensory involvement, developing art-centered curricula based upon phenomenological encounters, and research into the disciplines of inquiry in art and education. (Syracuse University)

We are striving to become discipline-based after years of being oriented toward child-centered/creative expression. (Western Michigan University)

I would best characterize our curricular/philosophical approach as a synthesis of studio/discipline-based art education and creative expression. We attempt to be current in our understanding and knowledge base without buying into a particular program at the expense of other points of view. (Indiana University of Pennsylvania)

Where separate courses exist on the teaching of the disciplines, they are found in larger art education programs (such as Florida State University, Pennsylvania State University, and University of Arizona), although there are exceptions (Baker University in Kansas requires a core course in art criticism for art education majors). Some institutions do require separate coursework in multicultural or ethnic studies (for instance, Northern Illinois University, Ohio State University–Lima Campus, and University of Arizona).

The case studies indicate that a broad range of art education texts, representative of a broad range of approaches and ideologies, are in use at the various case study institutions. Texts range from those that stress the teaching of art (e.g., authors such as Hurlwitz, Day, Mittler, Parks, and Ragans), to NAEA and the Getty Education Institute for the Arts (formerly the Getty Center for Education in the Arts) publications, to elementary "how-to" texts such as Wachowiak's *Emphasis Art.* One institution reported using Lowenfeld's *Creative and Mental Growth.* Several institutions design their own instructors' packets and put readings on reserve in the library (including University of Illinois at Urbana-Champaign, and University of Nebraska at Omaha):

We use a large assortment of art textbooks—Wachowiack with Chapman, *Spectra,* and other curricula resources most common for Elem. Ed. art methods with Hume (Survival . . .), Eisner, Feldman, Getty materials, and many others for art ed. majors. We have a large library of materials from which to draw ideas, information, and techniques. (Boise State University)

Each instructor is responsible for the textbooks used in their classes. A random sampling of books include the Herberholz and Herberholz books on early childhood and elementary; Armstrong's book, *Designing Assessment in Art, Art in Theory 1900–1990,* edited by Harrison and Wood, Barrett's *Criticizing Photographs,* my students read the journal *Art Education,* and I'm going to be using Susi's book *Student Behavior in Art Classrooms: The Dynamics of Discipline* for the first time this semester. There are undoubtedly others which I have not named. (Northern Illinois University).

We use a variety of texts and are not completely satisfied with any. We supplement texts with many journal articles. We use Lowenfeld and Gardner for child development, Hurwitz and Day for instruction, Hurwitz for gifted, Rodriguez for special needs. We will start to use *Learning by Heart* by Corita Kent for creativity this Fall. We use a variety of philosophical approaches but to summarize, we attempt to balance child-centered with discipline-centered as can be seen by our use of the work of both Lowenfeld and Gardner. (Plymouth State College)

Professional Education

The amount of coursework in professional education varies according to institutional and state requirements. Catalogue descriptions appear similar at most institutions, including courses related to the foundations of education, educational psychology and child development, the history of schooling in America, and instructional strategies and methods. Most institutions require a semester grade point average of 2.5 or above for student admission into College of Education coursework:

For registration in upper-division courses in the field of education, students must have been admitted to the teacher education program and have a GPA of 2.5, unless a higher average is stated as prerequisite in the course description. (University of Idaho Undergraduate Catalogue)

All majors take some form of student-teaching practica or internship at either the elementary or secondary level. At most institutions, student teaching is viewed as a capstone experience during the last semester of study.

Faculty

Some art education programs have a relatively small number of faculty as compared to their counterpart programs in studio art and art history. At the University of Idaho, for example, the one art education faculty member has a joint appointment in two colleges (it is also interesting to note that this faculty member holds a M.F.A. degree from the University of Idaho):

> I am the only faculty member teaching art education in the College of Education and my appointment is half-time. I also teach in the art department in the College of Art and Architecture supervising the foundation drawing program. (University of Idaho)

The two art education faculty at Plymouth State College in New Hampshire also teach studio classes, and the art educator at Central Washington University also teaches art history courses:

> I'm the whole show, but I feel very strongly that the studio and art history instructors are also part of "my" art education program. Fortunately our collective relationship is a strong one. (Central Washington University)

Art education is also taught by a number of part-time and/or adjunct faculty members (at Syracuse University and Western Michigan University, for example). In some institutions, studio art faculty are responsible for the art education coursework, and/or adjunct persons (often teachers from the local community) are responsible for art education coursework within colleges or departments of education:

> Art Education faculty teach courses in the studio foundation in addition to Art Education methods. (Plymouth State College, New Hampshire)

> This institution has a very small teacher preparation program (usually about 80 students) and art is not a very big draw. Last year I had two students, only one the year before. The Field Office does the placement and supervision of the pre-service observation and student teaching, and offers the subject-specific methods courses required for certification. For these courses I hire current or

retired teachers, persons who know the territory. If an art student turns up for this Fall, I have arranged for an art teacher at a local High School to work. (Northwestern University)

E-mail correspondence indicated that a number of institutions rely heavily on part-time instructional faculty (among them, Boise State, Plymouth State in New Hampshire, University of Nebraska at Omaha, and Western Michigan University):

We have one full-time, one part-time for supervision overload as needed, and four part-time for the service course (elementary classroom majors) only. (University of Nebraska at Omaha)

In another case (Ohio State University–Lima Campus), majors transfer to another four-year program within the Ohio state system to complete art education coursework.

I work for a branch campus within a large state system. I am the only full-time member of the art department. The campus has approximately 5 majors (declared) at any one time. They transfer to a four-year campus to complete their work. (Ohio State University–Lima Campus)

Drawbacks

The acquired data has drawbacks: a large proportion of the data comprises catalogue descriptions, which may not be fully representative of the curriculum. Faculty self-reports (the case studies) can also be problematic and inaccurate (Elizabeth Delacruz, University of Illinois at Urbana-Champaign, August 1995, personal communication). The E-mail survey was brief and failed to obtain certain information. It never really ascertained, for example, exactly how many majors were taught in the various individual programs, although there were certainly differences between the numbers of faculty within programs. This is an area that needs more investigation, as does the exact tally of how many art education programs there are across the country.

Yet, given the circumstances of the study, the research approach retains considerable power. For example, use of the Internet allowed me, almost daily for over two months, to visit a large number of institutional sites, to acquire E-mail addresses, and to provide baseline data to serve as seed for further, more detailed research. Specifically, some of the WWW sites allowed me to obtain information about studio, art history, and education faculty; other WWW sites contained pages that described the mission of the institution and its location and history, as well as any

core or general education courses required of all students. A number of the home page sites are recent additions to the rapidly expanding Internet and, presumably, provide information that is highly contemporary.

A second drawback was the low rate of return for the E-mail survey. A variety of reasons might explain this. In the first case, a large number of faculty for whom E-mail addresses were published have not maintained this address in an active form; thus, electronic communications to these addresses were returned as undeliverable. In other cases, one might expect that the faculty do not check their E-mail on a regular basis or are unable to compose a response. Inability to respond can be caused in part by the inavailability of convenient software and, perhaps, hardware. Although hardware requirements for E-mail collection are minimal (a 286-based computer or better and a modem of modest speed), E-mail programs allowing text editing (as opposed to mail routines allowing only text entry and not editing) are essential for composing detailed responses. A final possibility, of course, is that some persons might choose simply not to answer the survey.

DISCUSSION

The data suggest that issues of curriculum in art teacher education are wide in scope and may vary across institutions. Most programs offer undergraduate degrees that comprise 120 to 130 semester credit hours. Searches on the Internet indicate that, in some states, a surprisingly large number of public and private institutions are involved in preparing art teachers. They also reflect that most institutions, unless they have some strong affiliation (that is, they belong to the same religious denomination or to a consortium of small liberal arts colleges, or have programs from which students transfer to another institution within the state) do not communicate extensively with one another about art teacher education offerings. Thus, apart from complying to state certification and general institutional requirements, most art teacher education programs are fairly self-contained units which are responsible for devising their own courses based on faculty interests, availability, and resources.

The data need to be analyzed further and more research undertaken in order to examine what core concepts and experiences are central to each art teacher education program. Schubert (1986) suggests that educators tend to create course objectives without considering larger curricular issues. This raises the question of whether art education degrees are well planned and articulated, or whether they merely comprise an assemblage of courses that are conveniently meshed together. The data

suggest the latter; in a large number of instances, art education under-
graduate degrees simply consist of general education requirements
(taught by arts and sciences colleagues), lower-division studio art and art
history courses, and upper-division art education and professional
coursework. A student-teaching internship or practicum is viewed as the
capstone experience of the final semester. Thus, art teacher educators
have the added burden of trying to help majors link together as well as
comprehend the relevance of their degree programs.

Courses that reflect the disciplines of art, apart from studio art, are
sadly missing from many teacher education curricula, although most of
the faculty contacted in the case studies suggest that the disciplines are
incorporated within art education coursework. Many institutions with
smaller faculty numbers include the disciplines of art, multicultural
issues, and so on under the broad umbrella of methods course instruc-
tion and, in a few cases, within studio and art history courses. This will
prove unfortunate if the field is to experience any significant change,
especially for those institutions which offer only a few art education
courses. This leads to an important debate concerning issues of content
and pedagogy: Exactly how much coursework in the visual arts should
art teachers be expected to take? How much emphasis should be placed
on how to teach art? Does the curriculum pay sufficient attention to
what is actually being taught in K–12 schools?

Another issue is the availability of certain courses on campuses. For
example, offerings in art criticism and aesthetics may be hampered by the
fact that there are no aestheticians or art critics at a certain institution, or
only certain art history courses are offered that match the expertise and
interests of campus art historians, or majors take those art history courses
that conveniently "fit" into their busy schedules. Additionally, studio and
art history colleagues are also influential on prospective art teachers. How
these faculty instruct their classes and the enthusiasm they have for the
subject are all-important. Learning to teach art is very much entwined
with one's knowledge of the way concepts embedded in specific disci-
plines are accurately or inaccurately conceptualized by students.

Clearly, issues of turf and academic freedom also affect the establish-
ment of a curriculum. The extent to which faculty are fully capable of
defining the importance of what they teach is an issue that has to be
addressed as curricular matters are discussed (Braskamp and Ory 1994).
Faculty work is clearly important: it must be analyzed, reflected upon,
and studied. What are its complexities? What is the range of legitimate
faculty work within art education? Often faculty work as independent
(and often isolated) entrepreneurs, instead of working within a collective

whole for the art education area, art department, or even their institution (Ducharme 1993). This means that developing a common vision of faculty work—or, specifically, of art education—will prove problematic. There are also institutional factors to consider: issues of academic freedom, of longevity, and of tenure (Diamond and Roberts 1993; Howey and Zimpher 1994). Some of the faculty contacted in this study are responsible for heavy teaching loads. Others are part-time or adjunct personnel or teachers from the schools (as at Northwestern University) or even graduate teaching assistants who are working on their degrees (as at Syracuse University). Finally, not all of the faculty who teach in art education settings are art educators or have doctoral degrees; they often have studio degrees and teach a combination of studio and art education courses.

One of the issues that some state institutions are facing (those in Arizona, for example) is public pressure for students to graduate within a reasonable time frame. This means little room for additional courses within degree programs; on the contrary, faculty are being required to downsize their programs and do more with fewer resources. This inevitably leads to a re-examination of the curriculum. Thus, thought must be given to how art educators can inform their administrators and faculty colleagues what should comprise the curricular components of the art teacher education degree or certification program for both specialists and elementary generalists (Galbraith 1996). It is clear from the data and the literature (Murray 1996) that we college-level art educators must be strong advocates for our programs as administrators begin to take a strong and hard look at what degrees they offer and whether they can afford them. We will have to let our campus colleagues know about the value of arts-related courses in the education of *all* teachers. Yet, on a more positive note, changes may lead the way for new courses in visual arts education that not only address how to incorporate the disciplines of art, multicultural issues, interdisciplinary arts education issues, feminism, postmodernism, and so forth, but also to employ rapidly emerging computer and communication technologies as both learning and instructional delivery systems.

SOME CONSIDERATIONS FOR FACULTY CONTINUING EDUCATION AND FUTURE RESEARCH

I would like to conclude with some suggestions regarding the impact of electronic communications in the general areas of faculty continuing education and future research in art education. The potential offered to art education by networked communications technologies (the Internet)

should be clear. Specific mechanisms exist that enable electronic conferencing and data archiving without requiring real-time participation (for example, setting up an electronic list service). This would seem particularly attractive as a means for establishing a continuing program of curriculum development and assessment linked between institutions. The following situation might be envisaged:

Selected art education faculty from across the country are invited to participate in a sponsored conference, the topic of the conference concerning curriculum development and research in art education. A prerequisite for the target faculty is a willingness to continue their personal education and to provide a commitment to work on curricular issues and development. The process leading to faculty change not only requires enthusiastic participation by the faculty, but also requires recognition and accommodation by the home institutions. In the conference, faculty would be introduced to specific content in the visual arts, as deemed appropriate by the conference organizers. In parallel, they would be instructed in the use of computers and the Internet and in the means whereby curriculum can be developed, implemented in the classroom, and analyzed across institutions via the Internet. To facilitate the process and to encourage participation in the pilot study, the faculty would be given help in finding funds for computer hardware and software. Coordination and continuous monitoring of the study would be the responsibility of the study organizer. An important anticipated offshoot of this work would be the development of close collaborations and mentoring partnerships, both between individuals at different institutions and between the faculty and their home institutions.

The project would allow the use of a WWW home page and linked Hypertext documents to display the consensus curriculum that is developed. Such a document can be continuously updated, depending on the result of the pilot studies undertaken at different universities. This would be an attractive proposition to faculty who work within small institutions or in rural areas. Prospective art teachers and school practitioners can also be involved, via linking to K–12 servers. This type of project will allow college-level faculty to work collaboratively on enhancing college-level and school curricula. Finally, such networking will allow art education teachers and administrators in the future to ascertain more efficiently exactly what art teachers are taught within their education programs.

From my research involving the Internet, it is clear that most academic institutions are actively investing in communications and computer technologies, and these are allowing them to access the WWW and develop hypertext documents, including home pages. Universities

within some states (such as Nebraska and North Dakota) are already linked through their individual state servers. Individual faculty are beginning to put their syllabi and course descriptions on line (see, for example, the World Lecture Hall [http://www.utexas.edu/world/lecture/] which is maintained by the University of Texas at Austin). This makes the proposed development of Internet-linked projects and research both timely and appropriate.

CONCLUSION

Issues of curriculum are integral to the fabric of art teacher education. Schubert (1986) argues that the term *curriculum* serves as a "metaphor for a journey of learning and growth" (6). Inherent to a curriculum is the concept of collaborative inquiry. As the twenty-first century approaches, there is opportunity for unprecedented changes in the ways that information is trafficked. The chapters in this book serve as a means not only for initiating a dialogue around issues of art teacher education, curriculum, and faculty, but also for providing the impetus for such changes.

REFERENCES

Braskamp, L., and J. Ory. 1994. *Assessing faculty work*. San Francisco: Jossey-Bass.

Carroll, K., R. Sandell, and H. Jones. 1995. The professional art school: A notable site for the preparation of art teachers. In *Preservice art education: Issues and practice*, ed. L. Galbraith. Reston, Va.: National Art Education Association.

Clark, G. A., M. D. Day, and W. D. Greer. 1987. Discipline-based art education: Becoming students of art. *The Journal of Aesthetic Education* 21 (2): 129–98.

Day, M. 1993. Response II: Preparing teachers of art for tomorrow's schools. *Bulletin* [Council for Research in Music Education] 117 (summer): 126–35.

————. 1996. NAEA research task force on curriculum briefing paper on curriculum research. In *Art Education: Creating a visual arts agenda toward the twenty-first century*. Ed. National Arts Education Association Commission on Research in Art Education. Reston, Va.: National Art Education Association.

Davis, J. D. 1990. Teacher education in the visual arts. In *Handbook of research on teacher education*, ed. R. Houston. New York: Macmillan.

————. 1993. Art education in the 1990s: Meeting the challenges of accountability. *Studies in Art Education* 34 (2): 82–90.

Diamond, B., and A. Roberts. 1993. *Recognizing faculty work: Rewards systems for the year 2000*. New Directions for Higher Education, 81. San Francisco: Jossey-Bass.

DiBlasio, M. K. 1985. Continuing the translation: Further delineation of the DBAE format. *Studies in Art Education* 24 (4): 197–205.

Ducharme, E. 1993. *The lives of teacher educators*. New York: Teachers College Press.

Eads, H. 1990. Art teacher education programs in the United States. Ph.D. diss., Illinois State University, Normal.

Eisner, E. 1985. *The educational imagination.* 2d ed. New York: Macmillan.

Galbraith, L. 1991. Analyzing an art methods course: Implications for preparing primary student teachers. *Journal of Art and Design Education* 10 (3): 329–42.

———. 1993. Familiar, interactive and collaborative pedagogy: Changing practices in preservice art education. *Art Education* 46 (5): 6–11.

———. 1995. The preservice art education classroom: A look through the window. In *Preservice art education: Issues and practice,* ed. L. Galbraith. Reston, Va.: National Art Education Association.

———. 1996. Teacher education in the fine arts. In *The teacher educator's handbook: Building a knowledge base for the preparation of teachers,* ed. F. Murray. San Francisco: Jossey-Bass.

Guay, D. M. P. 1993. Cross-site analysis of teaching practices: Visual arts education with students experiencing disabilities. *Studies in Art Education* 34 (4)P: 222–32.

Hobbs, J. 1993. In defense of a theory of art education. *Studies in Art Education* 34 (2): 102–13.

Howey, K., and N. Zimpher. 1989. *Profiles of teacher education.* New York: State University of New York Press.

———. 1994. *Informing faculty development for teacher educators.* New Jersey: Ablex Publishing.

Jeffers, C. S. 1993. A survey of instructors of art methods classes for preservice elementary teachers. *Studies in Art Education* 34 (4): 233–43.

MacDonald, J. 1986. The domain of curriculum. *Journal of Curriculum and Supervision* 1 (3): 205–15.

May, W. T. 1989. Teachers, teaching, and the workplace: Omissions in curriculum reform. *Studies in Art Education* 30 (3): 142–56.

Murchison, E. M. 1989. *Visual arts education: A study of current practices in Louisiana.* Ph.D. diss., Louisiana State University and Agricultural College.

Murray, F., ed. 1996. *The teacher educator's handbook: Building a knowledge base for the preparation of teachers,* 3–13. San Francisco: Jossey-Bass.

Rogers, E. T. , and R. E. Brogdon. 1990. A survey of the NAEA curriculum standards in art teacher preparation programs. *Studies in Art Education* 31 (3): 168–73.

Roland, C. 1995. The use of journals to promote reflective thinking in prospective art teachers. In *Preservice art education: Issues and practice,* ed. L. Galbraith. Reston, Va.: National Art Education Association.

Schubert, W. H. 1986. *Curriculum: Perspective, paradigm, and possibility.* New York: Macmillan.

Sevigny, M. J. 1987. Discipline-based art education and teacher education. *The Journal of Aesthetic Education* 21 (2): 95–128.

Smith-Shank, D. L. 1982. Art attitudes, beliefs, and stories of pre-service elementary teachers. Ph.D. diss., Indiana University, Bloomington.

Susi, F. 1995. Developing reflective teaching techniques with preservice art teachers. In *Preservice art education: Issues and practice,* ed. L. Galbraith. Reston, Va.: National Art Education Association.

Willis-Fisher, L. 1991. A survey of the inclusion of aesthetics, art criticism, art history, and art production in art teacher education programs. Ph.D. diss., Illinois State University, Normal.

———. 1993. Aesthetics, art criticism, art history, and art production in art teacher preparation programs. *NAEA Advisory* [winter]. Reston, Va.: National Art Education Association.

Zimmerman, E. 1994. Current research and practice about pre-service visual art specialist teacher education. *Studies in Art Education* 35 (2): 79–89.

REFERENCE NOTES AND ACKNOWLEDGMENTS

Data included in Table 1 came almost exclusively from my searches on the Internet. I realize that data may be incomplete or are subject to revisions and change. Other institutions that are not represented in the table but whose Internet sites proved invaluable and have been mentioned in the text are Grand Valley State University in Michigan, Pennsylvania State University, University of Alabama–Huntsville, University of Florida, University of Georgia, and Western Washington University.

The small case studies were developed on the following institutions: Boise State University, Central Michigan University, Central Washington University, Indiana University of Pennsylvania, Middle Tennessee State University, Minot State University in North Dakota, Northern Illinois University, Northwestern University, Ohio State Campus at Lima, Plymouth State College in New Hampshire, Syracuse University, Western Michigan University, University of Idaho, University of Illinois at Urbana-Champaign, and the University of Nebraska at Omaha. I appreciate the E-mail and written correspondence that I received from faculty at these institutions.

Certification and Licensure Requirements for Art Education: Comparison of State Systems

Margaret Klempay DiBlasio
University of Minnesota

To gather information concerning certification and licensure is to confront the rich diversity of policies enshrined within state departments of education—policies that in the regulation of certification can be said to range from enlightened to embattled, from laissez-faire to obsessive-compulsive. When the area of certification being investigated happens to be the visual arts, the array of regulations can euphemistically be described, appropriately enough, as colorful. In a few certification offices, it seems, the tides of revolution that wash up against the visual arts pass virtually unnoticed; a few others seem consumed by the passion to keep abreast of the very newest wrinkles in the fabric of education, together with their attendant jargon. Between these extremes one often finds evidence of inventiveness in cobbling together requirements for art education certification.

In the conduct of this survey, inquiries were sent to the state licensing and certification offices of all fifty states, as well as to the District of Columbia and the U.S. Department of Defense Office of Dependents Schools. A letter was sent in June of 1995 requesting a copy of each state's certification and licensure requirements for art education, from kindergarten to twelfth grade, together with any explanatory materials describing the certification/licensure policy. If changes to the requirements were currently underway, drafts were requested of the new policies being considered, in addition to the current policy. The state offices were informed that data from all the states was being compiled for analysis with a view

to facilitating the improvement of art teacher preparation. Of these fifty-two offices, fifty responded (96 percent), though with widely varying degrees of specificity. The general survey summary chart (Table 1) illustrates this range of specificity in the information these offices provided regarding certification requirements in 1995 for art education licensure and for general professional foundations, as well as for pre-professional testing. Because not all respondents provided a comprehensive description of certification requirements, the survey should be regarded as a comparison limited by the information provided by the respondents.

GENERAL INFORMATION REGARDING CERTIFICATION REQUIREMENTS

Application Form or Certification Requirements

In the "A/R" column of the general survey summary chart (Table 1), five states (10 percent) are labeled "A," indicating that they responded by providing nothing more than application forms for certification, which forms provided no indication of certification requirements specific to art education. The remaining forty-five respondents (90 percent), labeled "R," did indicate art education certification requirements in some way. Some were quite specific in identifying art education coursework or competencies; others indicated general areas of instruction and preparation. In some cases, general requirements for art education certification were stated in, or could be deduced from, the application materials provided. Two states, Louisiana and New Jersey, accounting for 4 percent of the respondents, provided application materials from which no information could be gleaned regarding certification standards beyond the requirement of general professional and content-specific tests. In light of this response, the total percentage of response in columns three through seven does not exceed 96 percent.

Kindergarten through Twelfth-Grade Certification

In the "K–12" column (Table 1), forty (80 percent) of the respondents state that K–12 certification/endorsement in art education is available and indicate requirements for it. Ten respondents (20 percent), labeled "?", do not mention K–12 certification/endorsement in art education, or do not differentiate between levels of certification, or leave some doubt concerning whether elementary and/or secondary certification are subject to K–12 endorsement.

ART-RELATED REQUIREMENTS FOR CERTIFICATION

Completion of Approved Teacher Education Program Only

In the "teacher education program only" column (Table 1), ten respondents (20 percent) are identified as requiring only that applicants have completed a teacher education program at an "approved" institution of higher learning, without specifying coursework or areas of study or total credit hours required for certification. Beyond each of these states' designation of approved institutions and teacher education programs within their borders, alternative means of qualification are noted: completion of a teacher education program with either NCATE or NASDTEC approval, or completion of a program approved by another state with which the respondent has established a reciprocal agreement. California accepts completion of a teacher education program, provided that it is a *single-subject* program. Otherwise, a degree in professional education is not acceptable within California unless the program includes subject matter coursework equivalent to that required of majors in a subject other than education.

Requirement of Total Number of Semester Hours Only

In the "hours only" column of the chart (Table 1), twelve respondents (24 percent) identify a total number of hours of art-related coursework required for art education certification, without further specification of how these hours are to be allocated among areas of study or particular coursework.

- Arizona requires a thirty-semester-hour art major for secondary certification or an eighteen-semester-hour content area for K–8 certification; either certificate can have a K–12 endorsement.
- Connecticut requires thirty semester hours in art (unspecified) and nine semester hours in (unspecified) directly related subjects.
- Idaho requires twenty semester hours in art department coursework (unspecified).
- Maryland requires thirty-six semester hours (twelve hours upper division) of (unspecified) art content.
- Michigan requires a thirty-semester-hour major or a thirty-six-semester-hour "group" major in art.
- New Mexico requires twenty-four to thirty-six semester hours in art (unspecified), including twelve hours of upper-division credit.
- New York requires thirty-six semester hours in art (unspecified).

TABLE 1.
General Survey Summary Chart

State	A/R	K-12	Teacher Education Program Only	Hours Only	General Areas	Specific Areas or Courses	Detailed Requirements	Competency-Based	Studio Arts	Art History	Art Criticism	Art Theory/Aesthetics	Related Arts	Art Ed. Methods	General Foundations	Clinical Experience	Professional Educ. hrs. only	General Professional Tests	Content-Specific Tests
					Art-Related Requirements									Professional Education Requirements				Tests	
Alabama	R	■	■																
Alaska	R	■	■																
Arizona	R	■		■											■	■			
Arkansas	R	■			■				■	■						■			
California	R	?	■											■		■		■	■
Colorado	R	■	■															■	■
Connecticut	R	■		■										■	■	■		■	■
Delaware	R	■				■			■	■		■						■	■
Florida	R	■				■			■	■	■	■			■	■		■	
Georgia	R	?				■			■	■	■								
Hawaii	R	■	■															■	■
Idaho	R	■		■										■				■	

State	A/R	K-12	Art-Related Requirements											Professional Education Requirements				Tests	
			Teacher Education Program Only	Hours Only	General Areas	Specific Areas or Courses	Detailed Requirements	Competency-Based	Studio Arts	Art History	Art Criticism	Art Theory/ Aesthetics	Related Arts	Art Ed. Methods	General Foundations	Clinical Experience	Professional Educ. hrs. only	General Professional Tests	Content-Specific Tests
Illinois	R	■				■			■	■				■				■	■
Indiana	R	■				■			■	■				■				■	■
Iowa	R	■			■				■	■									
Kansas	R	■					■	■	■	■	■	■		■					
Kentucky	R	■			■					■				■		■			
Louisiana	A														■			■	■
Maine																			
Maryland	R	■		■										■	■			■	■
Massachusetts	R	?					■	■	■	■		■		■		■		■	■
Michigan	R	■		■															
Minnesota	R	■					■	■	■	■	■	■		■	■	■			
Mississippi	A	?	■			■													
Missouri	R	■							■	■	■	■		■	■	■		■	■
Montana	R	■					■	■	■	■	■	■		■				■	

TABLE 1 (continued).
General Survey Summary Chart

State	A/R	K-12	Teacher Education Program Only	Hours Only	General Areas	Specific Areas or Courses	Detailed Requirements	Competency-Based	Studio Arts	Art History	Art Criticism	Art Theory/Aesthetics	Related Arts	Art Ed. Methods	General Foundations	Clinical Experience	Professional Educ. hrs. only	General Professional Tests	Content-Specific Tests
Nebraska	R	■			■				■	■	■	■				■			
Nevada	R	■				■			■	■		■		■	■	■		■	■
New Hampshire	R	■				■			■	■	■			■		■			
New Jersey	A																	■	■
New Mexico	R	■		■											■		■	■	■
New York	R	?		■											■		■	■	
North Carolina	A	■	■															■	■
North Dakota	R	?	■	■												■			
Ohio	R	■														■	■	■	■
Oklahoma	R	■				■			■	■									■
Oregon	R	■			■				■	■						■		■	■
Pennsylvania																			

State	A/R	K-12	Teacher Education Program Only	Hours Only	General Areas	Specific Areas or Courses	Detailed Requirements	Competency-Based	Studio Arts	Art History	Art Criticism	Art Theory/Aesthetics	Related Arts	Art Ed. Methods	General Foundations	Clinical Experience	Professional Educ. hrs. only	General Professional Tests	Content-Specific Tests
Rhode Island	R	■				■			■	■				■	■	■		■	
South Carolina	R	■				■			■	■				■				■	■
South Dakota	R	■		■															
Tennessee	A	■	■														■	■	■
Texas																			
Utah	R	■				■	■		■	■	■			■	■				
Vermont	R	?				■		■	■	■	■			■					
Virginia	R	■	■											■	■	■		■	
Washington	R	■		■															
West Virginia	R	■	■																■
Wisconsin	R	■		■										■	■	■		■	
Wyoming	R	■					■	■	■	■		■	■	■	■	■			
Washington, D.C.	R	■				■				■				■	■	■		■	
Dept. of Defense	R					■			■	■				■	■	■		■	

- North Dakota requires twenty-six semester hours of subject area (unspecified) for secondary certification or thirty-four semester hours of subject area (unspecified) for elementary certification; no K–12 certification is mentioned.
- Ohio's current policy requires forty-five semester hours in art (unspecified). The proposed revision, based on general performance-based standards, specifies only an academic major in art or its equivalent.
- South Dakota requires eighteen semester hours of art courses (unspecified).
- Washington requires sixteen semester hours of study in art (unspecified).
- Wisconsin requires a fifty-four-semester-hour major in art (unspecified).

Requirement of General Areas of Coursework

The "general areas" column (Table 1) lists five respondents (10 percent) whose requirements for certification in art education do not go beyond the identification of general areas of art-related coursework.

- Arkansas requires eighteen semester hours of studio courses and three semester hours in art history.
- Iowa requires twenty-four semester hours in art, to include studio art—two-dimensional and three-dimensional—and art history.
- Kentucky requires a forty-eight-semester-hour art concentration or a thirty-semester-hour teaching major in art distributed among two-dimensional design, three-dimensional design, drawing, painting, and art history.
- Nebraska requires fifty-four semester hours distributed among art production, art history, aesthetics, and art criticism.
- Oregon requires twenty-seven quarter hours in studio production and basic design and eighteen quarter hours in historical, cultural, and appreciative aspects of art.

Requirement of Specific Areas or Courses

In the "specific areas or courses" column (Table 1), fourteen respondents (28 percent) identify the course areas or courses with more specificity than in the previous column.

Delaware requires thirty-six semester hours, including a minimum of two courses in each of the following three areas:

- drawing; painting; design; graphics, printmaking, related processes
- three-dimensional arts and crafts, including ceramics
- history and/or aesthetics

Florida requires thirty semester hours, including:
- two-dimensional art (twelve hours)
- three-dimensional art (three hours)
- art history (six hours)
- aesthetics or art criticism (three hours)

Georgia requires fifty quarter hours including:
- art production: two-dimensional and three-dimensional art, drawing, and design (thirty-five hours)
- art history/art criticism (fifteen hours)

Illinois requires twenty-four semester hours with appropriate distribution in:
- painting/drawing/printmaking
- sketching/lettering/jewelry/design/silk screen
- pottery/sculpture/constructional design
- history and appreciation of art

Indiana requires fifty-two semester hours, including:
- two-dimensional problems
- three-dimensional problems
- art history and appreciation
- related electives

Missouri requires twenty-eight semester hours, including:
- design/composition (2 hours)
- two-dimensional art: drawing/painting/graphics (seven hours)
- three-dimensional art: ceramics/sculpture/fibers (seven hours)
- history, theory, and criticism in the visual arts (three hours)
- electives (9 hours)

Nevada requires a comprehensive major in art (thirty-six semester hours), including:
- studio courses in fine art/drawing/composition/applied arts/painting/sculpture/crafts/graphic art
- art history
- philosophy of art
- principles of art
- art appreciation

New Hampshire requires courses in the following:
- visual arts forms including drawing, painting, sculpture, printmaking, and crafts
- personal art development (portfolio)
- elements and principles of art
- diverse techniques and skills
- art history/art appreciation
- criticism of visual arts works
- understanding and appreciation of other arts

Oklahoma requires:
- a minimum of three semester hours in drawing, color and design, painting, crafts, and art history
- a minimum of two semester hours in sculpture, printmaking, and ceramics
- art electives to complete a total of forty semester hours

Rhode Island requires thirty-six semester hours, including:
- two courses in art history
- studio courses in at least seven of nine areas: drawing, painting, design, ceramics, sculpture, printmaking, crafts, photography, and metals

South Carolina requires:
- courses in basic techniques of design and color (six semester hours)
- work stressing drawing and painting, using as many media as possible (six semester hours)
- crafts (three semester hours)
- art history/appreciation (six semester hours)

Vermont requires the following areas of competence:
- principles of art
- expertise in one of the following areas: architecture, crafts, drawing, graphics, painting, photography, printing, or sculpture
- demonstration of one area of visual arts expertise
- technology in the visual arts
- art in contemporary and past cultures
- aesthetic theory

District of Columbia requires forty-two semester hours, including:
- studio courses chosen from the following: design, drawing, painting, printmaking, commercial art, ceramics, art technology,

sculpture (twenty-one hours with a maximum of three hours in each area)
- studio courses chosen from the following: jewelry, fiber art, stained glass, other crafts (six hours)
- courses in one specialized art area (six hours)
- art history / appreciation (nine hours)

In addition, a portfolio review by an art specialist from the District of Columbia schools is required.

Department of Defense Schools require (K–8 certification) eighteen semester hours, including:
- at least one course in drawing
- at least one course in painting
- at least one course in art history or appreciation

Detailed Requirements for Certification

In the "detailed requirements" column (Table 1), seven respondents (14 percent) set forth their requirements with greater detail and specificity than those respondents cited in the previous columns.

Kansas, in its current certification policy, requires demonstration of the following competencies:
- skill in producing art in two-dimensional and three-dimensional media
- working knowledge of the elements and principles of design
- skill in use of art materials and equipment
- integrating knowledge of Western art history with the other arts
- awareness of art in past and contemporary cultures, worldwide
- appreciation of a variety of art forms
- ability to express a clear philosophy of art education
- ability to analyze and interpret art processes and products

In a contemplated revision of its certification policy, Kansas replaces the above requirements with a proposed schema for outcome-based licensure which focuses on ability to integrate the curriculum.

Maine requires thirty-six semester hours, including the following:
- design, drawing, painting, sculpture, printmaking (three hours each)
- one elective in another medium
- art concentration: a minimum of six hours beyond the introductory level in one discipline

- survey of art (six hours)
- advanced art history, art criticism, philosophy, or aesthetics of art forms (six hours)

Massachusetts requires demonstration of competency in the following areas:

- fundamental elements of art
- color theory
- two- and three-dimensional design
- technical art
- use of traditional studio material
- current and new art media
- various cultural art heritages and evaluation of civilizations
- aesthetic theory, including theory of aesthetic value and meaning
- relationships among the arts and other disciplines

Minnesota requires that studio, art history, aesthetics, and art education courses constitute at least 40 percent of the baccalaureate program. Coursework in six or more diverse studio areas is required, with emphasis in at least two areas. Additionally, Minnesota requires demonstration of competency in the following areas:

- proficiency in a diversity of media and skills
- communication and use of two- and three-dimensional elements and principles
- knowledge of past and contemporary theories of art
- broad knowledge of historical, critical, and research skills in at least one period of art history
- understanding the philosophic positions of leading art philosophers and artists

Montana requires a demonstration of competency in the following areas:

- skills in vocabulary in art production
- production of original and expressive art forms in a variety of media
- technological, health, and safety aspects of studio work
- skills in vocabulary of art history
- iconographic and chronological context of art as part of the cultural legacy
- ability to perceive, describe, interpret, and evaluate one's own work and the work of others
- skills in art criticism: understanding and responding to art in form and content

- relationship of art to contemporary and past cultures
- skills and vocabulary in aesthetic awareness and discriminate sensory intake
- philosophical, social, and aesthetic aspects of art and its value to individual and society
- understanding and appreciation of other arts in relationship to visual arts

Utah requires a total of seventy quarter hours in art, including the following:
- two-dimensional art chosen from design or composition,* drawing,* painting,* watercolor, acrylics or oil painting, printmaking, commercial art, color theory, or photography (nine hours minimum)
- three-dimensional art chosen from ceramics,* jewelry,* fine crafts,* sculpture, or fiber (nine hours minimum)
- art history/art criticism chosen from modern,* ancient, European, non-European art history, as well as art criticism* (nine hours minimum)
- remaining quarter hours are elective

Courses followed by an asterisk are of critical importance.

Wyoming requires demonstration of competency in the following areas:
- elements and principles of design
- basic concepts and skill processes
- creation of various art forms
- technological developments in environmental and functional design
- historical aspects of art
- critiquing artwork
- philosophies of art
- psychological and sociological aspects of art
- interrelating art with other disciplines
- knowledge and appreciation of related arts areas

Competency-Based Requirements

In the "competency-based requirements" column (Table 1), six respondents (12 percent) are identified as setting forth requirements for certification in a competency-based format. The competency requirements for these six states (Kansas, Massachusetts, Minnesota, Montana, Vermont, and Wyoming) are summarized in the state descriptions provided in the two previous sections. It can be noted that no

uniform usage appears to have emerged in the formulation of competency-based certification requirements; it is often difficult to estimate the level of proficiency that is contemplated within a particular standard, and some of the competency areas are too vaguely defined to provide direction for teacher preparation.

Listing of Specific Studio Arts Requirements

In the "studio arts" column (Table 1) are identified twenty-six respondents (52 percent) who specify to some degree the particular studio art coursework and/or competencies that are required for certification. Additionally, it can be assumed that the eleven respondents identifying only completion of an approved teacher education program as a requirement for certification (column 3) equivalently require the studio art courses/competencies that have been mandated within approved art education programs. Similarly, respondents characterized as identifying total hours of instruction only or general areas of instruction (columns 4 and 5) do require art-related coursework/competencies, although these are described in general terms.

Listing of Specific Art History Requirements

As is the case in studio arts, the "art history" column (Table 1) identifies twenty-six respondents (52 percent) who specify to some degree the particular art history coursework and/or competencies that are required for certification. Note that the eleven respondents identifying only completion of an approved teacher education program as a requirement for certification (column 3) may in effect be requiring the art history courses/competencies that are mandated within approved art education programs.

Listing of Specific Art Criticism Requirements

The "art criticism" column (Table 1) identifies eleven respondents (22 percent) who specify to some degree the particular art criticism coursework and/or competencies they require for certification. Additionally, one can only speculate whether any of the eleven respondents identifying only completion of an approved teacher education program as a requirement for certification (column 3) would equivalently be requiring any art criticism courses/competencies that might be incorporated within approved art education programs.

Listing of Specific Art Theory/Aesthetics Requirements

In the "art theory/aesthetics" column (Table 1) are identified eleven respondents (22 percent) who specify to some degree the particular art theory/aesthetics coursework and/or competencies that are required for certification. As is the case in art criticism, it is possible that some of the eleven respondents identifying only completion of an approved teacher education program as a requirement for certification (column 3) might in effect be requiring art theory/aesthetics courses or competencies that might be incorporated within approved art education programs.

Listing of Specific Related Arts Requirements

The "related arts" column (Table 1) lists five respondents (10 percent) who specify the related arts competencies required for certification. Additionally, some of the ten respondents identifying only completion of an approved teacher education program as a requirement for certification (column 3) might in effect be requiring related arts courses or competencies incorporated within approved art education programs.

- Kansas requires "integrating knowledge of Western art history with the other arts such as literature, drama and dance."
- Massachusetts requires demonstrating knowledge of "the relationships among the arts and of the arts to other fields of knowledge."
- Montana requires applicants to "develop an understanding and appreciation of related fine art areas of dance, film, music, literature, theater, and the applied arts, and of their relationship to the visual arts."
- New Hampshire requires that "the program shall provide opportunities to develop the student's understanding and appreciation of the other arts including dance, film, music, literature, theater, and practical arts."
- Wyoming states that "the program shall require knowledge and appreciation of related art areas."

Summary of Art-Related Requirements

The eleven categories of art-related requirements discussed above are summarized by percentage in Table 2.

TABLE 2.

Percentage of Respondents in Each Art-Related Requirements Category

		Art-Related Requirements										
A/R	K–12	Teacher Education Program Only	Hours Only	General Areas	Specific Areas or Courses	Detailed Require-ments	Compe-tency-Based	Studio Arts	Art History	Art Criticism	Art Theory/ Aesthetics	Related Arts
10% A ---- 90% R	80%	20%	24%	10%	28%	14%	12%	52%	52%	22%	22%	10%

PROFESSIONAL EDUCATION REQUIREMENTS

Professional education coursework and experience are important factors in requirements for art education certification. Foundational courses broaden the horizon of the art education student, establishing a context in which art-related concepts and issues can be invested with broader meaning and set into place against the background of the sciences and the humanities. These courses also help art education students locate themselves within the arena of pedagogy.

The variety of coursework, which is summarized here under the heading "Art Education Methods," embraces such studies as curriculum theory and development in the arts, human development in art, art for special populations, art teaching methodology, art classroom management, health and safety measures specific to the art classroom, research in art education, and the history of art education. The effect of these "methods" studies is to particularize broad conceptions of art and learning and general skills and appreciation in the visual arts, so that theory is set on the path to educational practice.

Clinical experiences of various sorts, observation, internship, case studies, peer mentoring, and student teaching usher students into the real world of art education and eventually provide opportunities for them to test themselves against the demands of that world.

Art Education Methods Requirements

In the "art education methods" column (Table 1), twenty-one respondents (42 percent) make explicit mention of the "art methods" grouping of coursework and specify courses and/or hours required in this category. Note that the ten respondents (20 percent) identifying only completion of an approved teacher education program as a requirement

for certification (column 3) may equivalently require the art methods courses that are incorporated within approved art education programs. Similarly, respondents characterized as identifying total hours of professional education only could be including art education methods courses within those hours.

- States requiring coursework in art curriculum and methods of teaching art:
 Connecticut
 Kentucky
 Maine (including methods of program evaluation)
 Montana
 Utah (three quarter hours)
 Vermont

- States requiring both elementary and secondary art methods courses:
 Arkansas
 Florida (four semester hours)
 Indiana

- States requiring either an elementary or a secondary art methods course:
 Nevada
 Rhode Island (one course)

- Requiring an elementary art methods course:
 Idaho (one course)
 Missouri (two semester hours)
 Department of Defense Schools (one course)

- Requiring coursework in art program development and art curriculum:
 New Hampshire
 South Carolina (three semester hours)

- Requiring unspecified art education courses:
 Illinois

Four respondents, stating competency-based requirements for certification, are more detailed in identifying "art methods."

Kansas requires the following:
- awareness of the history of art education, current trends in art education, current research, and resources in art education
- skill in writing art curricula and lesson plans

- strategies to elicit creative behaviors
- understanding of state and local government processes as they apply to art education

Massachusetts requires the following:
- integration of theory and practice in teaching critical/historical/ expressive/technical areas to students with or without special needs
- expertise in writing art curriculum and in the integration of art with other disciplines
- expertise in exhibition and presentation of art to diverse audiences

Minnesota requires the following:
- working knowledge of past and contemporary theories of art education
- commitment as an advocate of creativity
- knowledge of visual/emotional/physical growth patterns
- skill in budgeting an art program and managing art classroom procedures
- understanding and promoting the interdisciplinary relationship of art to other curricular areas
- developing evaluation techniques for art education
- knowing appropriate behavior and art products for various stages of development
- utilizing human and community resources for the art program
- developing a variety of art curricula for various levels and settings
- effectively using research procedures in art education
- knowledge of safety regulations for the art classroom
- relating art education to the total life experience of all students

Wyoming requires the following:
- interrelating art with other school disciplines
- developing art curriculum
- assessing and evaluating an art program
- methods of organizing, planning for, procuring for, and administering an art education program

General Foundations Requirements

The "general foundations" column (Table 1) lists fifteen respondents (30 percent) who identify particular coursework in various areas of foundational study as a requirement for certification. Additionally, it can be assumed that the ten respondents (20 percent) identifying only

completion of an approved teacher education program as a requirement for certification (column 3) may equivalently require the foundations courses that have been mandated within approved art education programs. Similarly, respondents characterized as identifying total hours of professional education only could be including general foundation courses within those hours.

For the purposes of this survey the requirements are grouped, as shown in Table 3, in nine categories of foundational study.

TABLE 3.
Number of Respondents in Each General Foundational Course Category

General Foundational Course	Number of Respondents Requiring Course
social/philosophical foundations	10
psychological foundations (including learning and human development)	12
social psychology/human relations	1
generic curriculum theory	8
generic teaching methodology	9
public law/school policy	4
measurement/assessment	4
diverse populations/special needs	7
information media	1

In addition, two states require coursework in the teaching of reading within content areas. Another state adds to its foundational requirements coursework in environmental education and education for employment.

Of the number of respondents (twenty-seven) who listed professional education requirements, six (22 percent) identified only general foundational course requirements without mentioning art education professional methods courses.

Clinical Experience Requirements

The "clinical experiences" column (Table 1) lists twenty-three respondents (46 percent) who make reference to various forms of clinical experience, including field observations, internships, and student teaching. It can be assumed that the ten respondents (20 percent) identifying only completion of an approved teacher education program as a

requirement for certification (column 3) would require clinical experiences as a component of an approved art education program. Similarly, respondents characterized as identifying total hours of professional education would also include clinical experiences within those hours.

As is noted in Table 4, eight respondents indicated the duration of the clinical student teaching experience; six respondents included a requirement for clinical student teaching experience with no specification for length of time required; and nine respondents specified the duration and/or level for both supervised field observations and clinical student teaching experiences.

TABLE 4.

Respondents in Each "Clinical Experiences" Category

Student Teaching Semester Hours or Duration	Student Teaching Listed as a Requirement with No Time Specification	Supervised Observation and Student Teaching	
Arizona (8 semester hrs.)	Arkansas (elementary and secondary)	Kentucky (150 clock hrs.)	Kentucky (12 weeks)
Florida (6 semester hrs. of student teaching or supervised internship)	California Maryland	Connecticut - (total of 6–12 hrs. for both) Maine (early and on-going)	Connecticut (total of 6–12 hrs. for both) Maine (15 weeks)
Nebraska (200 clock hrs., elementary; 200 clock hrs., secondary)	Virginia Wyoming Department of Defense	Massachusetts (75 clock hrs.)	Massachusetts (150 clock hrs.)
Nevada (8 semester hrs.)	Schools	Minnesota (all levels)	Minnesota (1 quarter, full days, elementary and secondary)
North Dakota (10 weeks)		Missouri (2 semester hrs.)	Missouri (8 semester hrs., elementary and secondary)
Oregon (15 weeks)		New Hampshire (unspecified hrs.)	New Hampshire (elementary and secondary, unspecified hrs.)
Rhode Island (6 semester hrs., combined elementary and secondary)		Ohio (elementary and secondary, unspecified hrs.)	Ohio (elementary and secondary, unspecified hrs.)
Wisconsin (5 semester hrs.)		District of Columbia (80 clock hrs.)	District of Columbia (120 clock hrs.)

Requirement Only of Total Hours of Professional Education

In the "professional education hours only" column (Table 1), five respondents (10 percent) identify a professional education coursework requirement solely by the total number of credit hours, without specification of the courses or content.

- Nevada requires fourteen semester hours of professional education (unspecified) in addition to the student teaching requirement.
- New Mexico requires twenty-four to thirty-six semester hours of professional education (unspecified).
- New York requires twelve semester hours of professional education (unspecified).
- Ohio requires thirty semester hours of professional education (unspecified).
- Tennessee requires six semester hours of professional education (unspecified).

TESTING REQUIREMENTS

General Professional Testing Requirement

The "general professional tests" column (Table 1) identifies twenty-eight respondents (56 percent) who have stated that they require some form of a general professional test for certification. The most commonly used test is the NTE (National Teacher Examination) Core Battery; nineteen respondents use either the entire battery—communications, general knowledge, and professional knowledge (PPST)—or the PPST component alone. The CBT (Computer-based Academic Skills Assessment) portion of the PRAXIS I Test is required by two respondents.

A number of respondents have developed their own proprietary tests. California uses C BEST, the California Basic Educational Skills Test; this test is also used in Oregon. Colorado has developed PLACE, Program for Licensing Assessments for Colorado Educators, which includes a basic skills assessment, a liberal arts and science assessment, and a professional knowledge assessment. Illinois uses ICTS, Illinois Certification Testing System, a state system for assessing basic skills. Massachusetts employs a state certification exam in communication and literary skills. Wisconsin uses its own state certification exam. New York is in the process of developing a proprietary testing system to replace the NTE Core Battery.

Content-Specific Testing Requirement

The "content-specific tests" column (Table 1) identifies twenty-two respondents (44 percent) who require a content-specific test in art education for certification. Thirteen of these respondents, as noted in Table 5, identify the NTE Specialty Area Test in Art Education, with minimum scores ranging from 450 to 530.

TABLE 5.

Respondents Requiring the NTE Specialty Area Test in Art Education

State	Required Scores
Arkansas	450
Hawaii	530
Indiana	not specified
Louisiana	not specified
Maryland	510
Mississippi	530
Missouri	500
Nevada	not specified
New Jersey	530
New Mexico	not specified
North Carolina	530
South Carolina	500
Tennessee	530

Two respondents (California and Connecticut) employ the PRAXIS II series subject assessment in art, which includes assessments in art education; in art making; and in content, traditions, aesthetics, and criticism. In the art education component, California requires a score of 620 and Connecticut a score of 580. In the art-making component, California requires 171 and Connecticut 148. In the component assessing content/traditions/aesthetics/criticism, California requires 160 and Connecticut 130.

Four respondents have developed proprietary content-specific tests for art education licensure. Colorado requires a PLACE content assessment in art. Illinois requires an ICTS subject-matter test for art. Massachusetts requires its own subject-matter certification examination in art. Oklahoma requires a state-developed teacher certification test in art. In addition, Ohio requires an unspecified content-specific test in art.

CONCLUSIONS OF THE SURVEY

Twenty percent of the respondents in this survey (Table 2) are willing to defer to NCATE and NASDTEC standards for certification in setting their policies. Another 24 percent (Table 2) commit themselves

only to total hours of unspecified art-related coursework An additional 10 percent (Table 2) identify only general areas of study within the art-related coursework requirement. Thus, 54 percent of the respondents do not offer state-originated detailed specifications of content in preservice art education; accordingly, they have no means of securing a balance among the disciplines of art study.

Of the twenty-one respondents (42 percent) (Table 2, columns 6 and 7) who do identify particular course or subject area requirements for certification, six respondents (Table 2, column 8) formulate their requirements as detailed competencies which address art studio, art history, and art criticism; five of the six also address aesthetics. Fourteen of the remaining fifteen respondents in this group stipulate particular groupings of coursework only within the studio arts area. The other respondent in this group, Utah, does differentiate coursework requirements in art history.

Forty-two percent of the respondents (Table 6, column 1) explicitly require coursework in art education methods. However, only four of the respondents (8 percent), all employing competency-based requirements, stipulate in detail what is to be accomplished in the "art methods" group of coursework. The other 36 percent merely mention an art methods requirement.

Thirty percent of the respondents (Table 6, column 2) identify particular coursework in foundational study of education as a requirement. Of particular interest to art education are the requirements in general curriculum study (16 percent), generic teaching methodology (18 percent), and diverse populations/special needs (14 percent) (see Table 3), which support the movement in art education toward integration of the visual arts in the general curriculum.

Although 46 percent of the respondents (Table 6, column 3) refer to forms of clinical experience, the disparity among requirements is noteworthy. Only nine respondents (18 percent) (see Table 4) specify early

TABLE 6.

Percentage of Respondents in Each
Professional Education Requirements Category

Professional Education Requirements				Tests	
Art Ed. Methods	General Foundations	Clinical Experience	Professional Educ. Hrs. Only	General Professional Tests	Content-Specific Tests
42%	30%	46%	20%	56%	44%

field experience, such as supervised observation, prior to student teaching. Given the national trend toward certification testing, it is not surprising that 56 percent (Table 6, column 5) of the respondents require a general professional test; it is noteworthy that 44 percent (Table 6, column 6) also require a content-specific test in art and/or art education.

DISCUSSION OF ISSUES

These requirements, collected in mid-1995, have undoubtedly changed somewhat during the past year. However, the wide disparity in certification policies raises some important questions concerning the preparation of art teachers for American schools. Issues related to who sets the professional standards for preservice education, how the certification standards are enforced within licensing institutions, and what kinds of knowledge and professional experience are deemed necessary for the preservice education of art teachers need to be revisited within professional organizations and to be addressed by state licensing and teacher groups. As the politics of control is played out in state after state, some developments—such as experiments in laissez-faire and interdisciplinary planning—could be jeopardizing the quality of art programs.

Traditionally, licensure is issued by the state as confirmation that all the requirements have been met for competence in teaching, whereas certification refers to completing the requirements (course requirements, competencies, internships, etc.) set by teacher education programs within institutions of higher learning. This distinction is blurred somewhat whenever a state board of teaching (BOT) defers to the judgment of teacher-training programs in granting licenses in a particular state. The functional merger of licensure and certification poses no problems, provided that teacher education programs are designed according to standards of quality in preparing licensure students for effective teaching, that careful monitoring of initial licensure programs (ILPs) is done in order to maintain quality control, and that good communications and a close working relationship are maintained between the BOT and the teacher-training institutions. Communication and collaboration are particularly challenged in states recognizing alternative forms of licensure that circumvent college and university systems.

Lacking collaborative quality-control efforts between professional art educators, state education agencies, and faculties at teacher-training institutions, there may be wide variations in competence among teachers attaining licensure. These variations might be expected in the 54 percent of responding states which do not offer state-originated detailed

specifications of content in preservice art education. In this scenario, teacher education programs with underprepared faculty may not have the motivation or resources to maintain a quality program of instruction—yet their graduates would receive the same state licensure that is bestowed on students from more demanding, higher-quality programs.

Given the disparity of quality among certification programs and licensing standards in many states, there is bound to be difficulty in generating regional guidelines that reflect the National Board Standards for art education, or in developing and implementing a more comprehensive approach to visual arts education, such as is presented by a discipline-based approach to art education (DBAE). Both of these outcomes depend on collaboration for their viability in maintaining coherent measures of quality. In other words, a laissez-faire attitude tends to generate an inhospitable climate for DBAE and promulgation of standards. To recapitulate, state certification standards can either help or hinder efforts to improve art teacher preparation. Specific professional teaching standards, conceptually coherent and adequately articulated, reinforce strivings for quality, whereas vague requirements and mere listings of credit hours to be amassed invite programs to follow an efficiency model without adequate regard for consequences in the field.

The establishment of a National Board for Professional Teaching Standards presents an additional opportunity to engage in meaningful discourse about quality in education, focusing on effective teaching and collaborative quality-control efforts shared among professional educators, state education agencies, and faculties at teacher-training institutions. Other developments reinforce a striving for quality. For example, the Holmes Group recommends a focus on developing the reflective practitioner. Given that effective licensure and certification practices need to evolve in order to maintain relevance, teacher-training institutions and state agencies have a responsibility to participate in these promising initiatives. Licensure and certification are not meant to enshrine the past; they are best conceived as mechanisms to construct the future.

■ ■ ■

State Certification Offices

Division of Professional Services
5108 Gordon Persons Bldg.
50 North Ripley Street
Montgomery, Alabama 36130-3901

Department of Education
Teacher Education and Certification
801 West 10th Street, Suite 200
Juneau, Alaska 99801-1894

Teacher Certification Unit
Department of Education
1535 West Jefferson, Room 126
Phoenix, Arizona 85007

Teacher Education and Certification
Department of Education
No. 4 Capitol Mall, Rooms 106B-107B
Little Rock, Arkansas 72201-1071

State Department of Education
Commission on Teacher Credentialing
Box 944270
1812 9th Street
Sacramento, California 94244-2700

Teacher Certification
Department of Education
201 East Colfax Avenue, Room 105
Denver, Colorado 80203-1799

Bureau of Certification
State Department of Education
P.O. Box 2219
Hartford, Connecticut 06145

Department of Public Instruction
Office of Certification
Townsend Building, P.O. Box 1402
Dover, Delaware 19903

Teacher Certification
District of Columbia Public Schools
215 G Street NE, Suite 101A
Washington, D.C. 20002

Department of Teacher Certification
325 West Gaines Street
Room 203
Tallahassee, Florida 32399-0400

State Department of Education
Professional Standards Commission
1452 Twin Towers East
Atlanta, Georgia 30334

State Department of Education
Office of Personnel Services
P.O. Box 2360
Honolulu, Hawaii 96804

State Department of Education
Teacher Education and Certification
P.O. Box 83720
Boise, Idaho 83720-0027

State Department of Education
Teacher Certification Board
100 North First Street
Springfield, Illinois 62777-0001

Indiana Professional Standards Board
251 East Ohio, Suite 201
Indianapolis, Indiana 46204-2133

Board of Educational Examiners
Practitional Preparation and
 Licensure Bureau
Grimes State Office Building
Des Moines, Iowa 50319-0146

State Department of Education
Certification Office
120 East 10th Avenue, 652 ED
Topeka, Kansas 66612-1182

State Department of Education
Division of Certification
500 Mero Street, 18th Floor CPT
Frankfort, Kentucky 40601

State Department of Education
Bureau of Higher Education and
 Teacher Certification
P.O. Box 94064
Baton Rouge, Louisiana 70804-9064

Department of Education
Division of Certification and Placement
State House Station No. 23
Augusta, Maine 04333

State Department of Education
Division of Certification and Accreditation
200 West Baltimore Street
ATTN 18100
Baltimore, Maryland 21201-2595

Division of Educational Personnel
Teacher Certification
350 Main Street
Malden, Massachusetts 02148-5023

Teacher/Administrator Certification Services
Michigan Department of Education
P.O. Box 30008
Lansing, Michigan 48909

State Department of Education
Personnel Licensing
550 Cedar Street
St. Paul, Minnesota 55101

State Department of Education
Division of Teacher Certification
P.O. Box 771
Jackson, Mississippi 39205-0771

Teacher Certification Office
Department of Elementary and
 Secondary Education
P.O. Box 480
Jefferson City, Missouri 65102-0480

Office of Public Instruction
Teacher Education and Certification
Capitol Building
Helena, Montana 59620

Department of Education
Teacher Education and Certification
301 Centennial Mall South
Box 94987
Lincoln, Nebraska 68509-4987

Department of Education
State Mail Room
1850 E. Sahara, Suite 200
Education Administration 9003
Las Vegas, Nevada 89158

Bureau of Teacher Education and
 Professional Standards
State Office Park South
101 Pleasant Street
Concord, New Hampshire 03301-3860

Department of Education
Division of Teacher Preparation and Certification
225 West State Street CN503
Trenton, New Jersey 08625-0503

State Department of Education
Professional Licensure Unit
Education Building
Santa Fe, New Mexico 87501-2786

Teacher Education and Certification
Cultural Education Center
Room 5A11
Nelson A. Rockefeller Empire State Plaza
Albany, New York 12230

Department of Public Instruction
Certification Section
301 North Wilmington Street
Raleigh, North Carolina 27601-2825

Department of Public Instruction
Teacher Certification
600 East Boulevard Avenue
Bismarck, North Dakota 58505-0440

Department of Education
Division of Teacher Education and Certification
65 South Front Street, Room 1012
Columbus, Ohio 43266-0308

Department of Education
Hodge Education Building
2500 North Lincoln Boulevard
Oklahoma City, Oklahoma 73105-4599

Teacher Standards and Practices Commission
255 Capitol Street NE
Public Service Building 105
Salem, Oregon 97310

State Department of Education
Bureau of Teacher Preparation and Certification
333 Market Street, 3rd Floor
Harrisburg, Pennsylvania 17126-0333

Department of Education
School and Teacher Accreditation
22 Hayes Street
Providence, Rhode Island 02908

State Department of Education
Teacher Certification Office
Room 1015 Rutledge Bldg.
1429 Senate Street
Columbia, South Carolina 29201

Division of Education and Cultural Affairs
Office of Certification
700 Governor's Drive
Pierre, South Dakota 57501-2291

Teacher Licensing and Career Ladder
 Certification
6th Floor North Wing
Cordell Hull Building
Nashville, Tennessee 37243-0377

State Education Agency
Educational Personnel Records
1701 North Congress Avenue
Austin, Texas 78701-1494

State Office of Education
Certification and Personnel Development
250 East 500 South
Salt Lake City, Utah 84111

State Department of Education
Educational Licensing Office
120 State Street
Montpelier, Vermont 05620-2501

Department of Education
Office of Personnel Licensure
P.O. Box 6Q
Richmond, Virginia 23216-2060

Professional Education and
 Certification Office
Superintendent of Public Instruction
P.O. Box 47200
Olympia, Washington 98504-7200

Department of Education
Office of Professional Preparation
Capitol Complex Room B-337, Bldg. 6
Charleston, West Virginia 25305

Bureau of Teacher Education
Licensing and Placement
Teacher Certification
125 S. Webster Street
P.O. Box 7841
Madison, Wisconsin 53707-7841

SDE Certification and Licensing Unit
Hathaway Building
2300 Capital Dr.
Cheyenne, Wyoming 82002-0500

Department of Defense
Office of Dependents Education
 Certification Unit
4040 N. Fairfax Drive
Arlington, Virginia 22203-1634

The National Board for Professional Teaching Standards: Implications for Art Teacher Preparation

Mac Arthur Goodwin
South Carolina Department of Education

GROWING interest in the development and implementation of content and student standards in the arts clearly indicate the need to examine art teacher preparation in the context of the *Early Adolescence through Young Adulthood/Art: Standards for National Board Certification* (National Board for Professional Teaching Standards 1994). Issues regarding the implications of these standards can best be examined in the context of the following questions: What should students know and be able to do to function in the twenty-first century? What should teachers know and be able to do to prepare students to function in the twenty-first century? Does America need national professional teaching standards?

THE NATIONAL BOARD FOR PROFESSIONAL TEACHING STANDARDS

The National Board for Professional Teaching Standards represents a coalescence of the leadership of the nation's education community. The mission of the National Board is to establish high and rigorous standards for what teachers should know and be able to do, to certify teachers who meet those standards, and to advance other education reforms for the purpose of improving student learning in American schools (National Board for Professional Teaching Standards 1990).

The National Board's conceptual framework for professional teaching standards focuses on three central areas: certification standards,

assessment methods and processes, and education policy. The National Board has identified education policy and reform issues that are related to National Board certification and has set the following priority areas: enhancing the teaching environment for teaching and learning; increasing the supply of high-quality entrants into the profession, with special emphasis on minorities; and improving teacher education and continuing professional development (National Board for Professional Teaching Standards 1990).

The National Board's decision to address the subject of what teachers should know and be able to do and its policy guidelines regarding assessments were both critical steps in launching standards development activities. The National Board appointed the Early Adolescence through Young Adulthood/Art: Standards Certification Committee to undertake the assignment of translating into standards that body of knowledge and practice shared by accomplished teachers of art.

The standards committee based its certification standards on these five broad propositions:

- Teachers are committed to students and their learning.
- Teachers know the subjects they teach and how to teach those subjects.
- Teachers are responsible for managing and monitoring student learning.
- Teachers think systematically about their practice and learn from experiences.
- Teachers are members of learning communities.

Considering these five proposition statements, the committee developed the following standards, published in *Early Adolescence through Young Adulthood/Art: Standards for National Board Certification* (National Board for Professional Teaching Standards 1994):

STANDARD I: *Goals and Purposes of Art Education*

Accomplished teachers set ambitious goals for students based on clear conceptions of how art links students to broad human purposes.

STANDARD II: *Knowledge of Students*

Accomplished teachers demonstrate an understanding of the development of adolescents and young adults in relationship to their art learning; recognize their interests, abilities and needs; and use this information to make instructional decisions.

STANDARD III: The Content and Teaching of Art

Accomplished teachers use their knowledge of art and students to help students make, study, interpret, and evaluate works of art.

STANDARD IV: Learning Environments

Accomplished teachers establish environments where individuals, art content, and inquiry are held in high regard and where students can actively learn and create.

STANDARD V: Instructional Resources

Accomplished teachers create, select, and adapt a variety of resources and materials that support students as they learn through and about art.

STANDARD VI: Collaboration with Colleagues

Accomplished teachers work with colleagues to improve schools and advance knowledge and practice in the field.

STANDARD VII: Collaboration with Families

Accomplished teachers work with families to achieve common goals for the education of their children.

STANDARD VIII: Reflection, Assessment, and Evaluation

Accomplished teachers are reflective: they monitor, analyze, and evaluate their teaching and student progress in order to expand their knowledge and strengthen their practice. They use a variety of assessment and evaluation methods, encourage student self-assessment, and effectively report assessment and evaluation results to families, colleagues, policymakers, and the public.

DOES AMERICA NEED NATIONAL TEACHING STANDARDS?

In the past decade, there has been great interest in practices and issues relating to public education. From the 1983 publication of *A Nation at Risk* (National Commission on Excellence in Education), to Goodlad's study of teacher education published in 1990, hundreds of reports, panels, commissions, and commentators have addressed problems about our nation's schools. (Zimmerman 1994, 79).

The report made by the NCEE made this observation: "While we can take justifiable pride in what our schools and colleges have historically accomplished and contributed to the United States and the well-being of its people, the educational foundations of our society are presently being eroded by a rising tide of mediocrity that threatens our very future as a nation and a people" (National Commission on Excellence in Education 1983, 5). How far have we come since the publication of this statement with regard to changing the public's perception of schools?

IN 1989, President George Bush and the state governors adopted six ambitious goals for education. These addressed children's readiness to start school; high-school graduation; student competency in core subjects and responsible citizenship; student achievement in science and mathematics; adult literacy; and the school environment (safe, drug-free schools). In 1993, President Bill Clinton and the national Congress expanded these education goals to address teacher education, professional development, parent participation, the arts, and foreign languages. The Education Goals Panel was established in 1990 to track America's progress toward achieving the education goals.

According to the 1991 *National Education Goals Report: Building a Nation of Learners* (National Education Goals Panel), progress was made in the areas of high school completion, achievement in science and mathematics, and basic literacy skills among young adults.

However, according to other data provided in this report, the need existed to initiate a decade-long campaign to increase education performance at all levels. The following data supported the need (National Educational Goals Panel 1991):

- Data reported by the National Assessment Governing Board (1991)—which measured performance against National Assessment of Educational Progress's consensus standards for what students should know and be able to do, rather than against past performance norm averages—revealed that fewer than 20 percent of students in the fourth, eighth, and twelfth grades had achieved expected levels of competency in mathematics.
- In addition, on two international tests of student mathematics and science achievement conducted during the last decade, U.S. students scored below students in most other countries tested.
- Literacy surveys suggested that most adults had mastered basic functional literacy skills, but far fewer were able to perform more

complex literacy tasks requiring them to process and synthesize many pieces of information.
- Far too many schools were unsafe, especially in our cities.

While the subsequent 1994 National Education Goals Report indicates improvement in some areas, the overall educational gains, for the most part, have been marginal. In many instances, there is a significant correlation between educational gains and socioeconomic status (National Educational Goals Panel 1994).

Attention given to the numerous studies and reports on education has challenged Americans to examine our current education system. As a result, stakeholders within and outside of the traditional education community have been examining and continue to examine the mission and goals of America's schools with a scrutiny unparalleled in the history of education (Goodwin 1994). In addition, because of the rapidly changing world, the nation is coming to grips with the idea that only those persons who achieve at high levels of skills and knowledge will be able to function in the twenty-first century (National Educational Goals Panel 1991).

Education stakeholders are demanding education reform to ensure that students can function adequately as citizens in the twenty-first century. Three questions need to be addressed prior to any attempts at education reform: What should students know and be able to do? What should teachers know and be able to do? How should schools be structured to facilitate the delivery of appropriate instruction? (Goodwin 1994). These questions on the part of a broad constituency have fueled interest in national voluntary standards for education, and the first two of them are discussed in greater depth in this essay. According to the National Council on Education Standards and Testing (1992), high national education standards and a system of assessment are important to foster equitable educational opportunity for all Americans, to enhance the civic culture, and to enhance America's competitiveness.

How far have we come since the publication of *A Nation at Risk*? Has the public's perception of education changed significantly?

> Continuing pressure for education reform is exerted by a pervasive public worry about the relationship between schools and the broader society. Corporate leaders worry about whether the schools can educate young people to succeed in jobs that will require a high level of collaborative decision making and understanding of complex processes. Intellectuals worry about the erosion of citizen participation in basic democratic processes and whether schools are teaching students core American values and the fundamentals of our government. Parents worry about whether schools give children a fair chance to learn what they need to get ahead and be happy (Holmes Group 1995, 3).

WHAT SHOULD VISUAL ARTS STUDENTS
KNOW AND BE ABLE TO DO?

A number of constituencies have delineated what students should know and be able to do in visual arts. I believe that art education will be an integral component of education reform only if the field examines the work of these constituencies for similarities rather than differences.

Ignorance of the arts is one form of illiteracy. Students need the special kind of knowing that makes instructional experiences in the arts distinct. Moreover, well-designed work in the arts can contribute to students' acquisition of basic academic competencies and enrich what they are learning in the other academic disciplines (College Board 1985, 17). According to the College Board (1985), while art education in America's schools is varied, all students need the following in order to obtain the necessary skills and knowledge for college preparation:

- Intensive work in at least one art discipline. Students need time and in-depth instruction in order to focus on the unique concepts and ways of thinking specific to an art form.
- Significant progress toward three kinds of abilities:
 —Knowledge of how to produce or perform works of art;
 —Knowledge of how to analyze, interpret, and evaluate works of art;
 —Knowledge of works of art of other periods and cultures (College Board 1985, 20).

Under the auspices of the Getty Education Institute for the Arts (formerly the Getty Center for Education in the Arts), a number of art educators and policymakers looked at art education theory and practices and concluded that art programs were dominated by studio production to the virtual exclusion of content and inquiry in the other domains of knowledge associated with arts (Delacroix and Dunn 1995, 46). Based on this existing condition, the Getty Education Institute for the Arts chooses to advocate a more comprehensive and multifaceted approach to making art a more integral part of general education. This approach, known as discipline-based art education (DBAE), strengthens the teaching of art through methods of inquiry in the classroom by leading students to study the concepts and disciplines of art production, art history, aesthetics, and art criticism (Getty Center for Education in the Arts 1993, 21). The content and skills that students should know and be able to do, based on the DBAE theoretical construct, include knowledge about art; understanding of its production; and appreciation of aesthetic properties of art, other objects, and events.

Through the study of art as an integral component of the general education, students should develop a store of images as a foundation for understanding, including the images at the base of much of our discourse, and develop a set of lenses or structures with which to think. The Information and modes of inquiry should be drawn from four disciplines: aesthetics, art criticism, art history, and art production (Greer et al. 1993, 23).

According to the International Council of Fine Arts Deans (ICFAD), in order for higher education to continue the process of educating students in the arts at an appropriate level, students must have a basic understanding and comprehension of the arts prior to undertaking college study. Building on this premise, in 1990 ICFAD developed a set of principles for prospective students entering collegiate study and delineated the following attributes that students (K–12) should develop:

- an understanding and appreciation of the arts as pragmatic elements of everyday life;
- a knowledge of the processes of creating works of art and the roles of the individual artists in those processes;
- the ability to use the skills, media, tools, and processes necessary to create or communicate art forms;
- a knowledge of historic development of art from various cultures; and
- an understanding of the aesthetic qualities of individual art forms (International Council of Fine Arts Deans 1990, 2)

According to the National Art Education Association (NAEA), successful visual arts programs can have different structures. However, there are certain keys to success in all visual arts programs. As programs are planned to meet the reform agenda, the following three questions should be raised in order to align instruction, curriculum, assessment, instructional materials, and professional development. First, is the focus on student art learning, rather than special events, teaching techniques, exhibits, art media, or resources? Second, is the focus on art education, not art enrichment, exposure, or entertainment? And finally, is the focus on art content instead of special projects, activities, contests, or processes (National Art Education Association 1995, 2)?

The educational success of students depends on creating a society that is both literate and imaginative, both competent and creative. Achievement of this goal depends, in turn, on providing children with the tools to function in the twenty-first century. Without the arts to help shape perception and imagination, our children stand every chance of

growing into adulthood culturally disabled (National Art Education Association 1995).

While there are multiple routes to competence in visual arts education, the National Consortium of Arts Education Associations and the U.S. Department of Education have endorsed national standards for the visual and performing arts. These standards embody a set of broad premises for what visual arts students should know and be able to do. They are written for all students. They affirm that a future worth having depends on being able to construct a vital relationship with the arts, and that doing so, as with any subject, is a matter of discipline and study. These standards state that every young American

- should be able to communicate at a basic level in the four arts disciplines—dance, music, theatre, and visual arts;
- should be able to communicate proficiently in at least one art form;
- should be able to develop and present basic analyses of works of art;
- should have an informed acquaintance with exemplary works of art from a variety of cultures and historical periods; and
- should be able to relate various types of arts knowledge and skills within and across the arts disciplines (National Consortium of Arts Education Associations 1994, inside front cover).

Building on the work of the National Consortium of Arts Education Associations, the National Assessment Governing Board (1994) facilitated development of an arts assessment framework which delineates expectation for student learning into several broad categories. First is creating—construction and communication of meaning through the making of tangible objects or performances, as well as feeling, thinking, and reflecting. Second is responding—interpreting works of art, as well as formulating and articulating judgments through oral, written, and visual presentations. Third are knowledge and skills—understanding the meaning of visual forms and how this meaning is conveyed through the study of the arts in a broad context, including personal, social, cultural, and historical viewpoints.

THE arts are basic in a purely educational sense because students think and often communicate through art (in pictures) long before they use words; and some students continue to think, learn and communicate better through the arts even afterward. The arts also facilitate problem solving, higher-order thinking skills, flexibility, persistence, and cooperation. The arts are essential to education reform in and of themselves.

When taught by arts specialists in an appropriate educational setting, students learn to develop, express, and evaluate ideas; to produce, read, and interpret visual images in an increasingly visually oriented world; and to recognize and understand the artistic achievements and expectations of diverse societies. No child in an American school should be deprived of the opportunity to see, hear, touch, and understand the accumulated wisdom of our artistic heritage, and to make his or her own contributions through productions and performances. Education can no longer be defined without the arts (National Assessment Governing Board 1994).

WHAT SHOULD TEACHERS KNOW AND BE ABLE TO DO?

Most of the national reports on American education cite teacher education as the starting point of major reform (Duke 1990). A review of the research indicates that theory and practice for visual arts teacher education have been limited to three areas: knowing about subject matter and content; knowing how subject and content are given form; and knowing about the impact of outside influences (Zimmerman 1994). Whether these areas of concentration result from choice, posturing, or assignment is not as important as the implications and perceptions they foster for teacher education reform.

How do we prepare teachers to function in today's rapidly changing school environment? Today's teachers face schools that are dealing with issues such as attempts to expand parental choice; the increasing influence of the business community; increasing local control; reduction of federal judicial activity in education; limited federal role in assisting states to carry our their responsibilities for education, significant reductions in Chapter 1 program allocations, as well as changes in how these allocations can be used; efforts to abolish the U.S. Department of Education; and state departments of education that are redefining their missions (Boschee 1989, 80). These conditions, along with the rapidly changing world, require a different kind of teacher than those produced in the traditional teacher education program. These issues beg the examination of the broader question: What should teachers know and be able to do? Simply put, what are the expectations of today's teachers?

Today's teachers are expected to

- understand their discipline in depth and be able to teach it in a broad context (Holmes Group 1995);
- provide relevant curriculum, instruction, and assessment;

- create a support network beyond the school;
- involve parents and guardians in the educational process;
- make meaningful connections to students' home environment;
- align curriculum, instruction, assessment, and instructional resources (e.g., teaching materials, technology, and resources); and
- effect and inform policy regarding curriculum, instruction, and assessment.

Prospective teachers are expected to possess a broad, coherent liberal arts foundation that incorporates multicultural values and forms of inquiry and be able to place their discipline in a broad curricular context (Holmes Group 1995). Where is the balance between preparing teachers to be deliverers of content and preparing teachers to be facilitators of learning? Where is the balance between preparing teachers to teach discipline-specific content and preparing teachers to facilitate learning in the context of the total education community? Where is the balance between preparing teachers that are knowledgeable of the impact of outside influences and teachers that can inform outside influences?

The roles of teachers in general and art educators in particular are of increased importance in shaping art education reform. While today's art teachers are better prepared than their predecessors in terms of content knowledge, understanding of pedagogy, and practical teaching experiences, it is questionable whether they are prepared to meet the demands of today's complex schools (Zimmerman 1994).

Four decades ago, researchers acknowledged that teachers were a part of the entire education community (Baker and Gomp 1964). Recognition of the importance of capitalizing on the interconnectiveness of the school community to move art education reform forward remains a critical attribute worth nurturing in today's visual arts teachers. The efforts of the National Board for Professional Teaching Standards (NBPTS)* provide a prototype that has significant implications for teaching as a profession. The Early Adolescence through Young Adulthood/Art: Standards provide a vision for visual arts teaching that could revolutionize teacher evaluation methodology, teachers' approaches to teaching, and the public's perception of teachers.

*In this book, the name Early Adolescence through Young Adulthood/Art: Standards for National Board Certification, where it appears in roman type, refers to the actual outline of standards developed by the NBPTS. (These are also referred to as the National Board Standards, or NBPTS standards.) Where the full name appears in *italic* type, it refers to the 1994 publication containing these standards and in-depth discussion of them. "Early adolescence through young adulthood" includes ages eleven to eighteen or over.

THE STANDARDS AND THEIR IMPLICATIONS
FOR TEACHER EDUCATION

The National Board Standards were developed under the aegis of the National Board for Professional Teaching Standards (NBPTS). These standards are compatible with current directions and research in teacher education and are thus worthy of serious contemplation in regard to visual arts teacher education reform initiatives.

The National Board Standards delineate what highly accomplished teachers should know and be able to do, thus setting an expectation level for all teachers of visual arts in the following contexts: an overarching framework for teachers' practices, highlighting attributes that highly accomplished teachers possess; skills and understandings that comprehend the learning objectives of art education, along with the knowledge of the content of art that is a hallmark of exemplary practices; the importance of creating a productive and supportive learning environment that enables students to achieve at high levels; and the importance of creating a rich set of instructional resources, contributing to the larger profession, and building productive working relationships with families and the community (National Board for Professional Teaching Standards 1994). The National Board also is developing a performance-based assessment system to measure these standards.

Given the nature of education reform in general and art education reform in particular, it seems appropriate to address visual arts teacher education in the context of National Board Standards certification. The need exists to reform teacher education in a manner that reflects these standards, while at the same time maintaining the integrity of individual programs.

Teachers are being held more accountable for student achievement—a departure from the 1980s, when teacher accountability was measured by on-the-job evaluations and written tests. Student performance in post-secondary education and the world of work provide the benchmarks for determining both teacher and school effectiveness (Cornett 1995, 30). Thus, teacher education programs should consider employing the following strategies as means of preparing the prospective teachers to address accountability issues:

- establishing partnerships among higher education and school districts to prepare prospective teachers as well as to assist novice teachers (Holmes Group 1990, 1995);
- spearheading efforts to strengthen academic majors for teachers and ensure a core of education courses based on proven best practices in the field;

- promoting partnerships between arts and sciences faculty and education faculty; and
- identifying exemplary teachers and drawing upon their expertise to nurture prospective teachers.

The National Board for Professional Teaching Standards for Board Certification process provides an excellent vehicle for addressing teacher accountability issues. The overarching framework for teaching practices set forth in the standards provides a measure of excellence for all teachers. While the debate over standards will continue well beyond the twenty-first century, standard setting is not a new phenomenon. The education community has always had standards. In higher education there are student admission standards. State licensing systems set minimal standards to protect the public interest and to assure that a teacher will do no harm. Professional standards take the next step to provide assurances of high-quality practice (National Board for Professional Teaching Standards 1990). What is unique about the National Board for Professional Teaching Standards is that they were developed by practitioners from the field. According to Albert Shanker, president of the American Federation of Teachers,

> The National Board does not represent a reform imposed on teaching from outside. Rather, we have a profession defining its own high standards for excellence and creating a national credential to recognize practitioners who meet the standards the way physicians and lawyers and architects have already done (Shanker 1995).

The National Board has identified a set of skills and understanding that teachers need in order to be effective facilitators of learning. These skills provide a basis for teacher evaluation that is relevant to visual arts education. More importantly, these skills and understandings set forth in the standards are related to student learning and understanding art. The National Board promotes the role of the teacher as one who takes respon sibility for providing an appropriate environment that encourages and supports student learning. The National Board also promotes an approach to teaching that transcends the classroom and extends to informing outside influences. The National Board encourages teachers to contribute to education reform beyond the classroom.

MUCH of the research reviewed during the preparation of this essay focuses on what teachers need to know and be able to teach. Arthur Efland (1993) asks these questions about the education of prospective teachers of art for tomorrow's school:

- What do arts teachers need to know about their respective subjects in order to teach well?
- What do arts teachers need to know about pedagogy to teach well?
- Are there specific identifiable characteristics generally possessed by successful teachers of art?
- Should the preparation of future arts teachers be changed and, if so, in what ways (Efland 1993, 170–71)?

In responding to these questions, Efland derives several conclusions regarding teacher preparation: first, that teachers need to know about their disciplines to teach well; second, that teachers need to be learners; and third, that teachers need to understand pedagogy and be able to transform what they know into pedagogical knowledge. In responding to the questions raised by Efland, Day (1994) focuses on the changing demographics and in so doing concludes that teachers also need to understand the importance of making connections with the cultures of their students. These issues raised by both Efland and Day are embraced by the National Board Standards.

Today's changing school environment requires prospective teachers to understand the criticality of informing, effecting, and affecting these areas in the education spectra: school-wide curriculum planning and implementation; school-based and community-based education planning and policy setting; and active participation in professional associations and professional development. These are among the points that the National Board for Professional Standards promote as means to move education reform forward. The National Board Standards value teachers' participation in the broader school community, as well as their active participation in professional organizations and activities, as being integral to highly accomplished teaching.

What are the roles of higher education, state departments of education, local school districts, state legislatures, professional associations, and the community in facilitating the development of attributes in prospective and novice teachers that will enable them to function effectively in the broad education communities? Where are the common grounds among these constituencies? Past successes and failures clearly indicate a need for partnerships among a broad constituency to provide the nurturing environment that fosters the experiential base needed by both prospective and novice teachers in order to function in today's complex school communities (Holmes Group 1995). The National Board Standards also provide an excellent opportunity for a broad constituency to establish common grounds for education improvement. The premise is that high-quality teachers as facilitators of learning

added to a creative supportive learning environment will lead to students learning and achieving at high levels.

Today's education setting requires teacher education to go beyond simply focusing on preparing teachers to deliver discipline-specific content. Successful teachers must understand and make meaningful connections with student environments beyond the classroom. That is, teacher education programs must better understand the communities in which their candidates are expected to perform. Teacher education programs must also work to enhance the image of teaching as a profession. The improvement of student learning by establishing and implementing a national teacher certification that speaks to the broader education community is at the core of the mission of the National Board for Professional Teaching Standards.

CONCLUSIONS

Americans continue to question not only the quality of the current education system but also whether the education system should remain in the pubic domain. The demands on teachers and schools have increased significantly over the past decade. Today's schools call upon teachers continually to make decisions about their teaching within and outside the classroom, relying on their understanding of students, their subject and how it can be taught, instructional resources, and assessment information. These decisions are shaped by the various contexts that influence practice; provide texture; and inform instruction, curriculum, and assessment. Rapidly changing conditions in the education setting provide new challenges for teacher education.

While the National Board Standards clearly recognize and address the importance of mastery of content and pedagogy as well as curriculum, instruction, and assessment, these issues should be dealt with in the broader context of imparting cultural literacy to the students. The National Board Standards are compatible with proven successful reform initiatives in visual arts education. The NBPTS certification process will provide a cadre of teachers with the capacity to mentor prospective teachers as well as to provide leadership in the field. Many entities at both state and local levels are developing strategies and providing incentives to encourage teachers to participate in the process. Such incentives have the potential to attract the best and brightest students to the teaching profession.

Even though the National Board Standards are voluntary, they will prove beneficial to teacher education reform. The analysis of data from the National Board certification process will provide valuable

information about highly accomplished visual arts teachers. This information also will stimulate the design of more rigorous programs of teacher education and continuing professional development. Whether these standards are met with total approval is less important than the fact that there now exists a prototype for the identification of highly accomplished teachers of art students ranging from early adolescence through young adulthood.

The United States is beginning to understand that if the nation is to have a future with promise, it must have world-class schools and a world-class teaching force (National Board for Professional Teaching Standards 1990). Serious consideration of the National Board Standards is paramount if we are to rescue art education for our children. The Early Adolescence through Young Adulthood/Art: Standards for National Board Certification are truly a catalyst for change.

REFERENCES

American Council for the Arts in Education. 1977. *Coming to our senses: The significance of the arts for American education.* New York: McGraw Hill.

Baker, R., and P. Gump. 1964. *Big school and small school.* Stanford, Calif.: Stanford University Press.

Bocshee, F. 1989. Has the United States lost its competitive edge or commitment? *NASSP Bulletin* 73 (17): 78–82.

College Board. 1985. *Academic preparation in the arts.* New York: College Board.

Consortium of National Arts Education Associations. 1994. *Dance, music, theatre, visual arts: What every young American should know and be able to do in the arts.* Reston, Va.: Music Educators National Conference.

Cornett, L. 1995. Lessons from ten years of teacher improvement reforms. *Education Leadership* 52 (5): 26–30.

Day, M. 1993. Response II: Preparing teachers of art for tomorrow's schools. *Bulletin* [Council for Research in Music Education] 117 (summer): 126–35.

Delacroix, E., and P. Dunn. 1995. DBAE: The next generation. *Art Education* 48 (6): 46–53.

Duke, L. 1990. Foreword. In *From Snowbird I to Snowbird II.* Los Angeles: The Getty Center for Education in the Arts.

Efland, A. 1993. Teaching and learning: The arts in the future. *Bulletin* [Council for Research in Music Education] 117 (summer): 107–21.

Ellis, A., and J. Fouts. 1993. *Research on education innovations.* Princeton, N.J.: Eye on Education.

Geiger, K. 1994. Defining excellence in teaching: National Board awards first certificates. *Washington Post,* December 4.

Getty Center for Education in the Arts. 1990. *From Snowbird I to Snowbird II.* Los Angeles: The Getty Center for Education in the Arts.

———. 1993. *Improving visual arts education.* Santa Monica, Calif.: The Getty Center for Education in the Arts.

Goodlad, J. L. 1990. *Teachers for our nation's schools.* San Francisco: Jossey-Bass.

Goodwin, M. 1994. *Standard for arts: Friend or foe?* Briefing Paper Series. Reston, Va.: National Art Education Association.

Holmes Group. 1986. *Tomorrow's teacher: The Holmes Group report.* East Lansing, Mich.: Holmes Group.

————. 1990. *Tomorrow's school: Principles for the design of professional development schools.* East Lansing, Mich.: Holmes Group.

————. 1995. *Tomorrow's school: Principles for the design of professional development schools.* East Lansing, Mich.: Holmes Group.

International Council of Fine Arts Deans. 1993. *Arts education principles/standards: An ICFAD position.* San Marcos, Tex.: International Council of Fine Arts Deans.

National Art Education Association. 1986. *Quality art education: Goals for schools.* Reston, Va.: National Art Education Association.

————. 1992. *Purposes, principles, and standards for school art programs.* Reston, Va.: National Art Education Association.

————. 1994. *Goals 2000 education reform handbook: Suggested policy issues for State Art Education Association officers.* Reston, Va.: National Art Education Association.

————. 1994. *A priority for reaching high standards.* Reston, Va.: National Art Education Association.

————. 1995. *Suggested policy perspective on art content and student learning in art education: Maintaining a substantive focus.* Reston, Va.: National Art Education Association.

National Assessment Governing Board. 1994. *Arts education assessment framework.* Washington, D.C.: U.S. Government Printing Office.

National Association of Arts Organizations. 1994. *Dance, music, theatre, visual art: What every young American should know and be able to do in the arts.* Reston, Va.: Music Educators National Conference.

National Board for Profession Teaching Standards. 1990. *Toward high and rigorous standards for the teaching profession.* Detroit: National Board for Professional Teaching Standards.

————. 1994. *Early adolescence through young adulthood/art: Standards for National Board certification.* Detroit: National Board for Professional Teaching Standards.

National Commission on Excellence in Education. 1983. *A nation at risk: The imperative of education reform.* Washington, D.C.: National Commission on Excellence in Education.

National Council on Education Standards and Testing. 1992. *Raising standards for American education.* Washington, D.C.: U.S. Government Printing Office.

National Education Goals Panel. 1991. *The National Education Goals report: Building a nation of learners.* Washington, D.C.: U.S. Government Printing Office.

————. 1994. *The National Education Goals report: Building a nation of learners.* Washington, D.C.: U.S. Government Printing Office.

National Endowment for the Arts. 1988. *Toward civilization: A report on arts education.* Washington, D.C.: U.S. Government Printing Office.

Shanker, A. 1995. Where we stand: Beyond merit pay. *The New York Times,* January 15.

United States Department of Education. 1991. *America 2000: An education strategy.* Washington, D.C.: U.S. Government Printing Office.

Zimmerman, E. 1994. Current research and practice about pre-service visual art specialist teacher education. *Studies in Art Education* 35 (2): 79–88.

Effects of School Culture on Art Teaching Practices: Implications for Teacher Preparation

Kellene N. Champlin

Fulton County Schools, Atlanta, Georgia

THE longer I ruminated on relationships among schools, the practice of teaching art, and the preparation of art teachers, the more ambiguous became connections which had at first seemed obvious. It was clear that terms and phrases associated with each component—school culture, teaching practices, teacher preparation—needed more definition before productive associations could be assumed among them. Questions such as these are not so easy to answer: What *is* "school culture"? What does school *culture* have to do with art teaching *practices?* What does this have to do with higher education?

The dictionary is often a good place to begin when we need to take phrases apart to explore their nuances. In this case, the terms *school* and *culture* coalesced as

> the shared characteristics and features of the environmental conditions, physical space, human relationships and interactions, and pedagogical milieu within the instructional setting of the institution called the school.

While descriptive, this sounded pedantic and certainly lacked vitality. In my reading I came across a statement that seemed to capture the intent of the topic and proved more useful for focusing points relevant to this discussion. Wanda May (1993), in her revealing studies of art and music teachers for the Center for the Learning and Teaching of Elementary Subjects at Michigan State University, advised: "How a teacher teaches depends not simply on who the teacher is but also on how the teacher

was trained and where the teacher is teaching" (37). A brief analysis of the several elements of this lucid statement shows its usefulness for this discussion:

- "HOW a teacher teaches" is another way of saying "art teaching practices."
- "WHO the teacher is" suggests such factors as background, character, motivation to teach, disposition, personality, and appearance of the individual.
- "HOW the teacher was trained" has to do with teacher preparation—such effects as the knowledge, content, skills, ideals, and philosophy that the teacher brings to the setting.
- "WHERE the teacher is teaching" alludes to aspects of place— location, facilities, and resources, as well as the character, motivations, and skills of the leaders who run the school itself.

I see numerous potential relationships among all of these elements, dynamic interactions which necessarily contribute to a construct that can be called "school culture." With the addition of two words, *what* and *and,* I propose that May's statement prescribes parameters for what we choose to look at and refer to as school culture—or, in other words, the realities of schools for art teachers. Now we read: "What and how a teacher teaches depends not simply on who the teacher is but also on how the teacher was trained and where the teacher is teaching." And now we have the elements of school culture: curriculum (what), instruction (how), the individual (who), the preparation (how trained), and the setting (where).

With regard to "implications for art teacher preparation," my comments do not suppose extensive knowledge and first-hand experience with the dynamics and inner workings affecting art teacher preparation programs and faculty in higher education. As a public school administrator for art education, however, I am prepared to elaborate upon how art teacher preparation looks from the vantage point of the school district which employs the art teachers. It may be helpful for the reader to understand at this point that, since 1986, we in the Fulton County Schools in Atlanta, Georgia, have emphasized district-wide implementation of a discipline-based art education philosophy. We refer to our approach as DBAE; but whether referred to thus, or as a "comprehensive approach," or as promoting the goals or components of quality art education, or as incorporating "national standards," all these descriptors are consistent with the imperative to develop and integrate the content of art history, art criticism, aesthetics, and art production. By whichever name one

prefers to reference the content of today's art education, it is vital to recognize the compatibility of viewpoints which converge toward a comprehensive approach to education in art. Whether one refers to a discipline, an area of study, or a component, all are looking in the same direction.

This essay is divided into five sections. The first, entitled "An Art Program or an Art Education Program—What Are We Teaching?" questions the critical issue of just what it is that art teachers do and teach in schools. "Face To Face with the School Culture" explores selected aspects of school realities that tend to be more consequential for art teachers than for teachers of other subjects, and relates to "where" the teacher is teaching. "What Do Art Teachers Need?" looks at expressed concerns of experienced art teachers in the classroom with regard to the preservice preparation they brought to teaching. "What Do Preservice Art Teachers Need?" suggests how various matters of concern in preservice preparation might be considered. "How Might This Discussion Inform Higher Education? Implications" provides some background for and summarizes needs identified from a public-school perspective.

AN ART PROGRAM OR AN ART EDUCATION PROGRAM — WHAT ARE WE TEACHING?

It is of common concern that the arts as subjects hold a tenuous place in contemporary school programs, if they hold a place at all. In general, art and music fare better than theater and dance. Music programs often have an advantage over art programs—an advantage embedded in rather effective "political" justifications: bands are an integral part of athletic events, which are school/community-spirit driven and are often money raisers; band parents therefore tend to be among the most enthusiastic supporters of the school scene. That is not, of course, the only thing bands are good for, but it does tend to be a fortuitous reality of the often-sacrosanct nature of instrumental music in schools.

Even more so than music, then, if art has a presence as a school subject in a state, a district, or an individual school, it is likely that its place was hard-won and continues to be tenuous. So who, or what, is responsible for the fact that art education must ever persevere in quest of turf within a contested arena for a "place," day after day, year after year? What are we in art education doing wrong? Why can't we turn it around? This seems to be an appropriate place to note that it would be not only more efficacious but more logical (since the subject is a program in an educational setting) to defend art in schools in terms of art *education* programs rather than *art* programs. This is a more consequential issue

than most people consider. To refer to a program as "art" would seem to be a benign, easier-to-say "abbrev."; but the insidious injury that it does to perceptions, impressions, and understandings about what is done with art in schools is thoroughly underestimated. I believe this is an issue that is not taken seriously enough; I believe it is one of the things we are doing wrong.

There is another critical question which lies at the root of the issue of an art or art education program: What does the "place" *look like* once it is won? What is its substance? Its content? Its justification? What does it offer to students and to the total school program that is of such a defensible nature that parents do not begrudge their tax dollars to it? It is not my intent to begin a defense position here; rather, I want to argue that this line of thought is as much a higher-education issue as it is a public-school issue.

What Do We Teach?

Quite simply, we, as practitioners who educate others about art, do not share broad-based ownership or a general consensus of understandings (dare I say "standards" at this critical point in time?) to present to the public about why they should *pay* (I should say, "support")—and continue to *pay* (support)—year after year for programs that consume quantities of art materials and supplies that somehow escape real definition. Reflecting the national climate today: Do I want my tax dollars to pay for a program called "art" that is based on contests, holiday art, and such? Certainly not. What about a program that turns out posters, crafts, and "credible take-homes"? No, I won't pay for that either. Will I pay for a program that produces exhibits of well-executed drawings, paintings, sculptures, and the like? Well, I'm not at all sure I want to pay for that kind of a program either; after all, this is a *school,* not a studio or an atelier or a workshop. Will I, the taxpayer, support a program promoted as art education that has a curriculum based in knowledge and information, that draws on the whole globe for its content, that requires higher-level thinking skills, that seeks out and enhances connections among subjects throughout the school curriculum, that celebrates *education* rather than training? Yes. Yes, I would. You would still have to show me, but I sure would be in a more receptive frame of mind. A major problem here is that many school districts with a school art program would be hard-pressed to say with conviction whether its teachers promote "art" or "art education." And, as suggested here, there is a major difference between art as a subject of study in schools (in effect, art education) and art as a program of activities which use art materials

but compromise the potential of art for being a subject of study integral to the process of becoming an educated person.

I propose that the major difference extends to higher education. Too often it is difficult to say whether prospective teachers I interview are prepared to build and promote an art program or an art education program. A parallel for higher education might look something like this:

> As chancellor, dean, department chair (or other) of this university, do I need, can I afford, do I want . . . the fine arts and art education faculty credentialing art teachers who are teachers first and foremost, or artists who teach? Are the roles mutually exclusive? Which is more important (and to whom)? The fine arts people tell me that art education students need pure studio, and a lot of it, in order to teach well; the art education people tell me these students need more methods courses and more content in the areas of aesthetics and art criticism and art history. Maybe my faculty needs to get together and determine a mission for themselves; do they want to prepare "artist/teachers" or "art teachers?" Since we are in the business of preparing teachers, do we need to pay more attention to certification criteria proposed by The National Board for Professional Teaching Standards (1994)? And what about the National Standards for Arts Education (1994)? They may be controversial and not yet mainstream, but the premises of their development would seem to have implications for what we do at this university toward preparing art teachers. Maybe it's time that my faculty shows me what and how and why they teach what they teach, and how it contributes to the preparation of the student graduating from this university who is presumed to be prepared to teach art to youngsters, pre-kindergarten through twelfth grade. And further, they need to show me how many of our graduates are getting teaching jobs in art *education* programs.

From my vantage point as a public school art education administrator, I know what I want from this university:

1. I want the university to graduate prospective teachers who are thoroughly versed in content and methods of integrating art criticism, art history, and aesthetics into their curriculum planning and instructional delivery. I want the prospective teacher to know the difference between an *art* program and an *art education* program—and I want teachers competent in the latter.

2. I want the prospective teacher to be knowledgeable and proficient in a broad range of media, with a concentration in at least one area. This concentration is important; how can a teacher really know how to motivate students to strive for the joy and satisfaction of creating a successful artwork if the teacher has never experienced a high level of aesthetic satisfaction through his or her own immersion in artistic processes?

3. I want to see and hear evidence that the student-teaching experience was fulfilled with a *master* teacher, selected for the role because the master teacher reflects the highest standards of the university's *teacher*

preparation program, and that the experience was dynamic and affirmed to this prospective teacher that teaching is, in fact, her or his calling.

4. I want the prospective teacher who holds the profession of teaching in the highest regard. A reality of school culture is that any educator in any school setting, regardless of specialty, must be able to respond to students of any level of competency in or out of class. The professional I employ must understand that he or she is a *teacher* first and an *art teacher* second.

I want these things up front, well articulated, and visible in that first interview. I want an idealistic prospective teacher who can't wait to get into the classroom to work with children. I want these feelings to be strong—because I know that every one of these desirable attributes will be mitigated to a greater or lesser degree once the art teacher comes face to face with the SCHOOL CULTURE.

FACE TO FACE WITH THE SCHOOL CULTURE

School culture would necessarily include the whole raft of issues, conditions, and circumstances within the school setting. The mitigating potential recalls the statement "[What and] how a teacher teaches depends not simply on who the teacher is but also on how the teacher was trained and where the teacher is teaching" (May 1993)—that is to say, the realities of the school setting. All of the personnel within a school setting, including administrators, teachers, and staff, are subject to similar realities of the school, although perceptions and status of the various personalities also become mitigating factors. *All* educators deal with cultural diversity, at-risk students, environmental issues, substance abuse, Goals 2000, National Board Standards, cooperative learning, technology, classroom management, evaluation—the list goes on and on, and it is not the intent here to enumerate the dozens of issues, conditions, circumstances, and trials that school people share. Particular features of school culture that I have selected to amplify here are those which tend to impact art teachers and art teaching practices differently than they impact teachers and teaching practices of other subjects. The first condition concerns attitudes about and support for art in the school program.

Attitudes and Support

First is a burden with which teachers of most other subjects need not contend: It is usually incumbent upon every art specialist/teacher, on a daily, monthly, or yearly basis, to "sell" her or his program all the way up

and down the line—from the IRT (instructional resource teacher) at the elementary level to high-school counselors, principals, parents, and PTAs, right up through the school board, and sometimes right into the state's department of education and its legislature. There are dozens, if not hundreds, of gatekeepers to keep informed and impressed in order to maintain an adequate to high level of support for the program in a school and/or school district. As some art teachers are more proficient at this than others, this aspect of the school culture necessarily affects their art teaching practices. Art teachers *know* that without nurturing positive attitudes and support, neither art nor art education programs thrive.

How does this affect art teaching practices? Many art teachers would agree that it is easier to "impress" with an art program through its visibility and product orientation than to "inform" with an art education program, which consists more of foundation building, reflection, and process orientation. Classroom teachers and parents are usually more comfortable with art in the school program when they can *see* the results of time spent in art class, whether the product is a fully rendered watercolor or simply a credible take-home. Both visibility and foundation building are necessary, but a genuine art education program does not "impress" at the expense of "informing." When the emphasis is on curriculum development and instruction in order to build foundations, the process is mastered; when the process is mastered, quality products are an outcome—products that usually are more deeply worthy of exhibiting.

Art teachers who must devote their precious forty-five minutes a week with each class to turning out artwork for exhibit after exhibit, for bank and mall and grocery store windows, for clean community week and posters for all good themes, have a difficult time building scope, sequence, substance, and foundations of art knowledge as the basis for a serious art education program. However, many principals demand constant participation and output, often because they simply do not know or do not understand the consequences, or the alternatives. It takes time and persuasiveness to enlighten a principal about such things, and many art educators lack the knowledge, management skills, and communication skills to make this happen. A related nemesis is contests, a pervasive reality of schools for many art teachers.

The issue of competition is pertinent here for the elementary level, in particular, because competition in art can actually sabotage substantive program goals, sometimes irreparably. When there is pressure from local school administrators and others to participate in contests and competitions, it almost always impinges upon, alters, and ultimately undermines the art specialist's curriculum and best intentions for art

education. At the elementary level, competition in art is usually initiated by well-meaning adults who have little understanding of its exploitive nature. Young children rarely possess the maturity to separate them-selves from their artworks or to understand the criteria for judgment. Not the least of the mischief created by contests is that of judges who possess few or no qualifications for the task of selecting "winners." "Competition in art is the quickest way to deflate interest, personal satis-faction, and artistic resolve in all of the young 'losers'" (Champlin 1991, 365). It works to dismantle reflective, thoughtful, mind-expanding thinking processes associated with substantive art education.

This argument is not meant to belittle competition in general, such as in spelling or arithmetic, where rules and criteria are clear and right and wrong answers are not debatable. At the junior-high/middle-school level, students want to "get their feet wet." At the high-school level, com-petition takes on aspects of real life and is often an integral part of the art and school experience. While pressure for competitions may be a reality, the master teacher insists that students come first. The issue of competition in art (especially in regard to young children) has implica-tions for the preservice education of general teachers and art teachers, as well as for the study of human growth and development.

Logistical Concerns

Another reality of school settings involves a variety of logistical concerns. Again, considering aspects that tend to be more consequen-tial for art teachers than for teachers of other subjects, most teachers do not have to worry about whether their instructional space of the moment is actually the art room/lab/studio, a converted classroom, a cart, or a storage closet, or whether there is running water or carpeting to stain. These kinds of concerns have been thoroughly examined in other places, as have issues of budgets for supplies, materials, equip-ment, and resources. How many other subjects regularly find themselves under pressure to rely on "found materials," to recycle, to raise money, and to apply for grants to keep their programs going? In addition to doing these things, elementary art teacher Zach Rozelle (1994) sug-gests a way to make the art budget go further: "Teach discipline-based art education" (46)—not because of its quality content, but because a studio-based program requires a large stock of materials, while

> not much is really required to provide an effective aesthetics, criticism, or history activity; those visuals that are needed are free for the borrowing from local libraries, universities, or the education department of a museum (Rozelle 1994, 46).

Rozelle is suggesting these things as interim fixes, of course, and not ideals. Like hundreds of art teachers, he continues to look for less transitory and less tediously won support and advocacy. He is responding in the best way he can to the reality of his circumstances, which he describes as "minimal conditions" (46). He is certainly not alone.

How these logistical concerns impact art teaching practices range from what materials are available, to where and how materials can be used, to storing work-in-progress, to availability of a slide projector, to usurped class time to accommodate the testing schedule; and on and on. But, once again, implications surface here that have to do with the difference between art and art education. While budgets for materials and supplies are essential, art teachers whose programs are grounded in art *education* are more inclined to regret inadequacies in resources such as textbooks, text materials, prints, slides and other visuals, books, videos, field trips, and computers with supporting technology and appropriate software. If looking at, talking about, and *studying* art works are, in fact, activities as important as making art, then the teacher whose program is grounded in educating children in and about art requires visual resources—lots of them. They need to be at hand, and they are not all free for the borrowing.

Collegiality: A Support System

Moving further on through the reality of the school setting, even beyond a workable facility, supplies, resources, and running water, there often exists an enduring lamentation of the art teacher: isolation. In a mid-size school of seven hundred students there will be enough teachers to have homogeneous grade-level or department meetings, of which the art and music teachers are rarely a part. Collegiality within the instructional environment—interactions such as exchanging professional repartee, participating with one another, and sharing plans and directions—often accounts for acquisition of very important information, knowledge, skills, and insights nourished by shared experience. May (1993) cites a rather prevalent outcome of an inadequate support system and its impact on teaching practices when she states that "problems in classroom management are essentially curricular ones . . . a teacher's preparation and experiences as a young learner or as an unmentored teacher can influence fuzzy conceptions of what to teach and how. Fuzzy notions can exacerbate problems of practice" (26). Further, May affirms, "It is critical that we understand that most novice specialist-teachers do not have an informal network of collegial support or 'shop talk' when they are learning to teach early in their careers, often even later" (26).

The problem is not limited to novice teachers; it is a problem that teachers of many years too often share. May recalls a case of an arts specialist of five years who, being "isolated," continued to experience difficulties similar to those of a beginning or student teacher. It appears that without a support or mentoring system there will continue to be teachers who acquire one year of experience five times instead of five years of experience. Of course, music specialists suffer the same consequences of isolation as art specialists; although the two may share some aspects of a collegial relationship, they lack the shared knowledge base to participate with one another in disciplinary content growth.

Thus far I have proposed that particular aspects of school realities impact art teachers more consequentially than teachers of other subjects and often compromise the purposes, content, and substance of art education. I have elaborated, first, on uninformed attitudes and a lack of support which work against strong art education programs, as well as visibility and competition at the expense of content and productive development; second, on certain logistical concerns which make the instructional milieu for art education more challenging, including time, space, supplies, and resources; and, third, on the liability of an inadequate collegial support system for art educators to nourish a sense of professionalism and growth.

WHAT DO ART TEACHERS NEED?

Supervising eighty-plus art teachers over a number of years has allowed me to observe teachers, listen to them, and accumulate ideas about concerns they consider to be persistent. The majority of "veteran" art teachers, whether they have been out of college for two years or twenty years, tend to identify similar concerns about the circumstances they face as art teachers. These concerns were identified previously as selected aspects of "the school culture."

In reference to attitudes and support, veteran art teachers continue to want the following: They wish they did not have to "sell," defend, or justify their program as an on-going task, including budget allocations, textbooks, space, and time with students. Observations show clearly, however, that the more thoroughly grounded the art teacher is in the disciplines of art education, and the more fully developed the teacher's skills for communicating the benefits of the disciplines, the less time-consuming program justification tends to be. Secondly, many teachers resent the lack of exposure during their preservice education to the content of the disciplines of art education beyond studio. These

teachers continue to *want* (and would take courses in) the content and methodologies of art criticism, aesthetics, and art history, and how they can be integrated—whether one prefers to refer to this content as "disciplines" (Getty Education Institute for the Arts [formerly the Getty Center for Education in the Arts]), as components of "quality art education" (National Art Education Association), or as "national standards for visual arts education" (National Committee for Standards in the Arts). They also want management skills, and they want to enhance communication skills to help them defend their programs; they want continuing education and graduate courses that take these needs seriously. These needs are also supported in the observations and interviews conducted by James Gray (1990, interim report) in an ethnographic study of art teaching activities in DBAE school sites, including art teachers in the K–12 art education program which I administer.

Many of the art teachers with whom I am in contact as a curriculum supervisor have personally made efforts, ranging from modest to tremendous, to supplement their own content knowledge of art criticism, aesthetics, and art history. At the district level, periodic staff development can help; however, episodic staff development rarely provides the substance, depth, and duration needed for enduring professional growth. It does not take the place of solid grounding acquired at the preservice level.

WHAT DO PRESERVICE ART TEACHERS NEED?

Of prospective teachers who have completed the art education certification process within the last five years or so, about two-thirds that I interview know at least that "discipline-based art education" does not relate to behavior problems in the art class; and the majority have conversational acquaintance with aesthetics, art criticism, art history, and art production as integral components of a comprehensive art education program. The other third are eager to initiate talk about and show graphic evidence—such as lesson plans, student-teaching portfolios, artworks, slides, and photographic accounts—of a comprehensive approach to art education in plan and practice. These prospective teachers tend to be enthusiastic and professional, and they possess the idealism that a new teacher ought to possess. Conversational acquaintance is simply not adequate. From my point of view, at least two-thirds of the prospective teachers I see clearly need more and better preservice preparation in the areas of (1) content and (2) tools to deal with school culture; and all could benefit from (3) a more informed understanding

of the state of art education at the national level. Words and phrases that appear in **bold type** in the amplification of these three areas below tend to be educational "buzzwords."

Content

More depth, more substance, and more methodology in the art disciplines are needed, individually and as integrated with one another. The teacher's grasp of content knowledge is the foundation for *any* subject which is to be taught well. Master teachers have an expansive repertoire of *content* knowledge which equips them to effectively respond, react, motivate, expand, and elaborate on topics and ideas which capture the imagination of—which *engage*—students in art learning and in other forms of inquiry. This is the teacher who captures the excitement of both teaching and learning—the teacher who can say with confidence that art education requires a tremendous amount of **higher-order thinking!**

What *is* art education when it is taught well? My observations indicate that it is a comprehensive discipline-based program with a strong evaluation component to aid in determining whether what was intended to be taught was indeed learned. It is less concerned with turning out artists than with educating all students in the visual arts; it is learning to *use* creative thinking and artistic understandings in all human endeavors. The following statement by Robert Root-Bernstein (a biochemist!) illustrates this point:

> The same tools of thought that an artist needs to paint or sculpt or that a writer needs to write or a musician to compose are those which a scientist needs to discover or a technologist needs to invent. But these skills are not taught within any standard scientific or technological curriculum. Virtually their only source is in the arts (National Endowment for the Arts 1993, 15).

Given the emphasis currently placed on a comprehensive approach to art education, how should the content of the art disciplines be structured so that it will be useful to the teaching practitioner? Does the art teacher need to know what the art critic knows to do a better job of teaching art criticism? Or would the preservice art teacher be better served if the content of art criticism was balanced with a pedagogical approach, blending the content of art criticism with methodology for teaching art criticism? Or should methodology follow content? Would aesthetics and art history have similar structural needs? How, where, and at what point should the content of the disciplines be integrated? How can the worth of one approach over another be judged? How can the acquisition of content knowledge be evaluated? How does one assess qualitative understandings about aesthetics, for example, that

are presumed to accrue? Just how much content preparation does the preservice art teacher need? "Much more than most are getting" would be the most probable consensus of art teachers and administrators.

Another essential content need that must be thoroughly woven into the fabric of the disciplines is an authentic global perspective that incorporates substantive understandings of **cultural diversity**. No one can claim title to a substantive, comprehensive art education program without understanding this issue and without acquiring knowledge (and resources!) to put the understanding into practice.

Tools to Deal with the School Culture

Armed with content knowledge and a repertoire of understandings to put this knowledge to work, the preservice art teacher needs to hone some basic skills in preparation for the role of art teacher within the reality of the school culture. These skills are also very useful for preparing to interview with prospective employers.

One set of tools includes **management skills.** There are many of these, including management of those physical, logistical concerns discussed earlier which tend to be a particular challenge for art teachers. A major area of management skills that is often overlooked, however, is the need for knowledge of how and why **classroom management** problems are essentially curricular problems (May 1993, 26). An example of a curricular problem that is often categorized as "classroom management" is organizing for art instruction: "It is critical that the art teacher plan for a balance among new skills, new concepts, and new subjects. When there are too many new elements in one lesson, the potential for expressiveness is obstructed" (Champlin 1991, 362).

While this understanding may take practice and some experience to recognize and attend to, it helps to start out with an awareness of it. When students are not fully engaged in a lesson, when the level of structure or guidance is not appropriate for the group of students, when the teacher is not clear about the objectives of the lesson, then restlessness, boredom, disinterest, and distraction readily encroach, resulting in behavior problems—problems with roots which are essentially curricular. Preservice and novice teachers need to be reflective about this; they need to be open to recognizing clues and signs.

Most new teachers, in my experience, talk about classroom management in terms of student behavior and of organizing supplies, equipment, space, and time to facilitate instruction. Classroom management has a multitude of consequential elements to which both new and veteran teachers need to be attuned. Master teachers build a repertoire

of strategies to deal with the rhythms and textures of each unique instructional setting, sometimes class by class. While these repertoires do not come in the form of a textbook, preservice teachers need to develop an eye and a conceptual orientation for recognizing and noting the importance of these elements.

An Informed Understanding of the State of Art Education at State and National Levels

It is increasingly critical for art educators to be even more than masters of content, methodology, and management; they must be able to *talk about* what art education does for students, schools, communities, and the nation. The set of tools I refer to as **communication skills** has more to do with *what* needs to be talked about than *how* it is articulated. For example, the "politics" of program justification is at issue here. In order to know what to say, preservice teachers need information and practice; they need to know what to look for, what is important. What, for instance, are "National Standards for the Visual Arts?" What are "Professional Teaching Standards?" What is the "Goals 2000 Arts Partnership?" What is happening with the National Endowment for the Arts? What is the potential impact of its possible demise on art education in schools? Is what is happening to the arts at the federal government level going to trickle down to states? To local schools? What is the technology market like for the visual arts? Like the professional in any field, preservice art educators must understand and pay close attention to current events, contemporary issues, and trends in their field. Preservice art teachers need to be able to generate informed opinions about where the field of art education stands in today's educational climate, what challenges are out there, what impact national, state, and local politics can have in the short and long run. They need to be able to recognize and keep up with current trends that may have an impact on art education and on the jobs that may or may not be available.

For example, **collaboration** of schools and school districts with museums, businesses, and universities is a national trend. In many places, collaborative efforts, or **"collaboratives,"** are providing resources, enhancements, and extensions to almost every aspect of school programs and often are especially fruitful for the arts and art education. Promotion of **interdisciplinary** connections is another national trend, and it may be politically expedient to attend closely to a premise that art education has as much to contribute to other subjects as other subjects have to contribute to art education. Art educators *need* to know (and be able to communicate) how we contribute importantly to the larger arena of

education. If we cannot show where and how we fit, we may not be able to justify any fit—at least in terms of dollars.

All of these issues warrant dialogue and serious attention. What does the arena look like these days? What are the agendas and who is calling the shots? There is a whole menu of contemporary issues that affects art education, and preservice art teachers need to be aware of it. One of the best resources for building awareness is a student chapter of the National Art Education Association. Every art education preservice program ought to have one as a professional thing to do. Group analysis of NAEA newsletters can track trends and issues in art education. It is very important that preservice teachers make a habit of *paying attention,* not only to anticipated and experienced realities of schools, but to the pressures on schools handed down as national agendas. One's school, one's school district, one's institution of higher education cannot be an island.

Another issue that ought to be of interest in preservice art education preparation is the proliferation of textbooks and instructional materials for the K–12 art education market which purport to be "comprehensive" or "discipline-based." It is increasingly important to prepare preservice students to be able to analyze and evaluate the merit and usefulness of instructional materials. Examining textbook adoption criteria and standards for art education from various locales provides a source of information which influences art teaching practices. Unfortunately, many art teacher applicants lack familiarity with available resources for thinking about and implementing a discipline-based or comprehensive approach to art education; for interpreting National Standards for the Visual Arts (1994), for appraising the merit of Professional Teaching Standards (1994).

Preservice students need more than a passing acquaintance with such trade magazines as *School Arts* and *Arts & Activities,* not necessarily because they need to master all of the projects in them, but because they serve as barometers, as guides to what is going on in art labs, classes, and schools today. Since they derive from the field, these resources often provide a good indication of how, how well, how thoroughly, and with what level of integrity the art disciplines are finding their way into art classes across the nation. Preservice students might find that an analysis of issues covered in trade magazines through the years could reveal a rather remarkable account of changes in art education from a variety of viewpoints. In the way that McDonald's golden arches may be referred to as "popular arts" (Lanier 1982), selected trade magazines might be handled with similar study potential by students. This level of resource

materials is not intended to be scholarly; however, a scholarly approach to analyzing them could yield persuasive data for students about the impact of a comprehensive or discipline-based approach to art education on the field, on curriculum, on art teaching practices, and on specific issues. Simply counting and categorizing references to Professional Teaching Standards (1994) or National Standards for Visual Arts (1994) in articles would provide rich data for analysis of trends and directions.

HOW MIGHT THIS DISCUSSION INFORM HIGHER EDUCATION? IMPLICATIONS

Elliot Eisner (1993) points out that schools are often separated from the out-of-school culture, that there is "a large gap between what they [students] study, what they learn, what they do in school itself, and the life they lead outside of school. The transfer problem is large" (24). A parallel argument might be made contrasting the relevance of many teacher preparation programs with the reality of the school settings in which these teachers find themselves once employed. Eisner suggests that teachers, as major stakeholders for school improvement, need to become "collectively reflective about the institution," thinking systematically about school structure, curricular matters, pedagogical processes, fundamental goals of schools and schooling, and how to evaluate what is happening (25). It appears equally compelling, if not more so, that higher education look at itself in the very same way—a position strongly endorsed in the research agenda Enid Zimmerman (1994) proposes for preservice art teacher education programs.

In reviewing the sparse research available on preservice art teacher education, Zimmerman indicates that, even in colleges and universities where there is interest and advocacy for incorporating a comprehensive approach to art education into preservice art education, the intention is not always the practice or the reality. Zimmerman cites 1984 survey data from the National Association of Schools of Art and Design which indicate that the "most significant advances toward incorporating discipline-based art education initiatives were in art education preservice *methods* classes" (81, emphasis added). Over ten years have passed since the study cited, and I consider that "the methods class" continues to be one of the most significant issues to address in preservice art education.

Based on dozens of my own interviews and transcript reviews of teacher applicants from all over the country each year, it appears that it is still the practice of most institutions of higher education to "cover

DBAE," as well as the dozens of methodological concerns (management, communications, technology, interdisciplinary and multicultural issues, and so forth), in the one or two methods courses that typically appear on a transcript—a rather unrealistic agenda.

There is something about these fantastic expectations for the methods class that seems conspicuously incompatible with a pervasive influence which Hobbs (1993) refers to as the "doctrine of formalism":

> Although the new art education—the ideals of which are most clearly embodied in the DBAE movement—seems to have won the day in the literature, art programs in colleges and universities continue to be inadequate for preparing art education majors to teach the subjects of criticism, art history, and aesthetics in a pluralistic world of art (110).

He cites as the explanation for this a continued—and possibly even increasing—emphasis on studio art and on the principles of design (i.e., the "doctrine of formalism") and argues for a new *theory of art for art education.* He contends that formalism tends to be inconsistent with and possibly counterproductive to the teaching of art criticism, art history, and aesthetics. In my own experience of numerous years of attending studio classes in colleges and universities, I cannot recall a single studio instructor who did not rely on a doctrine of formalism. How can this doctrine be combined with what needs to be accomplished in a methods class? This would appear to be an issue which must be reconciled in some way.

Maybe it is time that all of us who are involved in this process of educating and hiring art teachers (including studio art people) begin to exert pressure for a decision about whether or not the "education" in art education is as important as the "art" *for preservice art education majors.* The considerable effect of consigning almost all of the "education" part of art education to one or two methods courses does a tremendous disservice to preservice students, to art education faculty in colleges and universities, and ultimately to schools and children. It must be borne in mind by every faculty member who is responsible for some aspect of preparing the preservice individual who is aspiring to be called art *teacher*—that teacher and education go hand in hand. It is a major point with broad-based implications.

Methods classes alone are *not* adequate to teach both the subject matter content and the methodology of art education to the preservice art specialist, along with curriculum, multicultural issues, the state of art education in the nation, myriad tools to deal with school culture, and all the other concerns and issues mentioned previously, as well as to assess the merit of resources and text materials for art education. Attempting

to teach content and methodology in a couple of methods courses actually appears to contradict the underlying tenets of discipline-based art education, whose spokespersons (historically, as well as presently) promote first-hand experience with the unique and specialized knowledge and expertise of practitioners from each of the four disciplines—the art historian, the art critic, the aesthetician, and the artist (see Clark, Day, and Greer 1987). To construct a genuinely informed knowledge base, art education students need to be engaged with the reality as well as the pedagogy of art criticism, aesthetics, and art history. In regard to these nonstudio disciplines, May (1993) suggests that art education faculty need to "treat adults as *learners* first, immersing teachers actively in art forms and intensive arts experiences with arts experts before ever making any explicit connections to pedagogy" (4). Both are necessary. We say that art must be *taught* to children, just like any other subject; why is it that we are not as quick to say that preservice art teachers must be *taught* the content they are expected to teach?

Another reality stems from this one: A large number of veteran teachers, as well as prospective teachers, regret (quite vocally) their own lack of content knowledge in the disciplines of art. Some blame their preservice preparation, but the fact may be that many of the higher-education people they encountered in preservice preparation ten or more years ago did not possess knowledge and experience with nonstudio disciplines either! Even when higher education people do possess the knowledge, there are often competing factors (for example, the "politics" of higher education) that foil desired ends. In actuality, art educators in institutions of higher education deal with many of the same school culture realities identified earlier for art teachers, including attitudes and support, logistical concerns, and collegiality.

Zimmerman (1994, 86) enumerates several factors that inhibit the incorporation of the disciplines of art into preservice programs so as to provide counterparts to school culture realities. These include the complexity of implementing a comprehensive or discipline-based orientation, art education colleagues unwilling to accept this stance, insufficient funding and time to develop programs, lack of an adequate research base in art education, difficulty in organizing teams from different areas in related disciplines, and lack of support in universities for the development of quality preservice programs. Zimmerman also presents an ambitious list of suggestions as possible solutions for incorporating study of the disciplines into preservice art teacher preparation, each of which appears essential to the process. She includes the following, quoted here in **bold** type:

- **"Refocus content areas in undergraduate teacher education programs."** According to Gray (1990) and *many* of my own art teachers (new and veteran, K–12), this is a critical necessity; they *want* this knowledge.
- **"Re-educate teacher education faculty."** This, of course, is essential, where needed, for any of the suggestions to work, and content specialists need to consider themselves education faculty when they are working with preservice art education majors.
- **"Create a dialogue and collaboration of art education faculty with colleagues from the disciplines of art history, art criticism, studio arts, and aesthetics that may result in interdisciplinary courses."** This is probably the most realistic scenario to offer the most operative benefits for preservice students (as well as teachers in continuing education, recertification courses, and those returning as graduate students!).
- **"Include fewer studio course requirements and increase courses in other areas to achieve a better balance among disciplines."** Too few courses in what and how to teach seems to be the major complaint among art teachers, both new and experienced. While all art teachers need at least one studio area in which they are professionally competent, as well as a range of proficiencies in a broad variety of media, most would trade some of the many studio requirements for more "courses that make me comfortable teaching nonstudio things." A high level of personal studio competency may be essential for art teachers in magnet programs in the visual arts for high school students who aspire toward careers in art, while Advanced Placement studio art courses may require more excellence in pedagogy than studio prowess on the part of the art teacher. Regardless of specific focus, however, when an art teacher is responsible for teaching in a school setting, the main thing is *teaching*.
- **"Establish early and continuous field experience sites in which cooperating teachers are sympathetic to NAEA standards and the discipline-based art education agenda."** This issue comprises a variety of dynamics. Cooperating teachers must be selected for the role because they are master teachers, not because of the convenient location of their school. Colleges and universities must set high standards and stick to them. There is potential here to develop a strong collaborative relationship between school districts and colleges and universities which could prove highly beneficial to both in terms of this issue, as well as opening doors

to other issues. Cooperating teachers, in my experience, are adamant that weak preservice art teachers are not allowed to "pass through" a teacher prep program. Art education administrators need to attract and nurture the brightest and best students, and then place them with strong cooperating teachers.

Zimmerman provides a lucid and intense agenda of challenges for thinking about the issues involved in restructuring preservice art education preparation programs. The efforts it will take to institutionalize the suggestions are monumental. Art education faculty in higher education often share the same problem as art teachers and supervisors at local school and district levels; to use the words of Queens College (NYC) Professor Emeritus Warwick (1995), they lack "clout and power" within the college, department, or larger arena in which they exist. They have neglected, declined, or lacked the motivation and/or skills to nurture essential relationships with other faculty, departments, administration, and others outside of their own choir; they have not made themselves or their programs "conspicuous" (13). May (1993) alludes to the often-devalued status and tension between teacher educators and the fine arts "purists" in higher education as a "sociopolitical" problem (38); a context relating history, politics, and rhetoric of teacher education and art education. Restructuring preservice art teacher preparation programs is a daunting task to consider, but an essential one, if we are to reconcile some of the apparent contradictions about art as education.

Throughout this paper, associated in one way or another with conditions, realities, or issues of school culture, the distinction between art and art education surfaces. For those in higher education who are responsible for preparing art teachers, the results of whatever they decide to do need to be in the direction of resolving the basic dichotomy: Should prospective teachers be prepared to build *art* programs or art *education* programs? As for me—I will continue to make my vote clear by employing the best prepared teachers available who can contribute to helping a comprehensive art *education* program prosper. A final note in closing: I consider the idea proposed by Hobbs (1993) regarding the formulation of a new theory of art for art education to offer a challenge which warrants serious contemplation by all who are concerned with art education.

REFERENCES

Champlin, K. N. 1991. "Art is like explor-imenting": An ethnographic inquiry into the aesthetic sense of the young child. Ph.D. diss., Georgia State University, Atlanta. (University Microfilms International #9122822.)

Clark, G., M. Day, and W. D. Greer. 1987. Discipline-based art education: Becoming students of art. *Journal of Aesthetic Education* 21 (2): 129–96.

Eisner, E. W., in G. Marchant. 1993. User friendly, intellectually deep: An interview with Elliot Eisner. *Mid-Western Educational Researcher* 6 (2): 24–26.

Gray, J. U. 1990. PROACTA: DBAE—Personally relevant observations about art concepts and teaching activities in ten DBAE school sites. Unpublished report to participants following one phase of the PROACTA research project. The University of British Columbia, Vancouver, B.C.

Hobbs, J. 1993. In defense of a theory of art for art education. *Studies in Art Education* 34 (2): 102–13.

Lanier, V. 1982. *The arts we see: A simplified introduction to the visual arts.* New York: Teachers College Press.

May, W. T. 1993. *A summary of the findings in art and music: Research traditions and implications for teacher education.* Elementary Subjects Center Series, no. 98. East Lansing: Michigan State University, Institute for Research on Teaching, Center for the Learning and Teaching of Elementary Subjects.

National Board for Professional Teaching Standards. 1994. *Early adolescence through young adulthood/art: Standards for National Board certification.* Detroit: National Board for Professional Teaching Standards.

National Committee for Standards in the Arts. 1994. *National standards for arts education.* (Developed by the Consortium of National Arts Education Associations.) Reston, Va.: Music Educators National Conference.

National Endowment for the Arts. 1993. *Arts in schools: Perspectives from four nations.* Washington, D.C.: National Endowment for the Arts.

Warwick, J. F. 1995. Clout/power. *Art Education Journal* 48 (4): 11–14.

Zimmerman, E. 1994. Current research and practice about pre-service visual art specialist teacher education. *Studies in Art Education* 35 (2): 79–89.

My special thanks to Fulton County Schools high school art teacher, art department chair, and NAEA Secondary Division director (1995–97) Denise Jennings for valuable discussion and input.

Accomplishing Change in the University: Strategies for Improving Art Teacher Preparation

James Hutchens
Ohio State University

IN the wake of the first wave of education reform initiatives of the 1980s (National Commission on Educational Excellence 1983, The Holmes Group 1986, Carnegie Corporation 1986, The Getty Center for Education in the Arts 1985, Smith 1986), the 1990s brings a second wave propelled by initiatives for some fundamental, structural changes in teacher education, certification and licensure for teachers (Andersen 1993). The National Board for Professional Teaching Standards (NBPTS) (1994) will soon begin certifying art teachers (Qualley 1995); and recent work by the National Council for Accreditation of Teacher Education (NCATE), in conjunction with the NBPTS, suggests that the trend may be toward "a single, national, compulsory, accreditation system for teacher education" (Wise 1993, 13).

While some sectors of the education establishment are now moving with urgency to reform the teaching enterprise, colleges and universities have moved much more slowly as they have attempted to adjust to a multitude of criticisms and their own externally mandated reforms. But with the spawning of alternative routes to certification and licensure for teachers, and with national compulsory accreditation of teacher education programs a possibility (Andersen 1993), we in higher education must now begin to examine our own ways of doing things. And changes we make to art teacher preparation programs must be considered within the context of calls for reform, both in higher education and beyond our campuses.

■ *139*

Peter Slee's (1989) recent assessment of higher education's embattled position in society is one with which most academics can empathize. The value system behind higher education has come under attack by legislators and university governing boards, and faculty are often viewed as the problem (Sykes 1988, Smith 1990, Anderson 1992). Stakeholders in higher education—students, parents, corporate executives, and others—who now recognize that they are the resource providers, influence change through political activism. State governing boards for higher education, once advocates for universities, have now become advocates for stakeholders. They now often determine what is important in higher education. Believing that faculty have abrogated their teaching and service responsibilities to constituents, governing boards in this era of reform have taken it upon themselves to impact university missions, faculty roles, and curricular offerings across systems of higher education. Teacher education programs have not escaped harsh scrutiny (Lanier 1993).

The press for intellectual respectability through discipline-based art education (widely known as DBAE) has brought some changes in teacher preparation, but there is little evidence that widespread improvements have occurred or that any deep commitment exists to use discipline-based art education as a theoretical framework to guide teacher education. Recent national conferences suggest that faculty may be reluctant to alter customary ways of doing things (Getty Center for Education in the Arts 1988, 1990). And, considering the myriad forms that art teacher preparation takes in more than five hundred programs across the nation (Mills and Thomson 1986)—including different administrative patterns, resource levels, philosophical bases, and curricular structures (Zimmerman 1994)—the difficulty in eliciting a widespread, coordinated response in universities to improving preservice programs becomes obvious.

Some art education programs meet standards established by the National Art Education Association (NAEA); some do not (Rogers and Brogdon 1990). Some institutions have undergraduate certification programs, while others certify teachers only at the graduate level. Some programs are in research universities, some in liberal arts colleges. Some are in private art schools and museum schools. Some are accredited by NCATE, some by the National Association of Schools of Art and Design, some by both, and some by neither. There is no agreement on an ideal configuration for art teacher preparation. Add to this the availability of different degree programs, such as the B.F.A., the B.A., the B.A.E., and the B.S.; variations in certification and licensure requirements

for art education from state to state (DiBlasio 1995); and the inconsistency in credentials acceptable for university employment in art education (it is still common, for instance, to see both the M.F.A. and Ph.D. degrees accepted for art education employment), and the task of raising a coordinated response to improving art teacher preparation becomes a daunting one.

Embedded within the culture of the university and those departments in which art teachers are educated are customs and traditions that will be very difficult to change. But as Mario Fantini (1971) observed long ago in his remarks about education reform, those who hope to make dramatic and widespread improvements cannot ignore solutions that depart from customs and traditions. In other words, we who seek change should not persist in searching only for correctives that the present system can comfortably accommodate if we expect to overcome what I believe is the built-in obsolescence of many art teacher education programs in today's conservative higher-education environment.

We are on the threshold of a new and important dialogue about higher standards for student and teacher performance. We have national voluntary visual arts standards (Consortium of National Arts Education Associations 1994a) and standards for voluntary national certification for teachers of early adolescents and young adults (National Board for Professional Teaching Standards 1994). The visual arts standards assume a brand of discipline-based art education, albeit with a studio bias that gives less attention to aesthetics and art criticism than some would like to see (Smith 1995, Armstrong 1995). But as R. A. Smith (1995) notes, these standards represent a more comprehensive vision of art education than has been customary, as well as a realignment of values toward discipline-based art education. Certainly there are implications within these standards for teacher education programs.

The voluntary standards for what teachers should know and be able to do were developed by the National Board for Professional Teaching Standards with the assistance of many individuals from the field, whose work was supported in part by the Getty Education Institute for the Arts (formerly the Getty Center for Education in the Arts) and the U.S. Department of Education. They are also well positioned to advance discipline-based art education and other reform initiatives.

I do not mean to suggest that either set of standards is any panacea. Criticisms by some at the 1995 meeting of the Council for Policy Studies in Art Education clearly indicated only tenuous acceptance of the visual arts standards at best. But the Council tends to take a skeptical view of many initiatives and movements in the field as I suspect they should.

And some view the standards for National Board certification as an attack on academic freedom, claiming that they are "too authoritarian" (Young 1993). Both certainly will undergo revision with time. But they represent an important effort to establish the integrity and intellectual respectability of visual arts education in a political environment insistent upon educational rigor and high standards and unaccustomed to seeing either in art education.

An issue facing higher education is whether individual faculty specializations, priorities, and customary ways of doing business will permit consideration of the preservice education of art teachers in light of the standards, and in a widespread, coordinated way. In order to make significant inroads in implementing discipline-based curricula, some enervating conditions in universities and departments in which teachers are educated must be overcome..

First, university policy makers must commit to teacher education and its reform. The suspicion with which teacher education in general is viewed must be offset through strategies to inform university leadership of significant art education reform initiatives current in the field.

Second, the research-teaching nexus in art education must be improved in at least two ways. Funded research must focus more directly on needs of prospective teachers and the field rather than simply on the specialization and curiosity of faculty. The process of research and scholarship might evolve away from solitary research to scholarly teams involving faculty from several disciplines, prospective teachers, and in-service teachers. Doctoral research should probably undergo similar transformation from a culture of individualism to one of collaboration.

Third, the disciplinary and conceptual entrenchment of faculty must be overcome. Comprehensive approaches to art education in many states through six regional institutes sponsored by the Getty Education Institute for the Arts, NAEA's Quality Art Education, the national standards, and other reform initiatives within state departments of education have created the need for a closer disciplinary community of art educators, aestheticians, art historians, and critics, yet these faculty "have not yet learned to be natural allies" (Getty Center for Education in the Arts 1988, 16). Adversarial perspectives among faculty can obstruct the implementation of more comprehensive art education curricula for prospective teachers and leave faculty isolated in their own departments. And, given the range of institutions cited earlier as providing teacher education, the isolation of dissimilar institutions and faculty must be overcome by evolving a discipline-based art education consortium— one that extends beyond the regional institutes for in-service teachers

established by the Getty Education Institute for the Arts during the 1980s and includes faculty and prospective teachers in different types of colleges and universities where access is now limited. I am thinking here of the many small institutions throughout the nation in which faculty of art education have little or no direct contact with the developments in the regional institutes for discipline-based art education, the Getty Education Institute for the Arts, or the NAEA-sponsored academies, and few resources or incentives to motivate their involvement.

Finally, a stronger constituency for art teacher preparation must be built in state departments of education and university governing boards, and the support of the private sector must be enlisted to accomplish this. I am going to propose some strategies to accomplish these four propositions.

STRATEGY ONE: UNIVERSITY POLICY MAKERS AND TEACHER EDUCATION

Preparing teachers should be one of the modern university's most important responsibilities, yet few include teacher education in their mission statements. The Carnegie Corporation (1986) discovered this during research for *A Nation Prepared: Teachers for the Twenty-first Century.* Few colleges or universities give high priority to preparing teachers.

Teacher education has always been viewed with a "skeptical eye" (Lanier 1993, 19) on campus by discipline faculty, who may perceive it as anti-intellectual and narrow. Although most colleges and universities started to develop curricula for teachers early on—and the state normal schools were eventually destroyed by this development—teacher educa tion has continued to encounter hostility and contempt. As Arthur Powell (1980) describes this situation in *The Uncertain Profession*, education's "efforts to join the company of legitimate liberal arts lost out. . . . Education was accused of technical bankruptcy and anti-intellectualism" (vii).

This skepticism remains, as well, in the visual arts, where discipline faculty tend to be divided internally against themselves—creators against historians and critics—and all unsympathetic to the needs of art education (Morrison 1985, Ritchie 1966). This dysfunctional environment was underscored at the Getty Center–sponsored conference in Snowbird, Utah, by a participant's recognition that the most serious obstacle to the implementation of discipline-based art curricula in teacher preparation is the lack of political backing in the universities (Getty Center for Education in the Arts 1988, 10). All this is, of course, debilitating to the art teacher education enterprise.

Teacher education should be a university-wide responsibility. But some discipline faculty, provosts, presidents, and state university governing boards, who view art faculty as unable or unwilling to improve teacher education, would downsize or even eliminate teacher education from their university profiles altogether. Consider the regrettable situation involving art education at the University of Oregon a few years ago, when professional education programs were swept from the campus. What was an esteemed art *education* program is now the Arts and *Administration* Program. And my own discussions this past year with other heads of art departments attending the annual conference of the National Council of Art Administrators indicated that some find it easier to eliminate their art education programs than to engage in any real reform efforts or to suffer the criticism of being associated with what they view nationally as a failed enterprise.

As a strategy, we proponents of art education must communicate to university administrators—presidents, provosts, deans, and art department heads—the significant changes in theory and practice in teacher preparation that discipline-based and other forms of comprehensive art education can bring and the intellectual respectability that surrounds them. We must secure their commitment to strengthen art teacher preparation. Given that the International Council of Fine Arts Deans (n.d.) has published a position statement on art in the schools that recommends a comprehensive notion of art education, it seems reasonable to expect their support, and we should cultivate it. The statement by The Working Group on the Arts in Higher Education (1987) is, for me, more problematic. The Working Group is a cooperative project of the National Associations of Schools of Music, Art and Design, Theatre, and Dance, and it represents the academic and administrative leadership of over a thousand postsecondary schools and departments. While their statement alludes to study for art teachers in "creation/performance, history, and analysis," the statement also claims that "specialist arts teachers must have the basic skills of a professional artist" and that "specialist art teachers [must] have sufficient technical skills to be artists" (14). The statement by The Working Group reinforces the studio bias prevalent in art teacher education programs and runs counter to current national reform efforts in art education that require arts specialists to have the basic skills of critics and historians as well.

But we know that the organizational heads—the president, the provosts, the deans, and department heads—must play critical roles as leaders and educators in any transformation process in the university where the real challenge is the culture of "a rigid set of habits . . . and

disciplinary arrangements currently incapable of responding to change either rapidly or radically enough" (Duderstadt 1995). As Jaroslav Pelikan (1992) has argued, "the proper context of teacher training and educational reform is the university as a whole" (177).

STRATEGY TWO: IMPROVING THE RESEARCH-TEACHING NEXUS

The current debates on the tradition of research in the university are so widely known that I need not delve too deeply, I suspect, into the negative perceptions of faculty research. The literature on higher education is weighty with criticisms ranging from cynical, offensive indictments (Sykes 1988) to those more insightful and considered analyses that reconceptualize the nexus between faculty research, students, and teaching (Bakker 1995, Koroscik 1994, Pelikan 1992, Slee 1989).

It has been demonstrated that faculty who are highly active in scholarly research tend to be more effective teachers than faculty who practice scholarly abstinence (McCaughey 1993). But many legislators, members of state university governing boards, students, and in-service teachers have come to believe that most faculty research lacks any educational utility, is unrelated to and detracts from teaching, and is only a vehicle to enhance faculty and university affluence. A recent article in the July issue of *Governing* titled "Higher Ed.: The No-Longer-Sacred Cow" (Mahtesian 1995) exemplifies the potential of legislative action against the research enterprise in the university. Ohio legislator and education finance committee chairman Wayne Jones was incensed after reading of a research project at the University of Akron to study medieval Italian marble formations from which marble was quarried for sculptures. In his view, the award represented faculty "time spent on research of dubious value to Ohio's economy, or the needs of the university's undergraduates." Jones introduced a measure to increase by 10 percent time spent in the classroom by professors in Ohio's state-assisted institutions. Because he was the chair of the education finance committee, his measure was passed into law. Jones meant, he said, "to send a message to the higher education community that we're watching" (20). I suspect many could relate similar stories.

Research is one of the hallmarks of the university. But as David Pankratz (1989) has noted, the topics that get researched are generally chosen by individual researchers based on their own interests and their evaluative concepts of culture, art, and education. This has created a

negative assessment of much faculty research, which is unfortunate at a time when interactive, collaborative research is advocated as a valuable mode of teaching and learning (Koroscik 1994).

Incentives might be provided to strengthen the nexus between art education research and teaching so that research is viewed as responsive both to the requisites of productive intellectual debate and to the needs of prospective and in-service teachers. Gerald Bakker (1995) suggests that statements assessing the impact of a given research project on student learning should be a rule of thumb. Undergraduate teaching, graduate teaching, and research and publication should all contribute to the same enterprise (Pelikan 1992).

To those faculty who believe that this approach to research is too restrictive—and undoubtedly there are many—Koroscik (1994) issues a reminder that "scholars who teach . . . should welcome the opportunity to distinguish [their] work from that produced by independent . . . scholars" (7). Research with little capacity for generalization to the needs of prospective art teachers can be a programmatic liability in our conservative policy environment. While knowledge for its own sake is a valuable commodity, resource providers for higher education now demand that our research serve more practical ends (Smith 1990).

An environment in which learning is research-based not only addresses recognized deficits in research but is consistent with exemplary teaching practices identified in the NBPTS's (1994) core propositions. Propositions two and four recognize that teachers must know and value how "knowledge in their subject is created, organized, . . . and applied in real-world settings [and they must have] the ability to . . . adopt an experimental . . . orientation" to their teaching. Teachers must also continually "adapt their teaching to new findings, ideas and theories" (2–3).

Interactive research also addresses the need for collaboration between faculty and learners in educational events and helps to alleviate negative perceptions held by both prospective and in-service teachers. The research-practice gap may well be caused by researchers themselves, whose work may not be helpful to students and practitioners because it is too theoretical. In the future, those researchers who show no concern with the practical applications of their work may have a difficult time justifying what they do and an even tougher time giving teachers and policy makers a reason to care about their findings (Boostrom, Jackson, and Hansen 1993).

It is necessary to overcome the relative indifference with which prospective and in-service teachers view research. Incentives should be provided to encourage faculty to pursue research programs that

bring together prospective teachers, in-service teachers, and students in our schools. The Getty Education Institute's regional staff development institutes could be locales for initial commitments for these research programs. Where they exist, professional development schools that bring together faculty, prospective teachers, and in-service teachers (Holmes Group 1986) are others.

STRATEGY THREE: SCHOLARLY ALIENATION AND DISCIPLINARY TERRITORIALISM: THE CULTURE OF ART DEPARTMENTS

The range of disciplinary traditions and values among faculty who prepare future teachers can obstruct change in teacher preparation programs. Some art education, art, and art history colleagues are often unwilling to accept discipline-based art education and other comprehensive approaches, and some accrediting agencies have guidelines in place that perpetuate studio traditions in teacher education.

Reports of discussions at the Getty Center seminars in Snowbird, Utah, in 1988 and in Austin, Texas, in 1989 demonstrated the entrenchment of other orientations to art education. Participants in Utah were unable to come to a consensus on the ideal education for teachers. Proponents of multiculturalism in attendance at the Texas conference argued for the relevance and coexistence of several curricular orientations, including feminism, multiculturalism, post-modernism, and deconstruction, "without requiring that they be related to DBAE" (Getty Center for Education in the Arts 1990, 84). Competing ideologies remain even in light of the general congruence of discipline-based art education, National Board Standards, and other comprehensive approaches to art education.

This lack of consensus is a debilitating problem. Getting proponents of various brands of multiculturalism, discipline-based art education, the studio model, visual literacy, and so on to collaborate in the preparation of art teachers has not been easy. Although discipline-based art education theory has been supportive of multiculturalism and diversity since the beginning (Day 1992, Clark, Day, and Greer 1987), many multiculturalists still view it as irretrievably situated in Western traditions of art. Feminists and post-modernists view it as mired in antiquated, male-dominated modernism. However, as Karen Hamblen (in press) has noted, the concerns for conservative aspects of discipline-based art education in the sociopolitical climate of the 1980s were understandable,

although many art education faculty appear to be unaware of "the extent to which post modern factors and critical input have influenced and fostered change in DBAE theory and practice" (n.p.).

Another facet of conceptual entrenchment is the studio bias that is still prevalent in teacher preparation programs. Prospective teachers come to programs with studio expectations developed in their high-school classrooms. A considerable part of their preservice education is with studio faculty, and they often leave the university more a product of their studio curriculum than their art education training (Hobbs 1983).

Some studies show that more art history and art criticism courses are being included in teacher preparation programs (Kern 1987, National Art Education Association 1990, Willis-Fisher 1991), but the studio bias is still prevalent (Zimmerman 1994, Rogers and Brogdon 1990). In the case of teacher training programs situated in schools and departments of art, as opposed to autonomous art education units, this may be partially attributable to the guidelines of their principal accrediting agency, the National Association of Schools of Art and Design (NASAD). NASAD (1993) recommends that a minimum of 60 percent of the credit requirements in B.F.A. degree programs requiring 120 semester hours be in art and design courses. As Hobbs (in press) notes, "the B.F.A. degree has become the model of excellence in art at the undergraduate level. This, of course, bears on the self-esteem of all majors, including art education majors (whether or not they elect to pursue that degree)" (n.p.).

NASAD defines the *preferred* (emphasis mine) professional degree in art education as the B.F.A., in which approximately 55 to 60 percent of the credit requirements should be in art and design courses, with only 12 to 15 credit hours in art history. In addition, NASAD guidelines for accreditation state

> that primary and secondary art teachers who exhibit a high level of skill as artists and designers are generally more effective. Therefore, NASAD member institutions should focus their undergraduate teacher education efforts in B.F.A.–type programs which provide a primary emphasis in studio work. (National Association of Schools of Art and Design 1993, 86).

Clearly, the B.F.A. degree in art education may be anathema to efforts to infuse more art history, art criticism, and aesthetics into teacher education programs.

Interestingly, NCATE guidelines make no such stringent studio demands; but since NCATE and state education departments often now jointly accredit art teacher preparation programs, and since in-service

teachers heavily oriented to the studio assist in the development of state accreditation guidelines for art specialists, the studio bias continues.

Finally, department culture can isolate and then further divide the art disciplines into specialized fields, causing scholarly alienation and disciplinary territorialism. While this has produced a wealth of specialized inquiry, it has also produced what David Damrosch (1995) calls a poverty of general discussion about the needs of teachers. Art education faculty can feel isolated and without support for change in their preservice programs.

In fact, there is no consensus—no single, widely accepted overriding philosophy of art education or of art teacher preparation. How can more than five hundred programs involving thousands of faculty members and administrators have a unified philosophy? Harold Taylor (1971) defines the problem in his *How to Change Colleges: Notes on Radical Reform* when he said that, instead of a philosophy, we have a system of administrative and disciplinary conveniences.

My third strategy suggestion is to develop a national consortium of discipline-based programs. The original Holmes initiative might serve as a model, but with more technologically based teaching, learning, and professional development. There are, certainly, teacher preparation programs that will have neither the resources nor faculty inclined to be involved in such a framework; but I believe that our more privileged art education programs have an obligation to those less privileged in location and resources. Some resource problems in smaller institutions can be addressed through distance-teaching technology that conjoins different types of institutions to better serve art teacher preparation. Telecommunications, the Internet's World Wide Web, and other electronic media make possible the sharing of resources and expertise in ways previously unheard of, both nationally and internationally. Art educators must overcome concerns about the sanctity of the classroom, faculty job security, and quality control of long-distance learning and begin discussion toward creating electronic seminars and outreach programs to the many art education faculty and students isolated across the nation.

And does the nation really need over five hundred art teacher training programs? Can anyone expect consistency and high standards from so many programs? Whereas segments of the reform of art education can be addressed separately—curriculum, research, resources—authentic reform will not occur until the isolated disciplines, faculty, and teacher education programs are joined in an integrated movement. This fundamental realignment of our field is vital.

STRATEGY FOUR: BUILDING A NATIONAL CORPORATE AND GOVERNMENT CONSTITUENCY FOR ART TEACHER EDUCATION REFORM EFFORTS

The previous discussion has identified some constraints internal to our college and universities which affect the conduct of teacher education. But art teacher education is also subject to broad public attitudes and values. I find it odd that although the need for K–12 school reform and changes in business and industry are two of the most transforming forces in higher education today, the art education constituency remains small and weak. As I said earlier, the development of world-class standards for students or teachers is no panacea. Whether standard-setting at any level can foster improvements will depend on whether we who favor reform in art education can build a constituency with a positive value for what we do (Lagerman 1995).

The Getty Center institutes, the NAEA academies, National Board Standards, and comprehensive art education guidelines promulgated through state departments of education and others have helped to develop a constituency among some teachers, principals, and school district leaders. But there must be a strategy to mobilize broad public and private interest if we are to be taken very seriously on the campus and by university governing boards. We have not communicated a value for what we do that a large constituency can support.

If the story of the origins of art education are true, and Walter Smith created art education to respond to society's and industry's needs, that same constituency exists today. While the earlier need was for a narrow skill base engendered through line drawing and copy exercises, the contemporary need is for the kinds of skills and knowledge that benefit contemporary society and industry.

In its response to questions raised about the value and role of the National Standards for Education in the Arts, the Consortium of National Arts Education Associations (1994b) discusses skills and knowledge that have encouraged the commitment of business to arts education. "CEOs of Chevron, AT&T, Kellogg, Chase Manhattan, and Xerox have [now] made . . . public commitments about the value arts education holds for success in a competitive global environment" (11). Experts in visual, spatial, iconic, and interactive communications will, they know, be important players in the information management process as business adjusts to new world market conditions. Business will need workers who not only understand *what* images mean, but *how* they mean. Industry again recognizes its need for the expertise of workers trained in the

visual arts in order to conduct business effectively. We should cultivate the help of these CEOs and others in strengthening preservice education programs on our campuses and in building our national consortium mentioned earlier.

During this time of economic and educational conservatism, the only educationally defensible policy for art education is one based in the liberal arts and not driven by or subject to fluctuations of contemporary political agendas and their constituencies. With the assistance of the Getty Education Institute, the NAEA, certification and licensure bodies, and others, we are establishing the teaching of art as genuine academic knowledge, that is recognition of art—not in service to the elite, or poor and disadvantaged, not Eurocentric or Afrocentric—not in service to any constituency particularized by class, race, gender, or ethnicity—but cloaked in intellectual respectability. This is vital to efforts to locate our supportive constituency.

Powerful legislators and state governing boards, through budget control mechanisms, are now moving through higher education using a slash-and-burn process rather than an intelligent educational process. Under the guise of saving taxpayers' money, iconoclasts will cut education programs, including art education, and destroy traditional decision-making mechanisms in the university. Faculty who are not motivated to assume leadership roles in the reform of art teacher education, or who try to serve multiple political agendas, will suffer from educational policy-making driven not by their own conscious choice, nor by the needs of prospective teachers, but by the political motivations of legislators and governing boards who are not academics. If we wish to save our discipline, we must not abrogate our responsibility to engineer educational change.

REFERENCES

Andersen, D. G. 1993. The journey toward professionalism: Accreditation, licensure, and certification. *National Forum* 63 (4): 11–13.

Anderson, M. 1992. *Impostors in the temple.* New York: Simon and Schuster.

Armstrong, C. 1995. A realignment of values implied by translation of the national voluntary visual arts standards. Paper prepared for the annual meeting of the Council for Policy Studies in Art Education, April 6, Houston, Texas.

Bakker, G. 1995. Using "pedagogical-impact statements" to make teaching and research symbiotic activities. *Chronicle of Higher Education,* March 17.

Boostrom, R., P. Jackson, and D. Hansen. 1993. Coming together and staying apart: How a group of teachers and researchers sought to bridge the research practice gap. *Teachers College Record* 95 (1): 35–44.

Carnegie Corporation. 1986. *A nation prepared: Teachers for the twenty-first century.* Washington, D.C.: Carnegie Forum on Education and the Economy.

Clark, G., M. Day, and D. Greer. 1987. Discipline-based art education: Becoming students of art. *Journal of Aesthetic Education* 21 (2): 129–93.

Consortium of National Arts Education Associations. 1994a. *National standards for arts education.* Reston, Va.: Music Educators National Conference.

———. 1994b. *Setting the record straight: Give and take on the National Standards for Arts Education.* Reston, Va.: Consortium of National Arts Education Associations.

Day, M. 1992. Cultural diversity and discipline-based art education. Paper presented at the seminar on Cultural Diversity and Art Education, August, Barton Creek, Austin, Texas.

Damrosch, D. 1995. *We scholars: Changing the culture of the university.* Cambridge, Mass.: Harvard University Press.

DiBlasio, M. 1995. Certification and licensure requirement for art education: Comparison of state systems. Paper prepared for the Sundance Symposium on Improving Art Teacher Preparation, October 5–8, Provo, Utah.

Duderstadt, J. 1995. Academic renewal at Michigan. *Executive Strategies,* July, 20.

Fantini, M. 1971. Teacher training and educational reform. In *Improving in-service education: Proposals and procedures for change,* edited by L. Rubin, 189–206. Boston: Allyn and Bacon.

Getty Center for Education in the Arts. 1985. *Beyond creating: The place for art in America's schools.* Los Angeles: Getty Center for Education in the Arts.

———. 1988. *The preservice challenge: Discipline-based art education and recent reports on higher education.* Los Angeles: Getty Center for Education in the Arts.

———. 1990. *Inheriting the theory: New voices and multiple perspectives on DBAE.* Los Angeles: Getty Center for Education in the Arts.

Hamblen, K. In press. The emergence of neo-DBAE. In *Art education: Content and practice in a post modern era,* edited by J. Hutchens and M. Suggs. Reston, Va.: National Art Education Association.

Hobbs, J. 1983. Who are we, where did we come from, where are we going? *Art Education* 36 (1): 30–35.

———. In press. The interaction of art education and theories of art. In *Art education: Content and practice in a post-modern era,* edited by J. Hutchens and M. Suggs. Reston, Va.: National Art Education Association.

Holmes Group. 1986. *Tomorrow's teachers: A report of the Holmes Group.* East Lansing, Mich.: Holmes Group.

International Council of Fine Arts Deans. N.d. *Art education principles/standards: An ICFAD position.* San Marcos, Tex.: International Council of Fine Arts Deans.

Ishler, R. 1995. Education and academics: The preparation of elementary school teachers: A university-wide responsibility. *The Phi Kappa Phi Journal* 75 (2): 4–5.

Kern, E. J. 1987. Antecedents of discipline-based art education: State departments of education curriculum documents. *Journal of Aesthetic Education* 21 (2): 35–56.

Koroscik, J. 1994. Blurring the line between teaching and research: Some future challenges for arts education policy makers. *Arts Education Policy Review* 96 (1): 1–10.

Lagemann, E. C. 1995. For the record: National standards and public debate. *Teachers College Record* 96 (3): 369–79.

Lanier, J. 1993. Choices for the twenty-first century: Will universities strengthen or close schools of education? *National Forum* 63 (4): 18–22.

Mahtesian, C. 1995. Higher ed: The no-longer-sacred cow. *Governing*, July, 20–26.

McCaughey, R. A. 1993. But can they teach? In praise of college professors who publish. *Teachers College Record* 95 (2): 242–57.

Mills, E. A., and D. R. Thomson. 1986. *A national survey of art(s) education, 1984–1985: A national report on the state of the arts in the states.* Reston, Va.: National Art Education Association.

Morrison, Jack. 1985. *The maturing of the arts on the American campus: A commentary.* Lanham, Md.: University Press of America.

National Art Education Association. 1990. *Quality art education: Goals for schools.* Reston, Va.: National Art Education Association.

National Association of Schools of Art and Design. 1993. *Handbook.* Reston, Va.: National Association of Schools of Art and Design.

National Board for Professional Teaching Standards. 1994. *Early adolescence through young adulthood/art: Standards for National Board certification.* Detroit: National Board for Professional Teaching Standards.

National Commission on Excellence in Education. 1983. *A nation at risk: The imperative of education reform.* Washington, D.C.: National Commission on Excellence in Education.

Pankratz, D. B. 1989. Arts education research: Issues, constraints, and opportunities. In *The challenge to reform arts education: What role can research play?* edited by D. B. Pankratz and K. Mulcahy, 1–28. New York: American Council for the Arts.

Pelikan, J. 1992. *The idea of the university: A reexamination.* New Haven, Conn.: Yale University Press.

Powell, A. 1980. *The uncertain profession.* Cambridge, Mass.: Harvard University Press.

Qualley, C. 1995. NBPTS moving toward certification of secondary art teachers. *NAEA News* 37 (4): 1.

Ritchie, A. C. 1966. *The visual arts in higher education.* New York: College Art Association.

Rogers, E. T., and R. E. Brogdon. 1990. A survey of NAEA curriculum standards in art teacher preparation programs. *Studies in Art Education* 31 (3): 168–73.

Slee, P. 1989. A consensus framework for higher education. In *Higher education into the 1990s,* edited by C. Ball and H. Eggins, 63–68. Bristol, Penn.: Open University Press.

Smith, P. 1990. *Killing the spirit: Higher education in America.* New York: Viking Penguin.

Smith, R. A. 1986. *Excellence in art education: Ideas and initiatives.* Reston, Va.: National Art Education Association.

———. 1995. Aesthetics and national standards for the arts. Paper prepared for the annual meeting of the Council for Policy Studies in Art Education, April 6, Houston, Texas.

Sykes, C. 1988. *Profscam: Professors and the demise of higher education.* New York: St. Martin's Press.

Taylor, H. 1971. *How to change colleges: Notes on radical reform.* New York: Holt, Rinehart, and Winston.

Willis-Fisher, L. 1991. *A survey of the inclusion of aesthetics, art criticism, art history, and art production in art teacher preparation programs.* Normal: Illinois State University Press.

Wise, A. 1993. A vision of the future: Of teachers, teaching, and teacher education. *National Forum* 63 (4): 8–10.

Working Group on the Arts in Higher Education. 1987. *Teacher education in the arts disciplines.* Reston, Va.: Working Group on the Arts in Higher Education.

Young, M. W. 1993. Countdown: The goals 2000: Educate America Act. *National Forum* 63 (4): 3–4.

Zimmerman, E. 1994. Current research and practice about pre-service visual art specialist teacher education. *Studies in Art Education* 35 (2): 79–89.

RE

JA